Clive Head

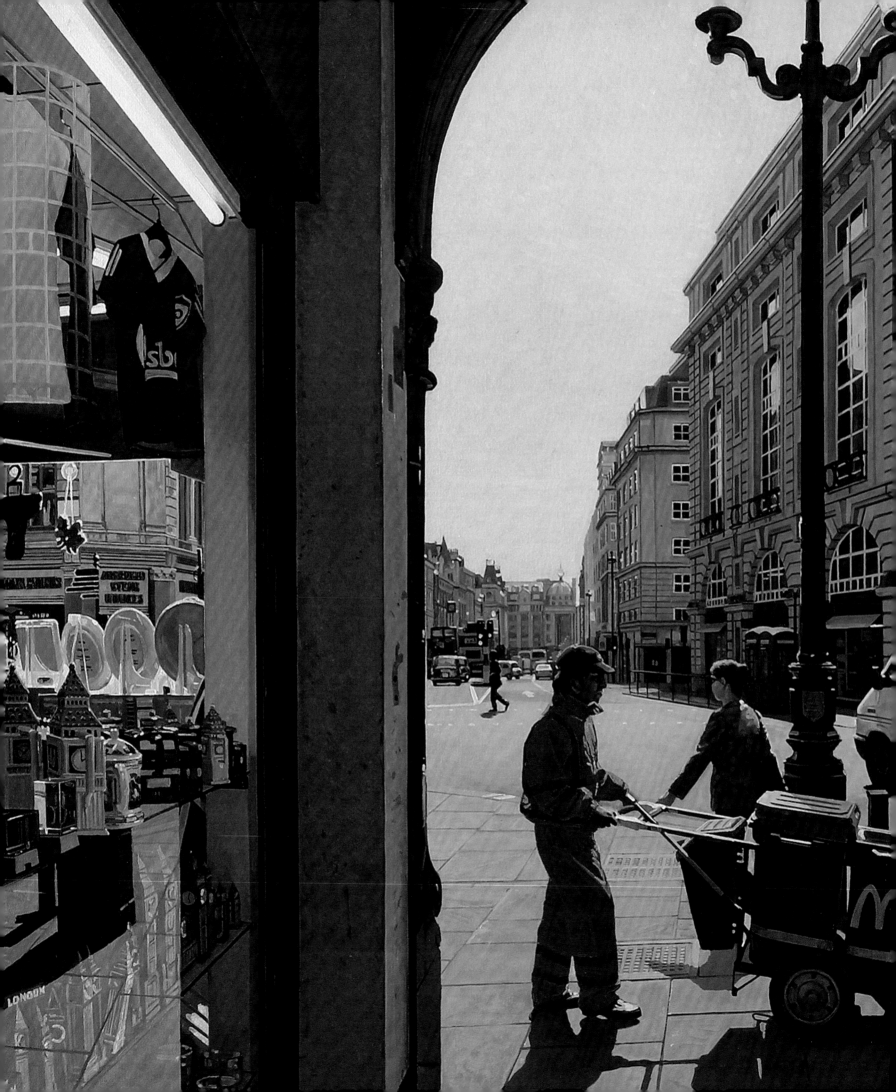

Clive Head

Michael Paraskos

with a foreword by Jools Holland

Lund Humphries

First published in 2010 by Lund Humphries

Lund Humphries
Wey Court East
Union Road
Farnham
Surrey GU9 7PT

and

Lund Humphries
Suite 420
101 Cherry Street
Burlington, VT 05401-4405
USA

www.lundhumphries.com

Lund Humphries is part of Ashgate Publishing

British Library Cataloguing-in-Publication Data:

Paraskos, Michael.
 Clive Head.
 1. Head, Clive, 1965- –Criticism and interpretation.
 2. Realism in art–Great Britain.
 I. Title II. Head, Clive, 1965-
 759.2-dc22

ISBN: 978-1-84822-062-1

Library of Congress Control Number: 2010927638

Edited by Sarah Thorowgood
Designed by Kevin Brown at park44.com
Set in Photina and Meta
Reprographics by Altaimage
Printed in Singapore

Frontispiece *Haymarket*, 2009 (see plate 94)

Contents

Foreword by Jools Holland 7

Chapter 1 *Metastoicheiosis* 9

Chapter 2 Ariadne's Threads *41*

Chapter 3 Hidden Harmonies *75*

Epilogue *99*

Plates *103*

Notes *193*

Chronology *195*

Bibliography *196*

Solo Exhibitions *197*

Select Group Exhibitions *197*

Index *198*

Acknowledgements *200*

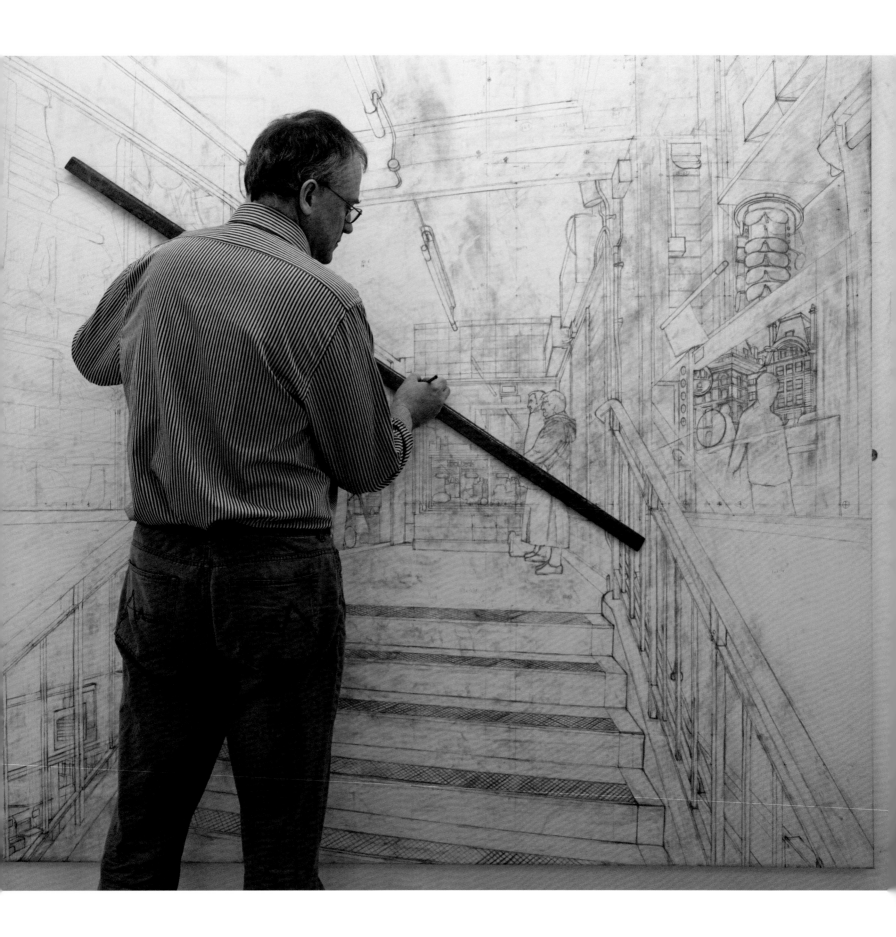

Foreword

I am delighted to have been invited to write the foreword for this book. I have long been an admirer of the extraordinary work of Clive Head.

Music and painting have certain similarities. No two musicians play in the same way and no two painters paint in the same way. One of the pleasures of music for me is hearing the individual styles of great musicians. I derive the same pleasure from studying great painters. I love looking at paintings and seeing the way each painter responds and interprets differently what they see before them, reinventing it for my eyes.

I am broad in my taste and enjoy contemporary, modern and old master painters. Perhaps my favourites are some of the Dutch artists from the Golden Age. Pictures which depicted insignificant everyday events but have somehow been given a magical sense in the way they are painted. When I walk round museums and see a great picture from the corner of my eye, I am drawn towards it instinctively.

This is how I first discovered Clive's brilliant work. In 1991 Clive had a small show in the Woodlands Gallery in Blackheath, near my recording studios. I walked in and couldn't believe my eyes. Each picture had such a strong atmosphere, and such an inviting look, that I stayed in the gallery much longer than I intended. I bought one of these which now hangs in the control room of my studio. All of the musicians, and artists, that visit my studio are drawn to it like a magnet, and ask about it. It depicts a car behind an articulated lorry waiting to cross the Kingsferry Bridge (Plate 54) on to the Isle of Sheppey. The sky, the distant fields, the rusting bridge, the water, mesmerise and captivate the viewer.

I mentioned earlier the old Dutch masters, and indeed it's like one of those. Where nothing is happening but everything seems to be happening at the same time. Where everything is real and at the same time unreal. Clive Head's pictures have the same affect on me as those Dutch old master paintings. Except they depict us and our world in our time.

As I have seen more of Clive's paintings, I have realised how he plays with perspective and captures our world in a way that no photograph can. His use of light and colour unconsciously inform the viewer of the temperature and atmosphere of the day we are observing. Clive Head's work is not unlike Aelbert Cuyp or Canaletto. The more you look at his pictures, the more you start to see.

I am so pleased this book now makes it possible for more people to see, and enjoy, his work to date.

Jools Holland
March 2010

1. Clive Head drawing *Leaving the Underground*, 2010

Image © Malcolm Tweedie MacDonald

7

Chapter One

Metastoicheiosis

The history of art is the history of space. This is a concept that causes many people, including many artists, a great deal of trouble. It is undeniably difficult to understand what is meant by space and, even more so, what is meant by a writer coming along and saying art is about space and the history of art is the history of space. Do not worry. I used to find it difficult too, and even now some aspects of space in art are obstacles to me. It would be so much easier if we could pretend that art is about telling stories in pictures, or about making pompous political or social statements, or that art is just about showing us pretty things. Unfortunately art is not about any of these. That is not to say there are no artworks that show us scenes from stories, or make political or social statements, or show us pretty things. But that is not the art in art. To say that it is is rather like saying the taste of a raspberry is the colour red. Ripe raspberries tend to be red, but the colour is subsidiary to the taste of a raspberry, not integral to it. In fact, I remember as a child a drink made from crushed ice that we used to call Slush Puppies, although I see now a similar thing rather grandly called a 'granita'. Into the ice would be poured various flavoured syrups, an orange syrup for the orange flavour, and a purple one for the grape. The lime flavour was lime coloured, but for some reason the raspberry flavour was blue. Not raspberry red, but a copper sulphate blue. So just as the taste of raspberry is not about the colour red, so art is not about stories, or political or social statements, or the sight of pretty things. Art is about space. It is about constructing space, defining space, exploring space and establishing space. We know this to be true from historic artworks such as the *Venus of Willendorf*, a stone-carved sculpture of a woman, estimated to be about 25,000 years old. No one knows who made it, why they made it or what it means in terms of its narrative, or its political or social meaning, or even whether it was made just to be a pretty object. Archaeologists and anthropologists will guess, but they are only guessing because the person who made it, and the persons for whom it was made, are not here to tell us. They have left no written records. So what we have is an art object with no known narrative function, and no known political or social message, and we do not know if it was purely decorative. All we know is that it still defines itself as an object in space. In other words, even if it once had narrative, political, social or decorative meaning, it has none of those meanings today. Its core function after 25,000 years – which is to say the thing it was, and still is, about – is its definition of space.

What if we were not looking at a small sculpture like the *Venus of Willendorf* 25,000 years after it was made, but at a supposedly highly political painting like *The Massacre at Chios* (Plate 3), painted in 1824 by Eugène Delacroix? *The Massacre at Chios* refers to a specific political event during the Greek War of Independence,

2. Clive Head, detail, *Cologne*, 1998

Oil on canvas
137 × 180 cm
(53 ⅞ × 70 ⅞ in)
Private collection

3. Eugène Delacroix, *The Massacre at Chios*, 1824

Oil on canvas
419 × 354 cm
(165 × 139 in)
Image © Louvre, Paris,
France/Giraudon/
Bridgeman Art Library

when Turkish soldiers killed almost the entire population of the Greek island of Chios. In 25,000 years' time will anyone looking at this painting, assuming it survives so long, know that? Isn't it more likely they will look on this remarkable thing made by a human being so long ago and not know the history behind it, its political narrative? It is possible that even the Greeks and the Turks will be forgotten as historic people, let alone what wars they fought. So what will we have as a painting? We will have an image that defines objects in space. A figure on a horse will be set in a spatial relationship to a figure on the ground. That ground will seem to recede into the distance, with the foreground figures in a spatial relationship to another group of figures in the background. None of the narrative meaning we are often told this painting is about will survive. All that will survive is the painting's true meaning as a work of art, which is to say its spatial meaning, and that is embodied within the material nature of the artwork itself. One object is depicted on the canvas in a certain way next to another object and so on.

This is what is meant when we say the primary purpose of visual art is the establishment, definition and exploration of space. We create spatial relationships between objects in a painting, or spatial relationships between objects in the real world in sculpture, and the skill with which we organise those objects and their relationships is the skill of an artist. It is the language of art. Great artists organise these spatial relationships in new and exciting ways, which in turn reflects back on our experience of space in our world. To understand this is to understand what the painter and critic Patrick Heron meant when he said, 'What time is to the musical composer, space is to the painter.'[1] If we want to sound impressive we might say that space is the aesthetic imperative of art, or even that it is the function of art, a statement that suggests that the functioning of an artwork is essentially the success of its spatial construction.

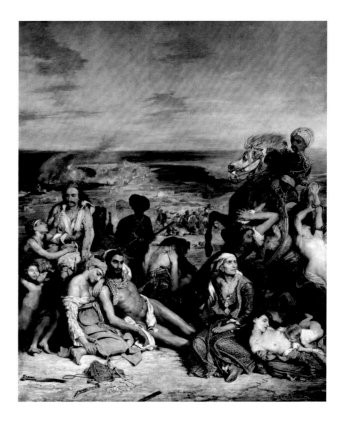

According to Clive Head, whose work is presented in this book, his art tutor, David Tinker, used to ask students to think about the question: 'Of all the Madonna and Child paintings that have been made why are some great and some ordinary? They all function semiotically in the same way. So what distinguishes a great painting?'[2] As Tinker states here, the semiotic or narrative meaning of a great and an ordinary image of the Mother and Child is the same, so the answer to his question had to be that the difference between great art, ordinary art and even bad art is the difference between the functionality of the space in the work of art. It cannot lie in the narrative or political or social meaning, because that is the same for every image of the Mother and Child. Instead the great painting functions as an artwork because of the success of its spatial construction. The less great down to the poor do not function so well in terms of their space.

In saying this we do not mean that one painting constructs space that is like the space we experience in our

world and the other does not. In fact, simply repeating the spatial constructions of our world would be a futile exercise as we already experience space in the real world, which is to say we already experience actuality. What we mean is that the painted space in the functioning image of the Mother and Child is convincing, or believable, in its own terms. Its space might be wholly unlike space in our world, wholly unlike actuality, but if the painting carries the authority to appear convincing or believable in its own terms then we will suspend our disbelief and be willing and able to enter into the artificial space of the painting, regardless of how extraordinary its spatial construction might be. A less great painting of the Mother and Child, on the other hand, will never persuade us to enter into the world it suggests. When a painting or other artwork persuades us of the credibility of its space then and only then are we able to expand our perception of the possibilities of existence. A new world opens out in front of us and we enter into it. What that world contains is only limited by the imagination of the artist, but if the artist fails to establish space in the first place then there is no new world brought into existence, and no alternative reality for us to enter into.

The ability of Clive Head to create strange new worlds, alternative realities, is not in question. If he has a problem with his paintings it is more likely to be that people do not recognise that this is what he is doing. Because a painting like *Cologne*, 1998 (Plates 2 and 59), in some sense resembles the city of Cologne, the assumption is often that it is the surrogate for Cologne, its mimetic twin. René Magritte recognised this in 1928 when he started producing his images in the series *La trahison des images* (*The Treachery of Images*). But Magritte's act of simple visual philosophy helped to mislead an entire century of art theorists into arguing that art is simply an act of symbolising reality. To use the correct theoretical term, they argued, *apropos* Magritte, that the image signified reality. Magritte could declare that his image of a pipe, *Ceci n'est pas une pipe*, was not the pipe but a painting of a pipe, and in later artists and writers this morphed into a belief that the painting of a pipe was the signifier of a pipe in our world. The visual image became no more than a hieroglyph, with a picture of a pipe operating in exactly the same way as the word 'pipe'. In this context it is hardly surprising that Head's *Cologne* should be seen as the surrogate of Cologne the city, because recent art theory demands that it is read semiotically as the signifier of Cologne. Photography does not help in this respect as there is a near instinctive assumption that the photograph of a place, person or thing is the surrogate for the place, person or thing depicted, derived in part from the mimetic appearance of the photograph, but also from the physical act of taking a photograph. Even that word 'taking' suggests the photographic image is the thing taken rather than rendered, and many well-known writers on photography have been struck by the apparent direct relationship between the photograph and the thing it depicts. Roland Barthes, in his great defence of the primacy of photography, *Camera Lucida*, considered photography to be the truest form of image-making because the image was formed from the light reflecting from the subject itself, and hitting the photosensitive surface to create the photograph, and not from the subjective hand of any artist.[3] This means the photograph becomes the most direct signifier of the original thing because it is, in Barthes' theory, a direct imprint or trace of the original thing, as close as it is possible to get to saying 'this is a pipe' without presenting the pipe itself.

As we shall see, Head's paintings have a relationship to photography, just as they have a relationship to actuality, but they are not photographs and they are not surrogates for actuality. Looking at *Cologne* we are right to say *Ceci n'est pas Cologne*, but that is not the same as saying Head's *Cologne* is a signifier of the city of Cologne,

or a signifier of this bridge over the River Rhine in Cologne. That would be to commit a Lollard heresy: that is, to argue a doctrine of consubstantiation that fails to recognise that the process of establishing, defining and exploring space through the materials of art results in *metastoicheiosis*, an ancient Greek concept that accepts the existence of something without the need of exegesis. In religious terms, adherents of consubstantiation see images as symbols, while believers in transubstantiation see them as being made real through a magical act, and those of *metastoicheiosis* accept them simply as being real. In other words, Head creates a new existence, an alternative world, and through *metastoicheiosis* that alternative world is independent of Cologne in actuality, and not a symbol of Cologne, as in photography. It is a 'Cologne' in its own right. The most obvious parallel for this aspect of Head's work has to be that of the Russian painter Wassily Kandinsky, who took from Orthodox Christian theology the concept of the painted icon in a church being an astonishing window that opens out not onto our world, but onto Heaven. The church icon is not, therefore, an object made of wood and paint that is worshipped, nor is it a symbol of the person or event depicted. It is a view into an alternative reality. To understand Kandinsky one needs to understand this belief because it underpins Kandinsky's art. His paintings might be wholly abstract, but they were for him windows into an alternative reality to the one in which we live. The existence of that reality is dependent once again on the artist successfully defining space in which that reality can exist, and as in an icon in a Greek or Russian church that definition is not achieved through sophistry or social convention. It is achieved through a physical engagement with the material reality of our world, the physical medium of the painter's tool kit, and the skill of the artist in establishing believable, or credible, or, to use Head's preferred term, 'conceivable' space. In that way the material is transformed into an

alternative reality, and we can conceive of the validity of Kandinsky's space. In the same way Head's *Cologne* is not a symbol or an imprint of Cologne, but an opening into an alternative reality. It is this act of opening up an alternative reality in art that goes by the name *metastoicheiosis*. Where Head might differ from the church icon painter or Kandinsky is in believing that on the other side of his window there is an actual place. In saying that, however, I am possibly assuming too much. There are often surprising correlations between different artists, and it is perfectly possible that Head harbours similar views to Kandinsky on what it is he is showing in his work. Equally, Head's paintings could be wholly secular openings, rather than spiritual ones, but the difference is unimportant. Implicit within the concept of *metastoicheiosis* is the recognition that physical existence is not separate from metaphysical existence, and that this applies whether we define that metaphysical existence in terms that are religious, spiritualist or intellectual. It was only through the separation of the physical from the metaphysical (or we might say the making of art from the ideas of art) that so many artists and art theorists have been led to bark up the wrong tree. In the words of David Sylvester: 'Before the work [of art] conveys reality it must achieve its own reality, before it can be a symbol it must rejoice in being a fact, and the more it affirms its autonomous reality, the more will it contain the possibility of returning us to the reality of life.'[4] It is difficult to imagine a more succinct, accurate or compelling definition of art.

———————

Looking at Head's painting *St. Paul's from Blackfriars Bridge*, 2006 (Plates 4 and 83), we see an image that looks almost photographic in its realism. A number of people seeing the picture for the first time reproduced in this book may well initially assume that it is a photograph rather than the reproduction of a painting. Even when

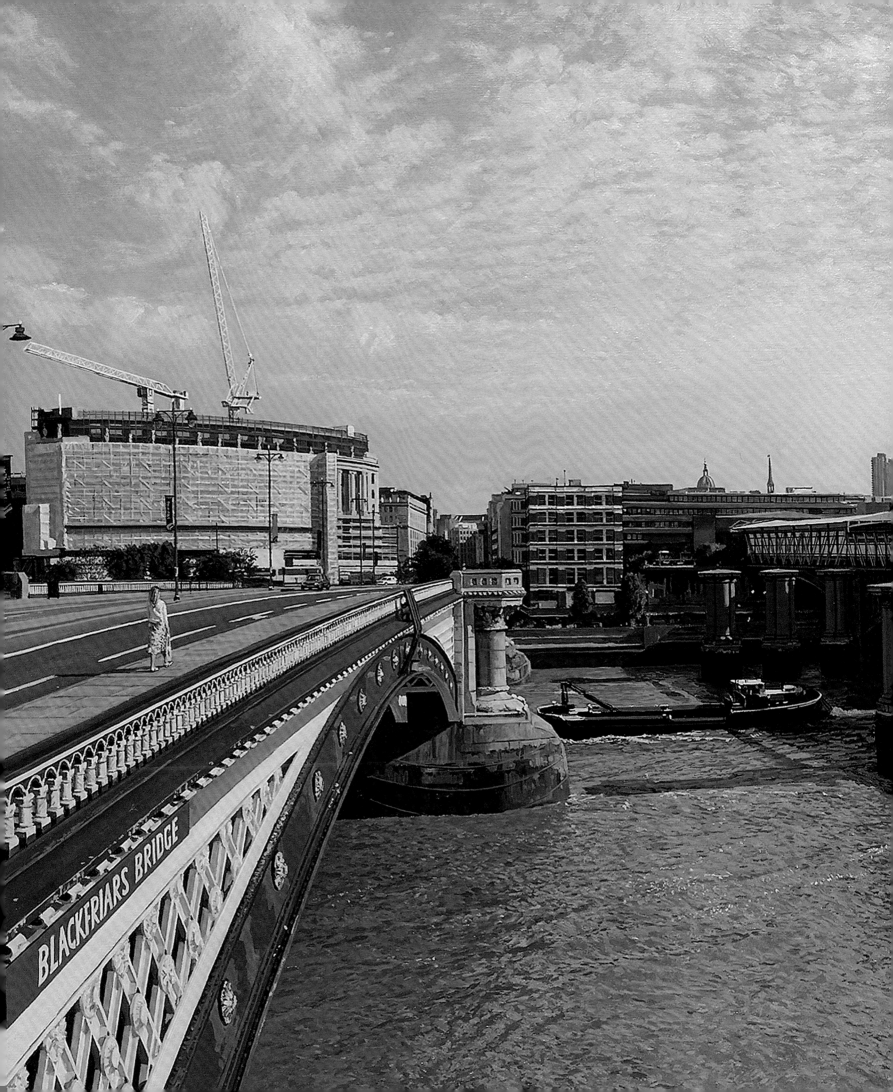

told it is a painting, exclamations of disbelief are often only gradually replaced by amazement at how any painter could capture the light glistening on the water of the River Thames so realistically, let alone render the extraordinary detail of the scene. Even the ordinariness of a view, familiar to the tens of thousands of commuters who travel into the City of London via Blackfriars railway station each morning, gives the painting the guise of a photograph. Somewhere in our minds we might well assume a painter would surely not choose to show Unilever House, in the top left hand corner of the image, covered in plastic hoardings and underneath cranes (Plate 4). Surely only a photograph, with its indiscriminate gaze, would end up showing things as unpicturesque as that? If this amazement turns to further enquiry then these same people might discover that Head does indeed use photography in the construction of his paintings, and they might also see his work reproduced in books alongside other artists who are described as 'Photorealists', which is to say a painter who paints photographs. There can be no doubt that for a significant proportion of the people who see *St. Paul's from Blackfriars Bridge* in this book, all of this will appear to be compelling evidence of the fact that Head is a Photorealist.

So how should I begin to argue against what many people would claim is the evidence of their own eyes? How shall I convince anyone that Head is not a Photorealist? Even if I put aside the inevitably imperfect photographic reproductions of Head's paintings printed in this book, I will still face a problem, with many people looking at one of Head's paintings in real life, of persuading them that a work like *Blackfriars Bridge* is not the reproduction of a photograph. This is not said out of disdain for the general public. It is not said with disdain for anyone. It is based on experience. I have seen people walking past a painting by Head suddenly stop as they are mesmerised by its presence. When they do, Head is generous with his time as he answers their

questions on how he made the image. Even for other artists and gallery curators there is an arresting quality to the work, and again Head will explain the making process, happy to have people interested in his art, not because of its subject matter, but its aesthetic impact. In those conversations Head is quite clear that his images are not paintings of photographs, there is no photograph that corresponds to the scene being shown and, most importantly of all, that there could not be a photograph that shows this view in this way. But at some point something is invariably said that makes one realise people do not believe him. With the painting *Haymarket*, 2009 (Plates 31 and 94), for example, Head is quite clear that there is no photograph of the scene, and that it would not be possible to take a photograph of the scene, but I did hear an admirer of his paintings say to him, 'I'd quite like to go and stand where you took *the* photograph.' With this in mind, Head's gallery, Marlborough Fine Art, even sent a professional photographer out to try to photograph the alleged view Head had painted, but the task was an impossible one (Plate 5). On other occasions people will mention fish-eye lenses, panoramic cameras or catadioptric photography. This is not ignorance or stupidity, although it is clearly frustrating for an artist who purposefully distances himself from too close an association with all forms of photo-rendering realism. It is simply a measure of the degree to which photography has penetrated our psyches over the past two centuries – to the extent that it cannot be dislodged so easily by a short conversation even with the artist. If Head cannot persuade so many people that these are not painted photographs, what should I do to establish that fact?

Head acknowledges himself that some of his earlier activities as an artist make establishing the fact that he is not a Photorealist more difficult. He has shown at the leading Photorealist gallery in New York, the Meisel Gallery, and appeared in Linda Chase and Louis K.

Meisel's book *Photorealism at the Millennium*, alongside artists who are Photorealists and photo-rendering realists,[5] even though Chase's text does acknowledge that he is a difficult figure to place in a Photorealist book. And many photo-rendering realist artists have been helped by Head in their careers. But it is not specifically this that leads to the assumption there must be a photograph behind each of Head's paintings. Most of those viewers arrested by the sight of one of his paintings will not have even heard of the Meisel Gallery, Linda Chase's book, or the names of any photo-rendering realist painters. Instead they will be under the sway of a cultural assumption about the ability of contemporary artists to make works of art. Possibly for the first time in history that assumption places contemporary artists in a very low position. Head's technical skills are very high, particularly when it comes to drawing, but almost the only other highly wrought contemporary realist images

we see in our culture are in some way photographic, whether directly photographic in the photograph, or indirectly photographic in the photo-based realist painting. Behind this is the general failure of drawing in the current art world, which means artists who are so dependent on photography are forced to import the language of photography into their work. The distinctive quality in Head's work is that his use of photography is not the use of the language of photography. Head's description of this is working in what he calls 'free fall', without the crutch of the language of photography to force him in a predetermined direction. Bizarrely, the lack of faith in the ability of artists to do this in our culture is now being transposed onto the Old Masters, thanks largely to the ersatz claims made by David Hockney that they too could not really draw and, like pre-photographic Photorealists, that they in fact drew using a machine called a *Camera Obscura*.[6] Leaving aside the

5. Photograph of location for *Haymarket*

supposed technical incompetence of the Old Masters, however, the problem faced by anyone wanting to write on an artist like Head is that no one believes you when you say these paintings are not copied from photographs. This point can even be taken further, to the extent that we may claim that photographic imagery is so ubiquitous in our society that it has become almost impossible for people to conceive of any form of image-making without reference to the photograph.

Head gives a good example of this in relation to broad brush painting, like that practiced by the impressionists and expressionists. Although makers of broad brush paintings will copy photographs as readily as a benighted photo-rendering realist, what they really get from photographs is an inability to differentiate their brush marks. A photograph is a flat thing and the surface is smooth. What marks out painting as being unique from photography is not the ability to make the surface rough and textured, but the ability to modulate the application of paint at different points on the canvas. Head calls this the hierarchy of paint, and through that hierarchy what we see is differentiation. A painted hand uses a particular set of brush marks, and with it a particular texture of paint, that will be different from the set of brush marks and texture of paint used for the table it rests on. This articulates the surface creating a sense of interest, but it also gives each object depicted its own identity, with a painted hand as different from a painted table as my real hand is from a real table in our world. What you see in many broad brush painters today is a uniform application of paint, not necessarily smooth like a photograph, but nonetheless uniform across the painting, with no hierarchy and no differentiation. The only thing that allows them to indicate that a hand is different from a table is its colour and outline shape, not its material nature. This, Head suggests, comes directly from the lack of hierarchy and lack of differentiation in a photograph.

In realist painting itself it is a particular problem as there is an unchallenged assumption that photography is the realist image medium *par excellence*; or, as Frank Van Riper stated in *The Washington Post*: 'arguably the truest way to depict reality.'[7] Yet the apparent reality of a photograph is only feasible if we consider our experience of the world – that is our experience of actuality – as a static and spaceless affair, for the simple reason that photography is a static and spaceless visual form. The static element is taken as read, as photography is singularly incapable of visual movement, unless it becomes a moving film. In terms of its spacelessness, however, we all know that photography flattens space onto the picture surface – the picture plane – simply from spending time looking at a photograph. Billboards are particularly good for this, as any sense of space begins to disappear, literally before one's eyes, simply by looking at the image for any length of time. At Balham train station in south London I recently had an excellent opportunity to test this when a huge billboard on the platform showed a landscape. Balham station is raised up and from its platforms you can also see the real landscape. The photographic billboard image was dull and flat, the real life landscape behind it, full of space and life. But we do not need a comparison with life to see this, we just need to spend longer looking at a photograph to see how spaceless they really are. We know that photographs are incapable of conveying a sense of space from the little tricks many of us play with our own snapshot cameras. It is the inherent flatness of the photograph that allows thousands of tourists each year to be photographed looking as though they are putting out an arm to support the Tower of Pisa, or similar tourist photographs in which the Eiffel Tower seems to be cupped in a hand or sitting on a saucer. The photograph cannot establish a difference between the space occupied by a figure in the foreground and the space occupied by a tower in the background, and so it conflates the two, thereby allow-

ing for the illusion that the Tower of Pisa is being supported by a hand or a finger, or the Eiffel Tower sitting in a saucer.

Even claims for the 'correct' perspective in a photograph[8] are not entirely accurate as what is being described is not recessional depth as it is experienced by people in everyday life, but a simple mathematical formula that dictates certain objects are proportionately smaller the further they are away from us. I am not suggesting that this is not a true formula, but it only correlates to the human experience of real life if we ignore the binocular vision most people have, and more importantly the selective vision that defines how we experience the world. In a noisy, crowded room our ears can often pick out the words of whomever we are talking to, not because they are speaking louder than anyone else, but because we hone in on them. We even use a vision word to describe this – we say we 'focus' in on them. Actual vision works in the same way, so that any object of our attention gains in importance, and therefore visibility. This was certainly understood to an extent even in the medieval world where the size of any object or person depicted was dependent on their relative importance. That was closer to how people experience actuality, even now, than the inflexible mathematical system of perspective which assumes we see everything with the same degree of clarity, as though our eyes are like cameras. Unfortunately for this assumption, our eyes are not like cameras.

All of this seems to suggest that far from being true to reality, photography is one of the least true ways of depicting reality ever invented. Even Barthes never defended his claim for the primacy of photography on the grounds of its mimetic quality. As we have seen, he thought photography was truer than other forms of image-making, such as painting, because it was the light bouncing off the subject itself that created the image, and not the subjective hand of the artist.[9] However, this is as applicable to the abstract 'rayographs' made by Man Ray, in which objects were placed directly onto photosensitive paper and light shone on to them, as it is to any of the great realist photographs of New York by Berenice Abbott. It is the equivalent of the hand prints of movie stars on Hollywood Boulevard, a trace evidence of them having been there, and nothing to do with the depiction of actuality. The problem is that we are now so conditioned to see photographs as a synonym for reality that we fail to see the artificiality of photography, and equally the realism of non-photographic art.

All of this brings us back to *Blackfriars Bridge*, which reveals itself as non-photographic, not because we can see the brush marks, or read the label that tells us it is made with oil paint on canvas, although both of these are true. It is non-photographic because of the way Head has defined the space. Again, we are not talking about the wide angle of the view, although the painting does take in perhaps 200 degrees of an arc. This allows us to look across and down the river simultaneously in a way that is outside the ability of an ordinary camera lens. It is true there are photo-rendering realist artists who now use computer graphics programmes to stitch together multiple photographs and thereby achieve a similar panorama, which they then paint. But in doing so they simply replace a single photographic space with, what Head would argue, is an awkward collision of several photographic spaces. Head has called this type of stitching together of photographs 'Frankenstein images', because rather than resolving the image into a coherent whole, the resulting painting is a mishmash of ill-matching spaces sewn together. Head, on the other hand, rejects the use of photographic space completely. His is non-photographic space, and he defines that space each time in a unique way for each painting. Contrast this with a camera which will use the same definition of space (that is to say, the same mathematically fixed formula) for every image it shoots. Head's non-photographic space is organic and particular to the

problems thrown up by the image he is painting. It operates more like the human experience of space, focusing in on some elements, even to the point of moving through a scene in a way that is closer to how the Cubists in the early twentieth century moved around a still life to see it from all angles; or the Futurists moved through a street to gain a sense of the vitality of existence. The eye moves in life and it has moved in a painting by Head. It really is more like a Cubist–Futurist composition, than a single point photographic experience, and although this might seem incongruous, in his recent painting Cubism and Futurism are probably the closest comparisons we can make with what Head is attempting. It is also worth remembering that both Cubism and Futurism described themselves as realist movements,[10] but more especially that Head himself makes connections between his work and that of the Cubist painter Robert Delaunay (Plate 6).[11]

The closest photographic equivalent to Head's paintings is not in fact the photograph but a movie film, moving through a landscape and panning round. The main difference in Head's work is that this movement is depicted as a single unified image on a canvas rather than a succession of images on a movie screen. As Gregory Saraceno noted: 'Like a film maker [Head] uses the language of representation to take the audience into a different world and, as with film, seeks an installation that can surround and captivate the viewer.'[12] With this alone we see an astonishing reinvention of the realist tradition in painting, that takes account of the lessons of modernism, the modernity of film and new media, and even the theoretical musings of writers like Barthes; but the images remain unapologetically paintings, not painted photographs, or mixed media hybrids, or illustrations of philosophical concepts. And yet, both Head and I know from experience, we will still have to persuade many people that a painting like *Blackfriars Bridge* is not a painted photograph, that it is not a Photorealist painting and that Clive Head is not a Photorealist painter.

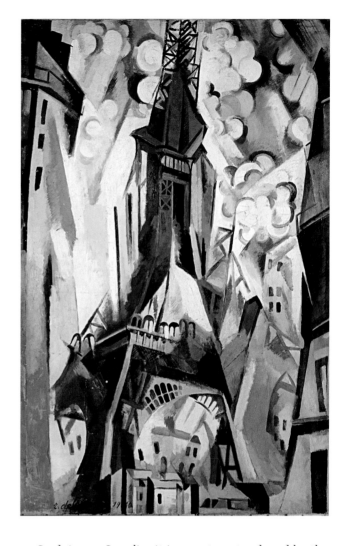

In doing so I realise it is easy to get seduced by the photographic quality of highly wrought painting by a photo-rendering realist. I once overheard a couple discussing a painting in London's National Portrait Gallery, when the man said, 'It's so good you can hardly tell it's a painting.' Mercifully his partner replied, 'Yes, but what's the point of that?' In the space of a couple of minutes this couple had gone from astonishment at the fact that a painting could look so like a photograph, to wondering why anyone would waste time and effort making a painting that looks like a photograph. Nonetheless, for many people, including a significant number of painters, there is some point in painting photographs, almost as though there is some merit in prov-

ing that a human being can do anything a machine can do. It leaves one wondering whether they are not victims of some form of mechanophobia, a bit like the neurotic fear that used to surround the question of whether a computer could ever beat a championship chess player. If so, it is ironic that such painters use so much technology in producing their work that they actually end up dehumanising it ever further by relinquishing the initial image capture to a camera, the organisation of space to a computer programme and the drawing process to a digital projector. If anything this suggests not so much a fear of machines, but a deeply problematic anthropophobia, a fear of humanity. That would strike against the essence of art, its reason for being. Talk to Head for any length of time and you will find that he defines art as the definition and exploration of being human, an expression of humanity. Without humanity art is nothing, and giving over whole processes of humanity to a machine, whilst clearly saving time, thought and effort, will inevitably leave us with paintings that are dehumanised.

――――――

I have never been to the top of the tower block at No. 1 Churchill Place in London's Canary Wharf. At 160 metres (525 feet) tall, the building gives astonishing views over south London, even as far as my neighbourhood, which lies in the shadow of the BBC's Crystal Palace transmitter some 10 miles away (Plate 7). As I have never been on top of Churchill Place you might well ask how I know about the views that can be seen from the top floor, a space usually reserved for the top brass of Barclays Bank. The answer is that I have seen the view, but not from the top of the tower, or even from a photograph taken there. I have seen a painting of it, called *Canary Wharf*, made by Head in 2008 (Plate 88). It was commissioned to hang, curiously enough, in the very same board room. This places the directors of Barclays Bank in the enviable, and possibly unique, position of being able to look at and compare the actuality of a scene with the fabricated reality of Head's creation. They can face one way and look out towards my house many miles in the distance, or they can look the other way and see the same view painted and hanging on their well-appointed wall. Except they will soon come to realise that it is not the same view. As they stand by the window looking out toward Crystal Palace they might wonder why the painting shows the West India Docks and the side of their building at the same time, when in real life they would need to move forward a few feet *and* turn their heads to move from viewing one scene to the other. They might question why in the painting can they see simultaneously the view straight ahead at eye level and the car park 525 feet down below, when in real life they must look up to see one and down to see the other. And, if they are sensitive to paradox, they might consider how they can be both looking out of the window in the painting whilst also looking in at part of their own room? This alone suggests they would have to be inside the room and at the same time hanging from a ledge somewhere outside, to achieve the same sight in real life.

If our mysterious bankers are alive to these things, and do not imagine Head's painting to be a giant hand painted photograph, they will soon realise that this view over Canary Wharf is not an exercise in copying a scene, much less an exercise in copying a photograph. Although the painting retains a high level of faithfulness to what could be seen in 2008 from this high window, the view has in fact been transformed dramatically, much as a master baker will transform raw ingredients like flour, sugar and eggs into well-baked cakes. Head has taken his ingredients from the scene in front of him – the edge of the steel and glass building, the car park below, other towers in the near distance, the Thames docks nearby and the landscape far away – and used them to

7. Clive Head, detail,
Canary Wharf, 2008

Oil on canvas
152 × 307 cm
(60 × 121 in)
Barclays Bank, London

fabricate a scene that is not a simple repeat of those in-gredients, but a thing that is unique in itself. It is not a copy of a scene, or a copy of a photograph of the scene, or even an amalgam of different photographs of the scene. It is a statement of *metastoicheiosis*, whereby ex-posure to the top floor of Canary Wharf, along with an engagement with the materials of art, and countless other experiences, such as a knowledge of the history of art, has resulted in the establishment of a new reality that is separate from our reality. That is its uniqueness. In saying this, a parallel can be drawn with Michael Craig-Martin's conceptual work *An Oak Tree*, 1973, in which a glass of water was exhibited with an explana-tory text as to why the glass of water was not a glass of water but an oak tree. Craig-Martin was insistent in this text that the glass of water was not a symbol of an oak tree, it was an oak tree, but one embodied in the form of a glass of water. In saying that, he appears to have shown a belief in the act of artistic transformation – something like *metastoicheiosis*. But in his typical fashion Craig-Martin managed to miss the point. Art does not transform one thing into another, whether that is a glass of water into an oak tree or the experience of Canary Wharf into a painted Canary Wharf. The artwork estab-lishes its own reality. If it did not we could happily use the term *transubstantiation*, and often this word is used interchangeably with *metastoicheiosis*. But the two are different. Transubstantiation suggests a process by which one thing becomes another, as in Craig-Martin's *An Oak Tree*. The 'oak tree' only exists as an oak tree through the process (direct or by proxy) of Craig-Martin asserting as an artist that it is an oak tree. This casts Craig-Martin in the role of a priest who must enact the magic of consecration in order for the miracle of trans-formation to take place. *Metastoicheiosis*, on the other hand, is not concerned with magic incantations; it is an undeniably difficult word that asserts the simple idea that any transformation that has taken place is embod-

ied within the thing itself. Craig-Martin's *An Oak Tree* re-quires someone external to the object to state that it is an oak tree, *even if it is an oak tree*; but Head's *Canary Wharf* is in itself an established alternative reality. We could even go so far as to say that the alternative reality of *Canary Wharf* is objectified through *metastoicheiosis*, whereas *An Oak Tree* is still subjective. Head is happy to acknowledge this, and asserts an experience that is sur-prisingly common among artists. There comes a point at which the work itself tells you what to do, as though it really is already an established reality that is simply in need of revelation. Head's point about this is that it sounds ridiculous to say it, but he is not alone in doing so. Historic artists like Kandinsky stated that their art is born of an inner necessity.[13] But contemporary artists do so too. The sculptor Ekkehard Altenburger, for exam-ple, is far from being a believer in Kandinsky's spiritual-ism, but he too has said that the stones he carves, 'almost tell you what to do.'[14] Interestingly, Altenberger seems to share some of the sense of embarrassment to be seen in Head when he admits this, which might have some-thing to do with the way conceptualist agendas in the late twentieth century stripped art of any metaphysical context. As Head says: 'It's inexplicable why a painting or sculpture should seem to possess its own reality when it is entirely invented by the artist, but it does, and you have to listen to what that reality is telling you.'[15] And in a letter to fellow artist Robert Neffson, Head notes: 'It is strange to think that art (our art) will guide us and we have to listen to its demands. It is something much bigger than our rational selves, and humility is the first lesson in our development.'[16] In this there is an element of mys-tery, and I would see it as similar to the mystery as it is understood in the church: not as something for which one must seek explanation, but as a phenomenon that one accepts, in the way *metastoicheiosis* is the mystery of the Eucharist without the 'explanation' provided by the term transubstantiation. In artistic terms, although

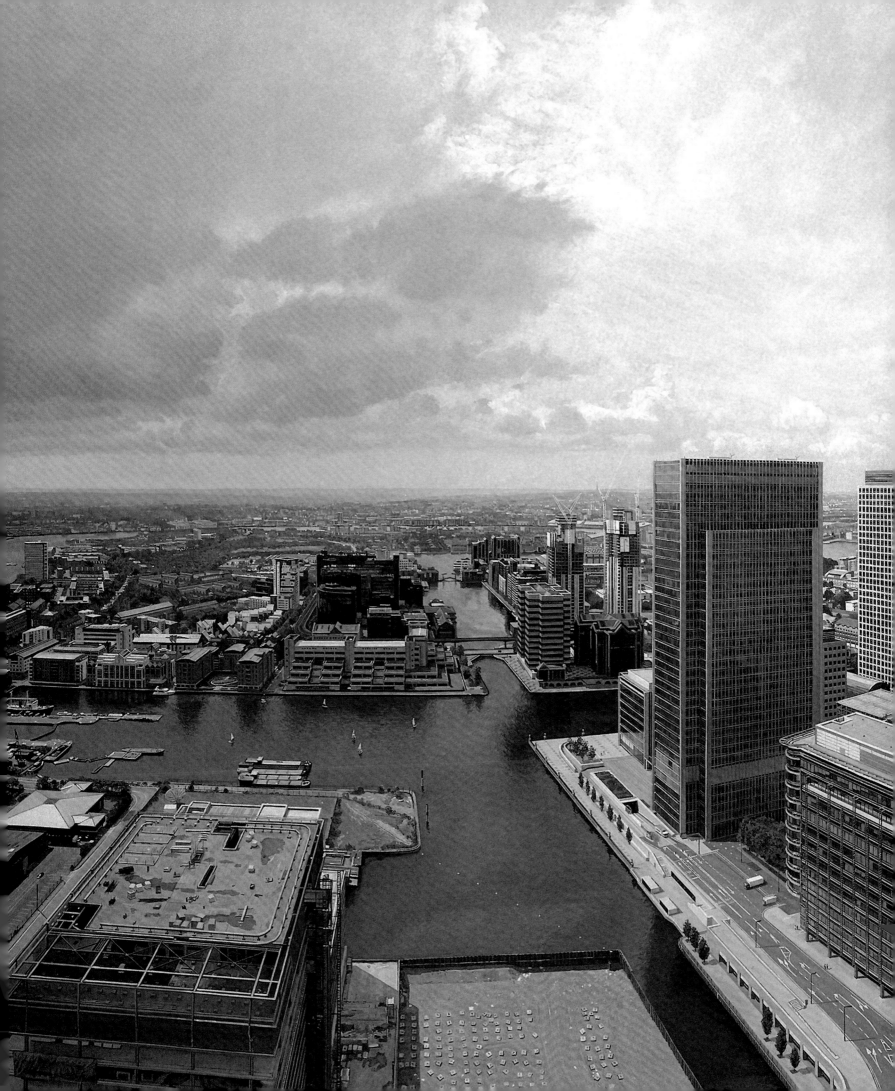

there remains a mystery as to how Craig-Martin turns the glass of water into an oak tree, the process is explained. He asserts, in his role of artist, that it is an oak tree and so it is an oak tree. With Head, however, both the phenomenon and the process are mysteries – not in terms of our not knowing how he applies paint to canvas, which is simply material skill, but in the mystery of *metastoicheiosis*, whereby the painted reality is a reality in its own terms.

On one level this might seem like an evasion, but that is simply a lack of faith in art. In our world we do not need to know how a rock or tree works to accept the existence of the rock or tree as independent entities, or indeed to enjoy their existence, as we have faith in the reality of these things. That faith in reality on this side of the picture plane is no less remarkable than faith in the validity of the reality on the other side of it. This is summed up in the words of Auerbach: 'All good painting enters some sort of freedom where it exists by its own laws, and inexplicably has got free of all possible explanations. Possibly the explainers will catch up with it again, but never completely.'[17]

Head echoes this, stating:

The world on the other side of the picture plane is not subject to the rules of our world. It may remind us of our reality, but it re-presents it in terms that are unique to art. To make art and to view art requires faith in this alternative reality. Without this faith we would read the work of art as a narrative on our world.[18]

This stands in direct contradiction to Craig-Martin's need to play the priest, and asserts the independent reality of the artwork by recognising that any artwork worthy of the name asserts its own independent reality. It also goes against a far more facile form of conceptualism, best called concept-illustration, that asserts the validity of the artwork entirely through its relation to our world (actuality). Concept-illustration is, if anything, more prevalent in the art world than Craig-Martin's far more hard core original version of conceptualism, and notably it too has an equivalent in Eucharist ceremonies, resembling the Protestant belief that the bread and wine of Communion are only symbols of the body and blood of Christ. Robert Crotty has made the concept-illustrators' position clear, stating:

Culture consists basically of a system of symbols. A symbol can be anything – object, colour, sound, smell, style of clothing, story and so forth. The meanings of symbols are derived from and determined by those who use them, the human beings of the group. Symbols do not speak for themselves. The colour red means what the group decides the colour red to mean.[19]

The artist is thus seen as someone who simply puts together these symbols, like words on the page of a book, to construct a narrative. This means a concept-illustrator's work has no independent existence, it is entirely reliant on something external to itself to assert its reality. As can be seen, this makes concept-illustration a close cousin to Craig-Martin's position, in which it takes the form of a priestly assertion that a glass of water is an oak tree (or that a painting is an artwork). Both rely on something outside of the artwork to assert its existence, whereas Head is clear that the work itself asserts its own existence – *metastoicheiosis*, not transubstantiation, nor symbolism.

From this we see one of the most fundamental objections Head has to the use of photography by recent photo-rendering realists. By relying on the photograph so heavily, to the point where most will simply copy a photograph or a montage of photographs, the painting becomes simply a symbol of that photograph or montage. It cannot assert its independent existence because it has no independent existence. More than this, however, the photograph itself is only a referent to an experience in our world. It too has no independent existence to the events it records. Writing to Neffson, Head says of the photograph:

[It] is tied back to our world, and its interest is as a record, or more commonly a reminder, of an event now past. It is part of our world, but is only ever a snapshot, framed and frozen in time. As such it is a moment taken out of the continuum of life. It is truly a still-life, devoid of life, cut off from the systemic function of the world that it mirrors. The photograph cannot show us what is round the corner because it can never be a functioning totality. It sits in the shadows of our world and as such cannot be an art form. We can invent a narrative reading on the back of a photograph. We can guess what led to the events that it presents, but we know that our readings will have little significance against the truth, if only the photograph would give this up. In other words, the narrative of actuality is always more important than our escapism. If only we knew more, if only we could expand the snapshot to give us more information.[20]

What this suggests is that the photograph can never be a universe in itself, it lacks its own reality and so becomes no more than a referent to actuality. In the same letter Head compares this with the art of painting, recognising the *metastoicheiosis* of painting when it achieves independence from actuality. Compared to photography, Head says, painting could not be more different:

The continuum that you talk of outside of what is seen is established because the painting has created its own reality. Our certainty of the events in space will not be compromised or challenged by actuality. The painting is the destination of a journey from the real, and is complete when the systemic totality functions in its own terms. This is what we mean by credibility. We are no longer concerned about the faithfulness of the painting to a different reality. We have passed into a new state where we take the painting to be the only reality with which we are concerned. That reality has its own parameters, and for the moments that we choose to enter it, it is sufficient and complete. We are not confronted by the desire to know more. All is laid out for us to see, even that which cannot literally be seen. How different this is from photography.[21]

The important thing to remember in relation to paintings by photo-rendering realists, however, is that they import wholesale the problems Head sees in photography into painting because, when the painting is simply the copy of either a photograph or photomontage, it is a reassertion of the photograph or photomontage. It is not an auto-assertion of its own existence. The photo-rendered realist painting fails to break free from the photograph which has, in turn, failed to break from actuality. The problem for most contemporary photo-rendering realists is that they do not even realise this is a problem. And the irony is that those that do, such as Head, cease at that point to be photo-rendering realists as the photograph becomes all but irrelevant to the existence of the final painting.

––––––––––

The problem for Head, and other contemporary realist artists, is the penetration of photography into human consciousness. As Linda Chase rightly states: 'In the nineteenth century critics may have debated the accuracy of the photographically recorded image, but the photograph has now gained such validity it takes precedence over all other modes of seeing.'[22] Consequently even historic realist artists like Canaletto (Plate 8) are often discussed anachronistically as if they were aware of the type of imaging that photography brought into being, when it is clear from looking at the paintings that pre-photographic art is informed by a different relationship to actuality than post-photographic art. It might surprise people to find that Head places the Venetian Renaissance artist Titian in his personal pantheon of influences, but when he discusses Titian's painting *Diana and Actaeon*, 1559 (Plate 21), the reason

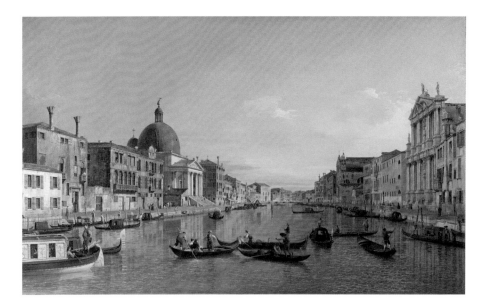

for this becomes clear. 'Titian wanted to show as much flesh as possible,' he says.

> So he doesn't just show you one view of Diana, he takes you around her. You see her leg from the side, but her buttocks from the back, then her body from the front, and then her head from the front and side. The twists of the body are astonishing and extreme, almost grotesque if you stop and think about it. Here you have Titian doing cubism three hundred years before Picasso. But the universe of Titian's painting is so convincingly right that these twists of her body seem natural.[23]

That universe is right in its own terms, of course, not right in terms of actuality, an actuality in which the twists of Diana's body would look more like that of a car crash victim than the figure of a desirable goddess. But Head adds an interesting rider to this, saying: 'Sometimes it seems that if you push the boundaries of the painted universe to their extreme it becomes even more convincing. It's a knife edge between being conceivable and being unconvincing.'[24]

With Titian there are prompts to tell the viewer that what they are looking at is not actuality or a referent of actuality. All realist art, on the other hand, works to some extent with a degree of mimetic correlation to actuality. This includes Head's *Canary Wharf.* Nonetheless, to move beyond confines of concept-illustration, the painting has to establish its own existence, and in *Canary Wharf* Head does this by establishing an illusion of space that is unique and distinct to the painting itself, and not copied either from the space that exists in the actuality of the world or the sense of space in a photographic image. In this it resembles Titian's *Diana and Actaeon* more closely than any photograph. This makes the painting the ultimate act of existential self-definition. It defines its own existence by creating the conditions for its existence. It is only when that happens that the link with concept-illustration, or mimetic correlation, is sufficiently broken for the painting to become an artwork. Commenting on Jan van Eyck's *Annunciation, c.*1436, Susie Nash noted that it is easy to mistake van Eyck's realism for reality: 'But we have to remember he is creating his own universe, not repeating ours.'[25] By the same token, we have to remember that Head is establishing unique universes through his paintings, as readily as Titian did, and not reflecting

ours. Those universes are established in terms of their spatial dynamics, so that *Canary Wharf* creates its own spatial relationships. With this in mind, there is a question mark over the status of photo-based painting in which the painting fails to define its own space, particularly where a photograph is copied so closely that the space of the photograph is effectively illustrated in the painting. In this case the painting does not even attempt to define its own existence by establishing its own space, and instead illustrates the space found in the original photograph. A great deal of contemporary realist painting would fall into this category, operating as conceptual work because it illustrates photographs external to itself, rather than establishing its own independent existence.

If this sounds like the over-intellectualisation of contemporary realist painting then it probably is. Most photo-rendering realists do not seem aware of any problem with simply copying a photograph. Many even think of this as a continuation of the Photorealism that emerged in America in the late 1960s, a movement for which Head has the utmost admiration, particularly artists like Richard Estes, Tom Blackwell and John Salt.

Unfortunately, for most current photo-rendering realists, true Photorealism really had very little to do with the photographic image as a photograph, and everything to do with the act of painting a painting as a painter. As John Baeder stated:

> I am labelled a Photo-Realist because I use a photograph to do a realistic-looking painting. However, the camera is an extension of my eyes, of myself. My paintings look photographic, but they are not photographic. They are pure painting. I paint the landscape, or part of it, and I represent an image that impresses me. Impression and Expression. Very simple.[26]

The misunderstanding of American Photorealism by contemporary realists probably stems from very few of them having seen the work of the original American Photorealists in the flesh. Instead, they have seen them as photographs in books, a reproduction process that destroys their essential quality as paintings. Seeing the paintings directly makes it clear that the original *raison d'être* for making Photorealist art was not to emulate the photograph. It was, as Baeder says, to engage with reality. In fact, the paintings of most first generation American Photorealists are not particularly photo-

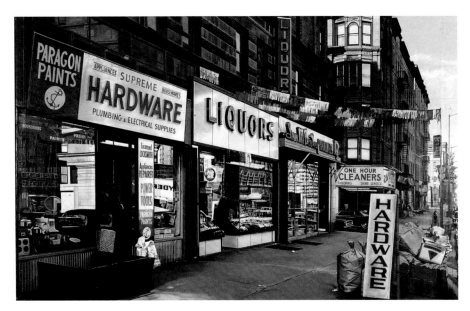

9. Richard Estes, *Supreme Hardware*, 1974

Oil on canvas
99.1 × 167.6 cm
(39 × 65 ¾ in)
High Museum of Art, Atlanta

graphic at all. Rather they show an enormous sense of joy in the handling of paint – as much as any Impressionist, Fauvist or Abstract Expressionist. Richard Estes' *Supreme Hardware*, 1974 (Plate 9), shows this well, with the window of the store 'Liqors' filled with objects that are not rendered in a hyper-realist manner, but with an economy that is as unlike the actuality of the real world as Titian's brushwork in *Diana and Actaeon*. In the same painting the rubbish bags on the street almost resemble Impressionist painting, while in his painting *Telephone Booths*, 1967, the handling of the paint is almost like that of an Expressionist painter. When one looks at his works reproduced in books, however, they are reduced to being a photograph, with the reproduced image underplaying the physicality and texture of the paint.[27] In other words, Photorealist paintings look more photographic when photographed than they do when seen in real life; and no contemporary realist painter who paints images that look like photographs would dare to claim to be the heir to figures like Estes, Schonzeit, Blackwell and Gertsch unless they had never actually seen the work of Estes, Schonzeit, Blackwell and Gertsch.

It is not only a failure to engage with actual works of art that renders most contemporary realism irrelevant as painting, however, it is also the misconstruction of the work of Gerhard Richter as a form of Photorealism. Richter was and is a conceptualist and as such understands nothing of the physical and sensual manipulation of paint. That is why his paintings are so bad as paintings, although they might be very good as concept-illustrations. While John Arthur, one of the most sensitive and intelligent writers on Photorealism, can state of Estes that, 'In the end, his paintings are not at all reproductions of photographs,'[28] the same could never be said of Richter's photo-rendering realist works – they were intended to be nothing more than reproductions of photographs.

No doubt some contemporary realist painters will argue that they do recognise the painterliness of artists like Estes, but they have moved on and no longer seek to emulate the Photorealism of his generation. This is a laudable and inevitable development, and it is one that also encompasses Head. Head too does not seek to emulate the work of earlier Photorealists, and he has moved so far from anything that could legitimately be described as Photorealism that the term is no longer applicable to him. Simply put, Clive Head is not a Photorealist. More than this, however, although some of Head's earlier works used methods very close to those of the Photorealists, (Plates 10, 11 and 12) he argues convincingly that he was *never* really a Photorealist. If Photorealism meant the working methods of artists like Estes and Blackwell as practised in the early 1970s, then Head certainly experimented with working in this way as a student and novice painter, but he quickly moved on. If Photorealism means what it has increasingly come to mean – the taking of a photograph and copying it meticulously in paint – then Head was never that. From this it follows that if Head is not a Photorealist then he is something else. The question is, what is that something else? Contemporary photo-rendering realists, including such notables as Damien Hirst,[29] effectively ditched the approach to painting of first generation Photorealism through their increasing obsession with the photograph, but Head insists he was never obsessed with the photograph. In conversation it is clear that he has what is almost a dislike of the photograph, and that this antipathy is rooted in a belief in the essential materialism of art. The artist engages with the physicality of the world and produces a physical response in the materiality of the artwork. The artwork is thus a material manifestation of the experience of actuality. In part this stems from what Head describes as a 'feeling of guilt', by which he

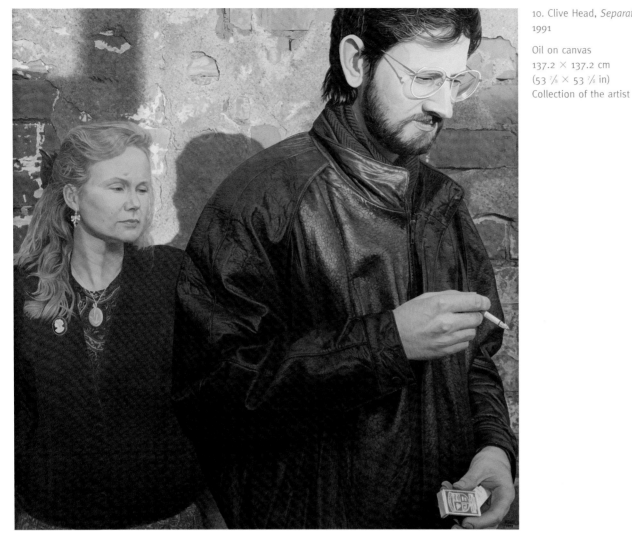

10. Clive Head, *Separation*, 1991

Oil on canvas
137.2 × 137.2 cm
(53 ⅞ × 53 ⅞ in)
Collection of the artist

means a feeling that the use of a photograph is indicative of a certain level of failure. Objectively, it would be impossible to record the street scenes that Head uses as his source material without photography, but subjectively he remains an artist with the highest esteem for non-photographic image-making, such as the work of the Spanish painter Antonio López García (Plate 13) or the English artist Lewis Chamberlain (Plate 14). Head takes this back to his schooldays where the boys who could copy a photograph of a sports car exactly were highly praised, but he couldn't help thinking they somehow cheated. At that time, a

sense that copying from photographs was cheating was the product of naive intuition, but Head is now one of the most erudite artists working in Britain today, and so his guilt concerning the use of photography, and his less than enthusiastic response to painters who copy photographs, is based on a great deal of knowledge, learning and experience in the production of art.[30] Head is adamant that the photographic snapshot is not an accurate or even adequate approximation of how he experiences the actuality of the world and so it is not adequate to use the photographic snapshot to underpin a painting. In recognising

right: 11. Clive Head, *Paris Window*, 1991

Acrylic on paper
76 × 56 cm
(29 ⅞ × 22 in)
Private collection

below: 12. Clive Head, *The Riviera*, 1991

Oil on canvas,
122 × 183 cm
(48 × 72 in)
Private collection

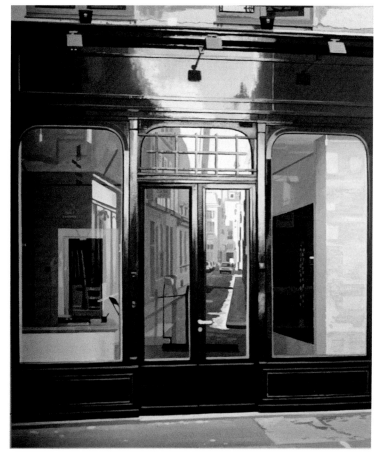

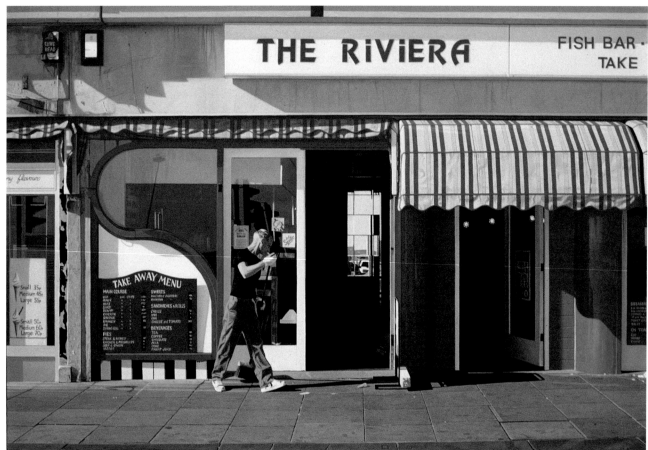

above: 13. Antonio López
García, *Madrid Desde Torres
Blancas*, 1976–1982

Oil on board
157 × 245 cm
(61 ¾ in × 96 ½ in)
Private collection

left: 14. Lewis Chamberlain,
Things That Go, 2007

Oil on canvas
117.5 × 153 cm
(46 ½ × 60 ¼ in)
Collection of the artist
Image © James Hyman Fine Art

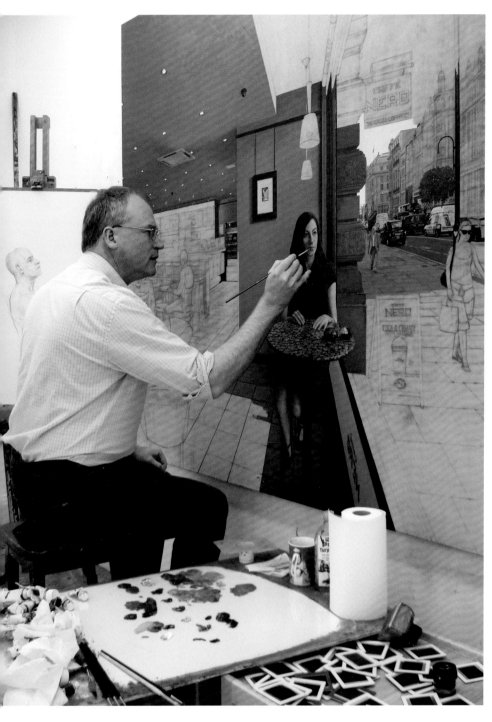

15. Clive Head painting
Rebekah, 2008

this as a problem, Head compensates for the inadequacies of the photograph by drawing his images freehand, and refusing to trace imagery or grid-up photographs for transfer to the canvas, in order to reassert the inter-relation between the artist and the physical materiality of art practice. This is most apparent in the way Head will generally tend to draw the main human figures in his paintings from life, and not use photographs at all, as in the paintings *Trafalgar*, 2007 (Plate 86), *Piccadilly*, 2007 (Plate 87) and *Rebekah*, 2008 (Plate 89).

Certainly if we stand in front of Head's painting *Piccadilly* we see an image that could not have been painted from a photograph. More than that, we can assert that there is no photograph that corresponds to the image we see. Head did not take one, and one could not have been taken. If the standard definition of photo-rendering realism is to copy (or shall we, more politely, say emulate?) the photograph,[31] then there is no photograph here to be emulated. The result is an image that is not photographic. That fact might not be immediately apparent to anyone looking at *Piccadilly* in reproduction in this book, particularly if they have never seen one of Head's paintings in real life. Like the photo-rendering realists who mistakenly think the works of Estes, Schonzeit, Blackwell and Gertsch are more photo-like than they really are, those who look at Head's paintings in reproduction might well think the same. But that would be a mistake, not only because of the material quality of the paint, but because of the way the artist has constructed and organised space in the painting. Clearly there is a street in London called Piccadilly that is not unlike the street shown in *Piccadilly*. In that street is a cafe not unlike this one; outside it on the other side runs Dover Street, which looks similar to this, and on Dover Street there is a sculpture of a figure on horseback by Elisabeth Frink, that looks very like this one. In our world, our actuality, there are glasses like the ones we see here, and there are lamp-

shades, chairs, pillar boxes and paving slabs not unlike these we see in Head's *Piccadilly*. But Head's *Piccadilly* is not actuality. It is not our world. It is a unique universe that is fabricated, but not copied, from elements of our world, and although it might look something like a place we know, it is not an attempt to represent that place, nor is it in a relationship of mimetic correlation to a photograph of that place. What this means in effect is that Head's painted *Piccadilly* does not look like the actual Piccadilly, and if we are mistaken into thinking that it does, it is simply that Head's fabrication is convincing. It is as convincing as the sets in Hol-

lywood film studios that look like downtown Manhattan. If we watch a film ostensibly set in New York but filmed in Hollywood we are usually convinced of the illusion. But if we could simultaneously stand in downtown Manhattan and on the Hollywood set at the same time we would instantly know that one is the actuality of New York and the other a fabrication. The bankers at the top of the Barclays building in Canary Wharf are in this fortunate position when they look at Head's *Canary Wharf*. Head persuades us that his painted worlds are convincing, and yet they are neither photographic nor a facsimile of actuality. The phrase he uses to describe

16. Clive Head, *Study for Lights on 2nd Avenue*, 2003

Acrylic on paper
56 × 76 cm
(22 × 29 ⅞ in)
Private collection

this persuasion is the establishment of *conceivable* space, although he might just as easily say that his work is *metastoicheiotic*.

———

What is meant by conceivable space is perhaps difficult to verbalise, but analogies to it are not. It can be thought of in terms of the difference between a good and bad novel. Even in a good novel the characters might be over the top, the scenarios fantastic and extraordinary, and plot lines ludicrous, but the writer establishes them with such authority and quality that we believe in the credibility of the world that is created. In *Wuthering Heights* a man like Heathcliff can exist, whereas in life he cannot. In *Jane Eyre* most people can believe in a 'celestial telegram' informing the eponymous heroine of Mr Rochester's injury.[32] In life few of us can. The point is that within the fabrication of written fiction the credibility of the character, action or event is not the result of scenarios that mirror actuality, it is due to the authorial quality of the writer. Indeed, the difference between a writer and an author is authority. In the same way, the credibility of a painting has nothing to do with its resemblance to life or a photograph, but everything to do with the authority and quality of its establishment. Head himself acknowledges this by preferring that his paintings not be shown alongside the photo-copying realists, but with the work of an artist like Frank Auerbach, whom he admires for producing paintings that possesses the same authorial credibility he seeks in his own work.

In the light of Barthes' claim that photography is a trace record of existence, the fabrication of Head's paintings can seem an almost arbitrary thing, disconnected from the actuality of the places he seems to show us. But this is clearly not the case. He has not, as Anthony Blunt once said of the modernists, given his life so wholly to the cult of art that he has forgotten about

17. Clive Head, *Paris Sunrise*, 2004

Oil on canvas
175.3 × 307.3 cm
(68 ¼ × 120 ⅞ in)
Private collection

18. Clive Head, *Coffee with Armin*, 2009, in progress

anything else.[33] It is an important point to make as in Head's paintings we are undeniably rooted in an aesthetic understanding of art. When Head writes to his friend and fellow artist Robert Neffson, that, 'too many so-called artists see art as dealing with issues of the everyday'; or that there 'is *no* alternative to an art that manifests the human ingenuity *to make* an ideal world'

[his emphasis], we are within a conceptual framework that rejects the presentation of existing reality as art, and instead gives credence to the idea that this is art removed from life. As Head continues, 'What defines an artist over an anti-artist is the fundamental belief in art to remove itself from the concerns of the everyday.' Yet, what is important here is that Head's work always be-

gins in the everyday, taking the sights and experiences of life and creating art from the experience of them. What we need to recognise is that we are dealing with a new aesthetics, one which does not detach art wholly from life, to become a cult of aestheticism, but which allows the experience of actuality, and the physical and sensual stuff of life around us, to provoke an aesthetic response. For all the assertions of art being distanced from life, the distancing is more like the distance between the roots and the leaves of a tree. The leaves emerge because of the physical engagement of the roots with the earth, but they are nonetheless different from those roots. Head's fabrication of an imagined London, or New York, or Paris, or Cologne, is rooted in the experiences of each of these locations and distanced from them in the same way. He writes: 'I talk about invention as if it comes from the imagination, but this isn't the case. It is all there, in the material, the shape repeats, the colour circuits and it is always holistic and unique to each subject.'[34]

As this suggests, it is easy to stand in the places that motivate Head to make his paintings. If we look at those paintings, we might see a view down Curzon Street in London's Mayfair (*Coffee with Armin*, 2009, Plates 18 and 92); or the well-known entrance to Victoria Underground Station (*Victoria*, 2008, Plate 90). Then there is the view down Piccadilly from the corner of Dover Street (*Piccadilly*), and that of Haymarket looking over towards Piccadilly Circus (*Haymarket*, 2009, Plate 94). The scenes are familiar, providing we know London and the temptation is always to assume that Head depicts a world we know, or perhaps we should say, he depicts the world as it is. But despite it being easy to stand in the places that motivate these paintings, it is impossible to stand in the place shown by the paintings. The reason for this is that the places shown do not exist. That seems counter-intuitive, of course, and I am not suggesting for a moment that

Mayfair, Victoria, Piccadilly and Haymarket do not exist in real life. They do exist and Head's paintings have an important relationship to them. But there is no view down Curzon Street that corresponds to what Head shows in *Coffee with Armin*. If you go to Victoria you could not stand in any particular place and see what we see in Head's painting *Victoria*. If you take a camera to Piccadilly at the corner of Dover Street you cannot photograph an equivalent image to Head's image of the same place. And if you stand under the arcade at the corner of Haymarket, you would not be able to see the view that Head seems to have seen. It is in that sense that the views painted by Head do not exist in actuality. As in all realist art the painted image has a relationship to actuality, but it should never be confused with actuality.

This aspect of Head's painting is often the most difficult for people to come to terms with. There is a painting made by him of the entrance to the Underground station at South Kensington, called *South Kensington, 2009* (Plate 93), showing the arcade of shops and cafes that cluster around the station entrance. To the right of the painting we can see a bus stop, and then, through the glass in the bus stop shelter, over the street to more cafes. We can look up the street and in the centre-right of the painting see a National Westminster Bank, and there is a double decker bus in the distance. On the centre-left of the painting there is the station arcade itself, with Miss Ellie's cafe, a cobbler and a small supermarket lining the far side. On the left of the painting, seemingly nearest to us, there is another cafe, unnamed in the painting, into which we can see. The view from the edge of the bus shelter on the right, to the edge of the cafe door on the left of the painting represents nearly 300 degrees of vision. To see this in life you would have to stand and turn your head from as far as your neck will allow on your right, round to as far as your neck will allow on the left, and this shows a remarkable

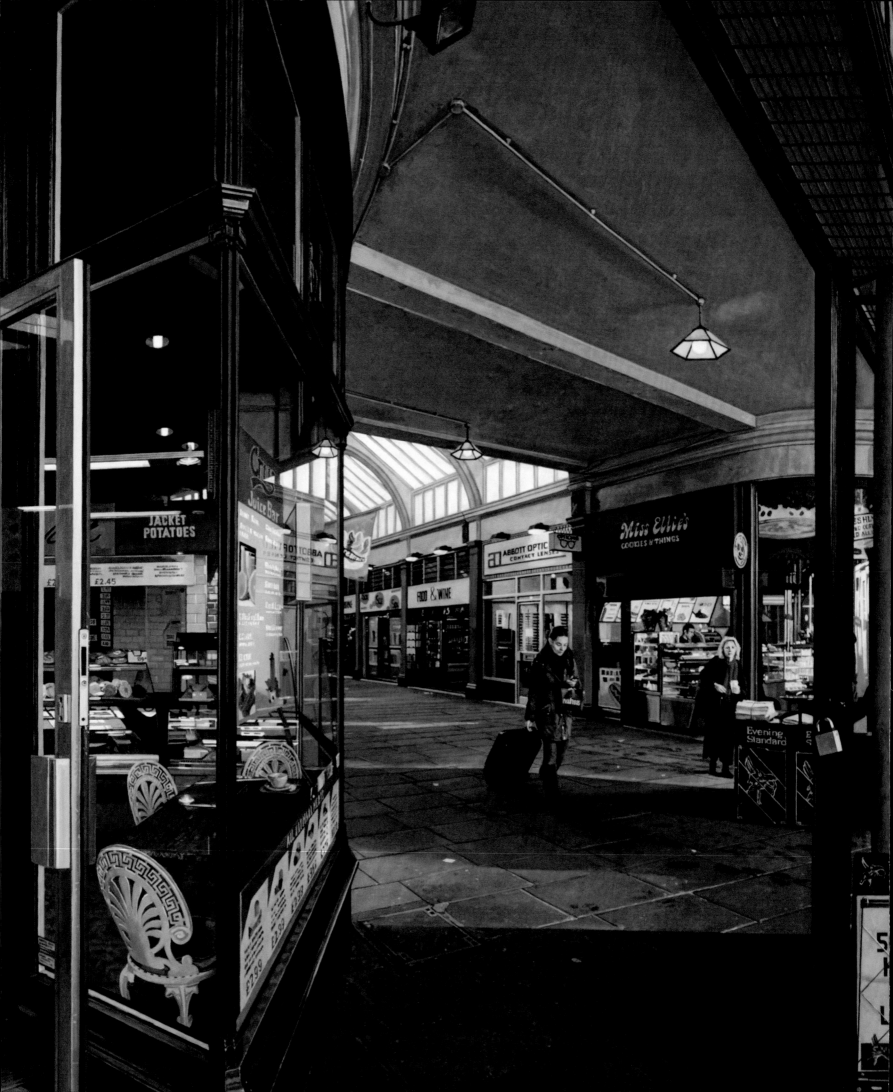

preceding page:
19. Clive Head, detail,
South Kensington, 2009

Oil on canvas
161 × 279 cm
(63 ⅜ × 109 ⅞ in)
Private collection

fact about the painting. It is not a single photographic view, so it cannot be a single photograph. It is more like turning one's head from right to left (or left to right) and seeing a panorama. More than that, however, we look on a single painting that is showing us a view that would, in actuality, require us not only to look left and right but up and down. Effectively Head creates a composite view, simultaneously straight ahead, left and right, and up and down. While there are photographic methods to do something similar, with a fish eye lens for example, Head's images do not show the curving distortion of fish eye lenses, called barrel distortion, that results in objects at the edges of the image curving inwards. Even ordinary cameras are subject to this type of distortion, as can be seen if you try to take a close up photograph of a rectangular object. The ends of the supposedly straight line of the rectangle will appear to bend down from the top or up from the bottom. In a wide angle photograph this distortion becomes ever more extreme as an essentially spherical view around the viewer is rendered on to a flat photographic surface.

Head's paintings are not without equivalent curving lines of perspective, but they are not calibrated to the rigid and pre-determined formula of a camera but rather to a need to create conceivable space. This difference comes from the different starting points of a photographic image and Head's paintings. A camera takes in light from a scene and organises the objects and space in a pre-given way. The only pre-given parameters Head has is his experience of having been in a particular place over a particular period of time, and the presence of particular objects. What he does not have is a spatial framework in which these things can co-exist in a painting. He must work this out for himself, and in doing so he will, like the camera, use mathematical and geometric equations. But unlike a camera these will be unique to the problem of the particular painting he is working on and his equations – again un-

like those of a camera – will not be transferable to any other painting.

We can see what is meant by this by reference to a student both Head and I once taught. This student was interested in digital imaging, and liked to take photographs which he then manipulated using computer graphics programs such as Photoshop. He was particularly proud of the number of filters[35] he had amassed on Photoshop, which allowed him, in his words, 'to do almost anything to an image'. All he had to do was combine the filters in whatever order he chose. Head's response was always the same. The filters are predetermined. That is to say they work according to fixed mathematical algorithms, and so the filters have no choice in how they manipulate the image. That meant, even if the student had a hundred filters, or a thousand of them, and the combination of these meant he could end up with a million different effects, he still could not do anything (as he had claimed) to the image. All he could do was what the hundred or thousand filters were programmed to do. By picking up a pencil, however, the student really could do anything to an image because he had to invent the image. The camera and a computer's graphics programs might offer a million possibilities, but a pencil and a blank piece of paper offer an infinite number. This is not just an issue of the use of computer programs to render images. It is an issue with cameras too, and the thing to remember about this story is that the camera is essentially a graphics program. Even a film camera is effectively a graphics program, albeit one in mechanical form, and the film camera's settings are its filters. Like many people, I have a simple snapshot camera with perhaps a dozen different settings. Combining these I might theoretically end up with 144 different ways to create a picture. More complex cameras, such as those used by the high-end Photorealists, will have more settings, but even if the camera itself has

enough settings to add up to a million possibilities with any image, the possibilities will still be fixed and finite. As a human being making a painting, however, Head has no settings. He has only knowledge, experience, technical skill, and talent. Consequently the number of ways which he can come up with to create a picture is potentially infinite. As Chase states: 'The camera transcribes things according to the mechanics of its lens and not according to culturally or artistically prescribed hierarchies.'[36] As Head notes, the problem with this is that cultural and artistic hierarchies are replaced by mechanical hierarchies, which again dehumanises the image. Once that happens, the image ceases to function as a vehicle for asserting human experience, and without that function it ceases to be art. In Head's words:

> I have learned never to be limited by the photograph. Otherwise the resulting painting will only be a stiff shadow of a photo, not of the world. This also means abandoning the secure world of the frozen photograph and accepting reality with all its flaws [and] movements, including mankind's great aspirations – in short, its humaneness.[37]

More pointedly, referring to the general direction of the new generation of photo-rendering realist painters, Head has also stated: 'For a long time now I have felt uneasy about my associations with other realist painting. For the most part it is just mundane craft. Without considering both the formal/linguistic structure of painting and, at the other extreme, its connectivity with human experience, we just have a lot of illustration.'[38]

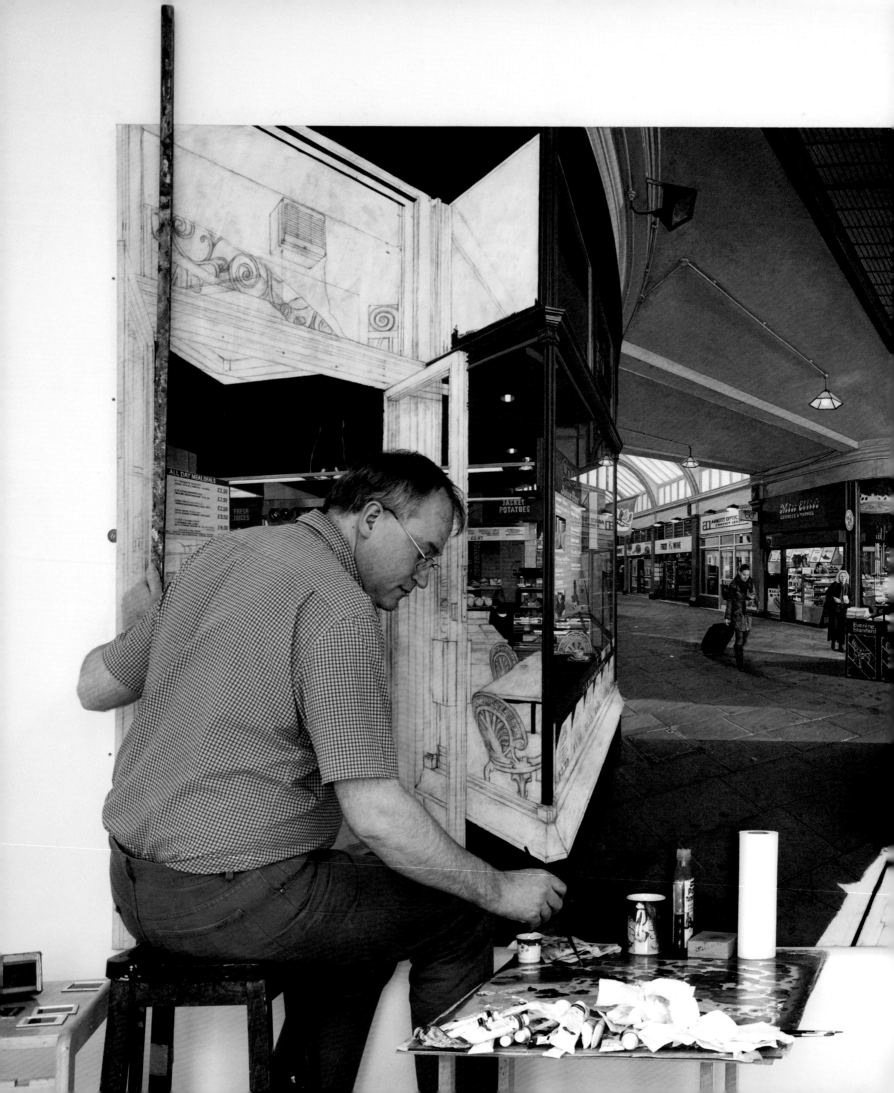

Chapter Two

Ariadne's Threads

Artists often criticise writers on art. Sometimes their criticisms are justified, but sometimes they are not. I have yet to hear an artist say: 'My exhibition wasn't very good so it's no wonder the critic didn't like my work.' Nor has any artist I know ever congratulated a critic for ignoring their show on the grounds that it consisted of poor work. And yet, criticism of writers on art can sometimes be justified, and as a writer and critic myself I am often a harsh critic of critics. I am particularly harsh on myself. That was not always the case. In fact, in my previous laxity, I have been guilty of the greatest sin of art writing, a sin that affects a lot of writers with an academic background. I have on occasion selected the evidence to fit my theory, rather than formed the theory based on the evidence. As I say, this probably stems from my university education in an ideologically driven art history department where the pervading (if unpublished) credo was never to let the evidence stand in the way of a good theory. In saying this I exempt some of the great tutors I had from my censure, but those are the ones who would probably agree with me in this judgement anyway.

Thoughts of this come to mind after some comments made on an earlier draft of this chapter. It might seem strange for me to discuss the mechanics behind the construction of this book in the book itself, as it is rare for a non-fiction author to reveal the processes that led to the creation of their work. Non-fiction rarely has the honesty of the author of *Tristram Shandy*. But the truth is that books do not emerge 'ready-armed from the ground'. Chapters and parts of chapters are read and re-read, and often amended after comments by others. None of this should be a surprise. A book will inevitably be tested against the opinions of others when it is published, but long before that the ideas need testing in order to arrive at something that approximates the truth. That is difficult when dealing with art because the only objective truth of an artwork is its existence as an object. Everything else is provisional. So some corroboration that this is at least a provisional truth before final publication is a useful safety mechanism. In this case, however, I was a little taken aback by comments from three different readers who refused to accept a suggestion I will make later in this chapter that Head's work is essentially Cubist in nature. I will shortly place Head's paintings in a direct line of descent from those made by Pablo Picasso and Georges Braque during the period known as their Analytical Cubist phase. What struck me as odd about my pre-publication critics of this idea was not that they did not believe it, but that they thought I had just let the idea pop into my head from nowhere. In effect they suggested that I had not let the evidence of Head's work stand in the way of an eye-catching theory. Of course, as an idea, it might be

20. Clive Head painting
South Kensington, 2009

Image © Malcolm
Tweedie MacDonald

wrong, but the assumption of these critics was that I did not discuss what would be an astonishingly radical reappraisal of Head's paintings with Head in the first place. I had, it was implied, just made the whole thing up. In fact it was Head's own comments, made during a visit to the National Gallery in London, on Titian's great work *Diana and Actaeon* (Plate 21), which he described as a form of Cubism (see page 24), that sparked the whole idea off. But it was then developed through discussion with Head over many meetings. Although this might seem like a diversion in this text, it is important to recognise that if astonishing claims are being put forward for the paintings of Clive Head it is because they are astonishing paintings, and not because a particular writer is being creative with the truth.

I have in fact been corrected by Head in the same way on other occasions. An example of this is my general adherence to the principle of historical accident. If Napoleon woke on the morning of the Battle of Waterloo with bad indigestion, it is an historical accident that would have had an impact on his ability to win the battle. By the same deduction, therefore, it seems reasonable to assume that the countless thoughts, emotions, bodily sensations, pieces of luck and misfortune during the day that might be experienced by Head would have an impact on his painting. And yet Head says a categorical NO to this idea. Once the decision is made to paint a subject, the evolution of those decisions is not decided by accident, but by the necessities of the painting itself. Those necessities are outside of the painter, governed by the evolving image, and so having a headache or running into an old friend on the street that morning, will not impact upon them, either for good or bad. It is, according to Head, as if they are governed by their own system of logic, and not according to the whim of an artist. This might come as a surprise to some people, as the assumption of art appreciation tends towards the idea of the artwork being highly influenced by the top-

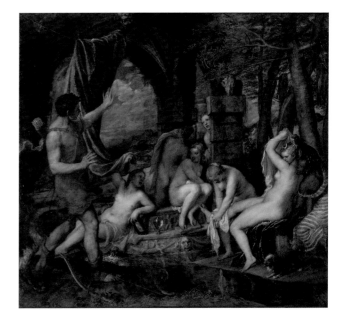

ical state of the artist. But Head insists those states of mind, body and emotion do not apply in any case, and it is unnecessary to force the artist out of the production process to achieve a sense of objectivity, it happens in the studio anyway, in the same way one would not expect the results achieved by a chemist, mathematician or physicist in a laboratory to be influenced by their mood on a particular day. Head recognises there is a balance to be struck here between thinking of the artist in the studio as a dispassionate maker and the necessity of the artist's intellectual and emotional interaction with the physicality of the world, and the media they use, to produce works of art. But Head can draw on the experiences of Samuel Taylor Coleridge as back up for this, with Coleridge suggesting the process of art consisted of two stages – the first one of emotional, intellectual and physical engagement, and the second of an active contemplation and objective ordering.[39] More prosaically, an analogy could be drawn with the discovery of DNA, by James Watson and Francis Crick. This was a process that started as a discussion in the Eagle pub in Cambridge. No doubt it was a lively and wide-ranging discussion, and the excitement partly fuelled by drink.

But that does not mean that the approach of the bar was carried through into the scientists' laboratory. With Head there is a similar excitement when on location, but he talks about needing to leave that location at some point, to enter the calmer world of the studio where the experiences that initiated the process of painting can be ordered. As in the case of Watson and Crick's laboratory, once in that studio the raw experiences that motivate Head to make a painting no longer have a place.

In balancing this, however, Head is also aware that it is possible to go too far towards depersonalising the work. The use of digital processes by some artists, particularly photo-rendering realists, exclude the artist so completely from the painting that the image loses its humanity. According to Head this is usually the result of ignorance, as most contemporary photo-rendering realist painters do not understand that by going for easy solutions, such as taking a single shot photograph and copying it, or taking several photographs and allowing a computer program to stitch them together into a single image, they are not making a painting that is more convincing in terms of its space. On the contrary, the painting is less convincing, the space less conceivable, as it is no longer a human space, but a space created entirely by machines. By its very nature, space created by machines can never be human space, but unless a painter understands the first principle that art is concerned with the establishment of conceivable space then they will never understand the importance of humanity in establishing that space. This reduces painting, in Head's words, to being just craft:

Tracing is craft, matching colour to the colours on a photograph is craft, projecting an image is craft. Accepting the solutions presented by the outcomes of a computer program is craft. We may think we are in control, but a little part of us is sacrificed for processes that seem to make it all just that bit more convenient. We struggle to draw so we allow some known process to solve the problem, but in not drawing we are alienating our artwork from ourselves. We are failing to set up the frameworks to catch the part of ourselves that we cannot logically process. There may be a role for the machine, and for the studio assistant, but it is not something that should be embraced without considerable assessment of the risks. I don't think even the most experienced of painters who have gone down this route have recognised this dilemma.[40]

As should be clear, the studio for an artist like Head, and most aesthetic artists I have known, is a curiously calm place (Plate 20). There are passions at play, of course, but those passions are not the arbitrary feelings of transient moods or experience, they are something more like faith – a faith in the processes of active contemplation, a contemplation which does not mean, for the artist, sitting in a chair and thinking. Contemplation for the artist is the means by which the artwork is made. Other processes can exist, but if they lie outside of the process of art they show bad faith, or at best are an activity that is simply something other than art. For Head the use of digital photography seems to show a particularly pernicious form of bad faith towards art, its immaterial or virtual form being notably abhorrent to the materiality of the artwork. Head has written:

I have watched other painters use a digital camera. With seemingly endless shots, and the capacity to delete as they go along, there appears to be none of that responsibility towards creation, no heightened experience. The choice to abdicate from the responsibility to make, seems to turn these artists into nonartists. It is all too easy. Art is about making decisions and listening to what is needed. It is not just about passing through. A friend recently said to me that the advantage of the digital camera is that he doesn't have to worry about running out of film, or worry that he may not have anything until he gets the film

processed when it is too late. But since when was art meant to be stress free? And can we really expect anything to come out of such a relaxed position? Clearly not, because it does not.[41]

None of this is indicative of an artist being a passive figure on whom an art theorist imposes a theory. What sort of artist would be a victim of that? Nor is it the sign of a writer 'artificially starting art movements to bolster their scholarly kudos in the artworld',[42] a charge with which I have also been accused. Real artists are not such innocent Eves that they cannot resist the serpent critics. But perhaps I am being too generous to most other artists, and perhaps what we see in Head is an unusual painter whose strong opinions on art result in strong art. He is right to hold his opinions so strongly. Out of the strong came forth the sweet, and no great art in history has ever come from the fickle or mealy-mouthed.

———————

When I was young I remember thinking it would be possible to reconstruct the exact route of any journey taken by a man or woman simply by observing the way they entered a room. Every step down every street, each turn made, a decision to go one way rather than another, whether the journey was entirely on foot, partly by bus, train or car, or even whether it was short or long, would somehow be recorded – I thought – in the slant of the body, the gait of the legs, and the angle of the feet as that person entered the room. I thought that anyone entering via Delph Lane would invariably incline more towards the left hand door jamb, and those from Pennington Street towards the right hand door jamb. A wearier tread might also characterise the latter, at least if they had come far, as they would have had to walk up a steep hill. But with more observation, more practice and more deduction one could take the history of a journey ever further back in time, and visualise its consequences in ever more actions in the present. Unfortu-

nately I did not pursue this line of research. It would have been a great boon to forensic science, allowing the police eventually to apprehend a villain on the grounds that the way he held his pint of beer was indicative of him having been in Brudenell Road last Tuesday week.

My pseudo-science of forensic deduction might seem fanciful, and it is true that I failed miserably to take account of chaos theory, but it has to be at the heart of an understanding of both art as an historical phenomenon, and art as a contemporary fact. This is not meant to be a dialectical statement – it is *not* art as an historical phenomenon *or* as a contemporary fact – it is a singular assertion. Art as an historical phenomenon is art as a contemporary fact. The art objects we have before us when we enter the National Gallery in London are nexus points at which certain bodies of knowledge, experience and choice meet, resulting in a painting by Canaletto, or Caravaggio, or Titian. But that does not make them end points in a journey. Just as my imagined visitor, whom I might have successfully deduced walked in from Delph Lane rather than Pennington Street, continued his or her life, away from the nexual point of entering my house, so the painting continues its journey, a contemporary fact, forever in the here and now, but trailing infinite lengths of Ariadne's Thread in all directions behind it. Everything that was is, and its presence is always contemporary, always manifest, not necessarily in its original form, but none the less in the way something is today. Whilst a single thread might connect a visitor who tended towards the right hand door jamb to a journey via Pennington Street, thousands, and perhaps an infinite number, of similar threads connect to Clive Head as he interacts with a location, defines space through drawing, applies paint and modifies the image during fabrication. These threads are the warp and woof of his activity as an artist, and they form links back to the wider history of art, to the particular history of Head's art, and to the historic and contemporary re-

lationships Head has with other artists and the wider world around him. They form a web that underpins his whole image-making activity.

What is important to recognise is how unique this web is to Head. It is woven from his life experiences, and is in that sense deeply personal to him. And yet it is also impersonal, and has similarities to the frameworks of other aesthetic artists. There is an inevitable tension between these two positions. The artist must be individual, but the artist must also work within the collective framework of art. In recent years many people in the art world have found this dialectic to be too difficult to cope with, and so they have gone for the easy options of either abandoning individuality completely, becoming little more than illustration machines, or they have jettisoned the need to depersonalise experience in art, the process of aesthetic distancing, and offer a sort of confessional image-making. For all their possible merits, neither of these approaches are manifestations of art, which is always an aesthetic tension between the warp of the personal and subjective, and the woof of the impersonal and objective. Head achieves that tension. As viewers, however, we have an inevitable curiosity about where the threads that form Head's framework lead to. If I pull on one will it reveal a personal experience that led in part to this painting? If I pull on another, will I see a connection to an artist like Canaletto, or a less expected connection to an artist like Frank Auerbach? And do others lead to impersonal distant events, possibly even as unexpected as the definition of painted pictorial space by aestheticians over a thousand years ago, leading to Head having a specific conception of art now? Ariadne's Threads are fascinating individual stories, and although there is no logical way to approach them, it is still almost impossible not to pull on some of them to see where they go.

One of these threads leads to an idea of the sense of place. There is something defiantly specific about the world depicted by Clive Head. In a painting such as *South Kensington* (Plate 9 3) there is a definite sense that we are looking at London, or rather a particular place in London. To those who know this city, and specifically the area around South Kensington Underground Station, everything in the painting will be familiar, from the entrance tunnel, to the arcade of shops that marks the entrance to the station to the view down Thurloe Street, towards what is now the National Westminster Bank. If we were in this spot in life, behind us would be Daquise, the well known Polish cafe, and further back still the South Kensington Museums, most notably the Victoria and Albert Museum. It is tempting to put the apparent specificity of the painting *South Kensington* down to a mimetic quality in Head's art, as though the painting is a captured image of London achieved through mirroring the look of London. In the words of Hamlet, it is as if, ''Twere the mirror up to nature.' That mirroring seems to show a strong thread that links the place that is South Kensington to the painting called *South Kensington*. But this is only partially true. Stand outside the slightly strange cafe, with its point-of-sale advertisement for Cruz Smoothies, and the difference between the actuality of life and the reality of the painting is striking. Immediately the distance between the corner of the station arcade and the National Westminster Bank is not as far as it seems in Head's painting. Head extends, or we could say telescopes, the length of Thurloe Street, a process called 'lengthening the station point'. The reason for this is simple, and something we have all experienced. If we want to take in more of a view we take a step backwards. Head wants to paint more of the view, extending the field of vision, but instead of him taking a step backwards, he pushes the painting backwards – lengthening the station point, which is to say extending the point at which the viewer is nominally stationed. In Head's work, however, the lengthening of the station point is not uniform. This means that if we look into the cafe, on the left hand side,

we see again a dramatic extension of the station point, a telescoping of the space, but the degree of this extension is far greater in the cafe than in the street. You can measure this by taking a look at the relative sizes of the road sweeper and the man serving in the cafe, with the latter seemingly far smaller than the road sweeper. He must be further away, but this would be impossible given the available space in actuality. The station points looking left, into the cafe, and looking right, up the street, are therefore different, and a questioning begins as to the veracity of the thread that seems to link the location of this painting to its counterpart in real-life.

In that questioning what we are really denying is not that there is a thread that connects this painting to the place that is South Kensington. Rather, that there is a thread that links this painting to a particular view, or perhaps photograph, of South Kensington. Or we might say we are denying a thread that links this painting to anyone who stands in South Kensington acting like a camera, unnaturally restricting their stare to a single view, without moving their head, their body, their eyes and without focusing in on some aspects of the scene and focusing out of others. There is no thread linking the painting to something as abnormal as a camera, let alone an unnatural act like looking at the world as though one is a camera. Conversely there is a thread that links the painting to the experience of being in South Kensington, and in that experience we might have looked into the cafe with its strange signs, we might have wandered past its window, looking up and down and through the glass; perhaps we would have walked further along and looked up the arcade of shops, and craned our head around the pillar, shown in the centre of the canvas, just a little. Perhaps we would walk a little further up the street and find our attention drawn towards a man standing out in his yellow jacket, and then turned, almost 200 degrees from our original orientation when we looked into the cafe, and looked

out over the street, taking in a large expanse of sky above us and the dirt, cracks and discarded chewing gum that litters the pavement at our feet. The thread that links this painting to South Kensington in life connects not to a view or vista, or even a panorama, of this part of London; it links to an experience of being there, wandering about, looking around, pacing up and down a little and generally experiencing the place as a human being, almost as though we were standing a little too long at that bus stop, and had started to pace around to stave off the tedium of having to wait for the bus. As Head says with vehemence, 'It is not a picture of London, but it is close to the experience of London.'[43]

It should also be recognised that this is not ekphrasis on my part. It is not a case of looking at the painting and telling stories of what it would be like to be in the place it shows, seeing the things we see in the painting as if in real life. The process I have described, of moving around the scene, changing the angles at which one looks at things, and the intensity with which some elements are

studied over others, is the starting point from which this painting came into being. There was no standing on a street corner looking at a view, there was only ever a wandering around a specific place, just as any of us might wander around a specific place, and it is to this specific experience of place that the thread connects the painting *South Kensington* with the actuality of South Kensington. It is a thread connecting the painting to a realistic experience of life, rather than the wholly unrealistic experience of the photograph. In effect, a comparison is better made between Head's relationship with London and the London of another painter, Frank Auerbach, with whom Head claims some affinity (Plate 22). For many, Auerbach is unlikely to register as a realist painter at all, with his broad brushstrokes, non-naturalistic colour and simplified rendition of form. But like Head, Auerbach describes his relationship to his subject matter as essentially experiential, by which is meant he experiences a sensual or aesthetic phenomenon, which throws up visual difficulties that are in turn solved, or not solved, through the act of painting. That process is always a very direct one as aesthetic phenomena cannot be experienced by proxy. There are visual difficulties in photographs, but these are difficulties with the photographic image, not with the thing depicted by the photograph, and so Auerbach is essentially a realist in so far as he engages directly with the actuality of the real world, and his art is a response to that engagement. His art is an attempt to reconcile the problems thrown up by that engagement, and the same can be said of Head. In essence Head is as much a painter in the School of London tradition as that of Photorealism, and one of our threads must connect him strongly in this direction. Francis Bacon stated in 1952 that, 'a picture should be a recreation of an event rather than an illustration.' Similarly, Lucian Freud said in 1954 that, 'the picture in order to move us must never merely remind us of life, but must acquire a life of its own.'[44] Such statements indicate Head has a stronger allegiance to the School of London than Photorealism, particularly contemporary photo-rendering realism, given the emphasis placed by the School of London artists on direct experience, rather than on photographic recording. As James Hyman has noted, one of the principle apologists for the School of London, David Sylvester, even placed an emphasis on the importance of drawing as a means of direct engagement with the subject in the work of many School of London artists. Hyman writes: 'In championing the artist's engagement with the experience of modern life, Sylvester also gave central place to drawing as the artist's most direct means of responding to the world.'[45] With these affiliations we have to question even further whether in the painting *South Kensington* Head is mirroring South Kensington back to his audience. The process is more like an experience of a particular place throwing up aesthetic issues which are then dealt with by art in the only way art is capable of doing: visually. Art cannot deal with the aesthetic issue thrown up by sounds in the city, or smells in the city, because art is a visual form, and art cannot deal with the narrative issues thrown up by the politics of the city or the sociology of the city, because art is a non-narrative visual form. This is a thread that goes far beyond Auerbach, Bacon and Freud into an earlier phase of English art, the Neo-Realists of the Camden Town School at the start of the twentieth century, and in particular back to Charles Ginner (Plate 23) and Harold Gilman. Writing in 1914 Ginner effectively defined realism in a way that Head would certainly accept:

All great painters by direct intercourse with Nature have extracted from her facts which others have not observed before, and interpreted them by methods which are personal and expressive of themselves–this is the great tradition of Realism. It can be traced in Europe down from Van Eyck and the early French primitives of the Ecole d'Avignon. It is carried through the dark period of the Poussins and Lebruns by Les Frères

le Nain; in the eighteenth century by Chardin; in the nineteenth by Courbet and the Impressionists, and unbroken to this day by Cézanne and Van Gogh. Realism has produced the *Pieta* of the Ecole d'Avignon, the *Flemish Merchant and Lady* of Van Eyck, the old man and child of Ghirlandaio at the Louvre, *La Parabole des Aveugles* of Breughel (Le Vieux), the Repos de Paysans of Les Frères le Nain. Greco, Rembrandt, Millet, Courbet, Cézanne–all the great painters of the world have known that great art can only be created out of continued intercourse with nature.[46]

As we can see, it is not mimicry of nature that is significant (and by nature we mean the world at large, rather than simply fields and hedgerows); rather it is the 'continued intercourse with nature'.

As in Ginner, the relationship between Head's London and the actuality of London is far more complex than one being a mimetic mirror reproducing the look of the other.

On one level a painting like *South Kensington* is derived from Head having observed, drawn and photographed London, but the sense of reality that is created is not the simple reproduction of an image of London. This is not a Photorealist painting. Instead the image emerges from a direct, physical, emotional and intellectual engagement with a part of London. Perhaps one should say, the intensity of reality emerges from these experiences, so that we can see a process whereby the artist does not simply take a photograph and then paint it, or even take a series of photographs, join them together, and then paint them. Rather, there is a far more intimate relationship to a particular place, and the particular things in that place, which results in an image that is specific and intense. If the simple photograph distances the artist from a scene by placing a mechanical device between the experience and the image, Head attempts to reassert the specifics of a particular period of time and place.

To a young art student this process of engagement might seem mysterious but, as Head explained it when I joined him teaching an art summer school in Irsee, Germany, in 2007, it is not difficult to grasp. One of the phrases that came to typify the start of each day in Irsee was that: 'Artists should slow down and experience the world. A quiet cup of coffee is often the best starting point for art.'[47] The students and I took this at first to be a gentle joke, but there was something serious about it as a method. Sitting quietly, observing, experiencing and even feeling a location was the start of an aesthetic experience, and as such the start of an aesthetic artwork. To the young student, therefore, the starting point becomes apparent: dwell in a location, observing, experiencing and feeling what are its essential elements.

The phrase Head uses to describe his process of painting is the 'establishment of credible space'. Discussing this with him he is wary of my suggested alternative that it is the 'establishment of believable space' for the legitimate reason that it is too easy to misconstrue this as meaning painting something that looks like our world. Head is insistent that the believability of credible space is as valid a concept in an abstract painting by, say, Thomas Scheibitz, as it is in his own work, and it has nothing to do with the illusion of the space created in the painting looking like actuality. What is meant, however, is that the viewer is sufficiently engaged with the illusion of space that they are willing to suspend their disbelief that what they are looking at is not real. The space has to be credible, in the same way that a fantasy action movie set in outer space might depict scenes that are far removed from our expe-

24. Clive Head, *Drawing for Victoria*, 2008

Pencil on paper
10 × 18.8 cm
(3 ⅞ × 7 ½ in)
Collection of the artist

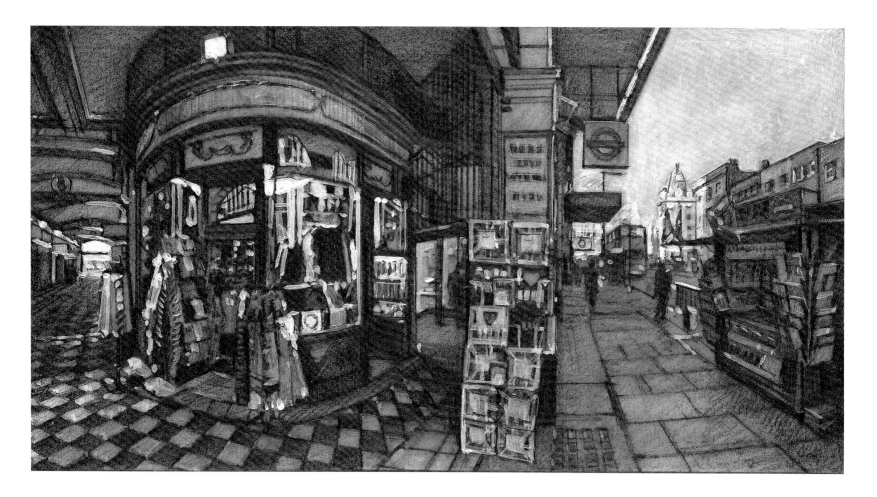

rience of everyday life but which the director of the movie has to persuade the viewer to believe is credible. That way the viewer will suspend their disbelief and enjoy the film. Painting operates in the same way. The street scene of *South Kensington* might look like London, but it is still a fabricated London and it is not credible because it looks like London, anymore than a Scheibitz abstraction is credible because it looks like anything; it is credible because it is coherent within the set of rules the artist has set for himself. Inevitably this creates a curious paradox with Head's paintings, where there is an obsession with the specifics of time and place at the same time as a denial that the resulting work is a depiction of a specific time and place. There is a direct, material, physical and intellectual engagement with a particular place in London that is essential to establishing the credibility of the depiction, but the artist is insistent that the world depicted in the painting is an entire universe in itself, not a looking glass in which we see reflected the London we inhabit. Asked

about this paradox Head falls back on the answer given to him when he asked exactly the same question of Richard Estes in the 1980s. Head says of *South Kensington*: 'It is London and it's not London. It's both and it's not.'[48] Such paradoxes are the bane of much contemporary art theory, rooted as it is in theories of society that are clear cut and consequently false. Yet, to an earlier generation of artists, and theorists, this would have been perfectly acceptable. Writing on Coleridge's poetics Herbert Read claimed that at its heart was a belief in the tension between thesis and antithesis. 'Antithesis operates by a tension or suspense between two ideas', Read stated. 'The sentence becomes a balance between equal but opposite forces'.[49] In the same way the painting, if it is a work of art, is the tension or suspense between two equal but opposite forces – Head's paintings of London are London, and they are not London, just as Estes' paintings of New York are New York and are not New York. In a measure of how this type of thinking throws

up unexpected affinities across a range of artists, it is notable how Barbara Hepworth, a maker of abstract sculptures, held the same beliefs. The abstract carvings she created in stone and wood were intended as pure forms and not of this world; but at the same time they were derived from the shapes she saw in nature (Plate 25).

What we need to come back to, however, is the relationship between the artist and particular objects in a particular time and space. That relationship is an inherently physical one, between Head and the materiality of objects in a material location. Head is in fact adamant that by looking at objects, such as the plastic signage of the interior of the cafe in *South Kensington*, or the concrete of the paving slabs, or the fabric of a coat or fluorescent jacket, he is touching them, and that the engagement with a particular place is a physical one.[50] It is, in the true sense of the word, an aesthetic relationship,[51] a synaesthesic response to actuality. As Jean-Paul Sartre noted, the senses do not experience actuality through the individual senses, but through an array of them:

> The lemon is extended throughout its qualities, and each of its qualities is extended throughout each of the others. It is the sourness of the lemon which is yellow, it is the yellow of the lemon which is sour. We eat the colour of a cake, and the taste of this cake is the instrument which reveals its shape and its colour to what may be called the alimentary intuition.[52]

Similarly Maurice Merleau-Ponty stated in a radio broadcast in 1948:

> [I]t is fairly widely recognised that the relationship between human beings and things is no longer one of distance ... Rather, the relationship is less clear-cut: vertiginous proximity prevents us both from apprehending ourselves as a pure intellect separate from things and from defining things as pure objects lacking in all human attributes.[53]

This is a significant point as a great deal of aesthetic theory has tended to prioritise sight as purely a visual engagement with actuality, which has in turn led to the error that a photograph can stand in for the act of engaging with the world. The assumption, even among many artists, is that when we look at the world and we look at a photograph of the world we are doing the same thing. But as the philosopher F. David Martin has stated:

> Our bodies are not walls separating us from things but active mediators with things. We are interlaced with things because our bodies are thoroughfares rather than boundaries. Our bodies extend into things and they extend into us. Our worlds are masses without gaps that penetrate our pores. Our bodies are inside of our worlds, and our worlds are the outside of our bodies. We are always here and there, and our awareness of here depends on our awareness of there. We are, before we are anything else, a continuum.[54]

As Martin goes on to suggest, sight is part of a complex sensory apparatus, the elements of which – such as sight, hearing, touch, taste, smell and so on – do not operate separately as discreet units, but as an integrated whole. To see is in a sense to touch.[55] To look at the actuality of the world is to experience, or sense, or even feel the actuality of the world, and it is through this engagement with the material world that a material response in the form of a painting emerges. *South Kensington* is a painting of London both in the sense that it depicts somewhere that looks like London and that it is derived from an engagement with London. But it is also not London, not only for the reason it is made of paint, wood and canvas, but because in creating the painting Head is establishing a new, alternative spatial reality that operates differently to the actuality of London, despite its apparent mimetic similarity.

––––––––––

Unfashionable though it is to suggest it, there are works of art that give comfort. (Fashion does not interest anyone

26. Claude Lorrain, *Landscape with Apollo and Mercury*, 1660

Oil on canvas
74.5 × 110.4 cm
(29 ½ × 43 ¼ in)
Image © Wallace Collection, London/
Bridgeman Art Library

with a real belief in art, however, as fashion is the last barricade of the doomed mainstream, the ordinary world of culture that will soon pass and be forgotten. The radical is never fashionable.) For me, I find comfort in Claude Lorrain's *Landscape with Apollo and Mercury*, 1660 (Plate 26), in London's Wallace Collection. Or, in the National Gallery, it is the paintings by Aelbert Cuyp. By the logic of some artists and critics working today, neither Claude or Cuyp would be judged good artists because they have this ameliorative effect, but those artists and critics are not worth listening to. One artist went on record recently to say that, 'Art is not meant to make you feel comfortable.'[56] But that is precisely what art is meant to do. That is not to say art should be pretty, nice or polite. On the contrary, all works of art are a confrontation with a problem, but they are also its resolution, and an artistic problem could just as easily be a problem of spatial relationships as one of social injustice. Head would argue more so. But in no case is it the function of art to rub the nose of the viewer in horror, or to make them feel bad about being alive, no matter how bad being alive might be. Matisse knew this and so does Head. In Head's own words:

As to my pictures, increasingly I am trying to find a warmth (a comfortable armchair as Matisse would have it) from a world that is chaotic, shabby and often leaves us feeling that we just have to endure it, get through it. How often have we felt like that passing through our underground stations? This is far from the martyrdom of St. Sebastian, but we all have our own personal struggles and the fate of us all is ultimately the same. When we talk about a faith in art it is to find salvation in its permanence, not to show us what is conventionally regarded as attractive or politically poignant. Here lies the greatest challenge and the greatest rewards.[57]

As this suggests, the comfortable armchair of Matisse is not a passive position for an artist. It is a struggle to achieve that comfort (if it is ever achieved at all, rather than just being a dream), and behind it is always a fear of the annihilation of the abyss. Consequently the fabrication of Matisse's comfortable armchair is a direct response to an absolute sense of angst. It takes a smug and complacent individual to be satisfied with turning art into no more than an exercise in reproduction, and a nihilistic one

who wishes to inflict more chaos and pain on an already chaotic and pain-ridden world. I escape into Claude's vision of Arcadia, or the pastures of Cuyp in order to return to the lost Arcadia – the concrete fields of south London – with restored hope. But I also enter the London of Head for the same reason. His is not a pretty vision of the city, any more than Francis Bacon offers a pretty vision of humanity. But Head and Bacon's vision, like that of Claude, or Cuyp, or Canaletto, or Titian, or Estes, is always human and humane, ordered and aesthetic. It is always a comforting armchair and never a Judas cradle. The failure to understand this is the failure to understand art.

Unfortunately a failure to understand art is common. I have long been known for a sceptical attitude towards art criticism and have often held vehemently opposing views to things I have been told are true. In part this is probably due to my schooling in a system that was designed to tell its victims constantly that they could not do things. In that system you either accept what you are told or you learn to question everything you hear. But later, my scepticism about art criticism came from listening to artists whose opinions I trusted and valued. None of them seemed satisfied with the general level of art criticism. And finally, my scepticism came from the evidence of my own eyes. I looked at works of art, and what I was told frequently did not fit what I saw. In Head I find an artist who has a similar attitude to my own, albeit for different reasons. Commenting on his own childhood Head has stated:

> Thinking back to my childhood it was always the painting problem that engaged me. In many ways this was a technical challenge but the criteria for judging the outcome was, as it is now, not one that has boundaries which exist outside an intuitive sense of rightness, and this sense of rightness is bound with emotions, head and heart. Early on I painted alongside adult amateurs. I was the only child in an art club, but I felt more at home there than I ever did

undertaking the themed projects in an art class at school. In fact at school I used to resent the teacher setting us a project which always came from a narrative. It was indoctrinating children to think of art as illustration, to come up with clever ideas, and even back then I remember feeling that school had missed the point, and just wanted to go back to the environment of the art club where people cared about the problems of painting and were not judged by their subject-matter. Worrying about having an idea, and then finding an object or image to show it seemed to me a dilution of the purity of art. It took me away from my enjoyment of making art. It just seemed to miss the whole point.[58]

In a similar vein, he states: 'I have always lived my life by simple rules. At a very early age I struggled at school. I didn't like being a C-grade pupil, so I decided to work. For me, self-worth is intrinsically linked to work. As you say, it is about making a decision.'[59] That last comment was in response to my suggestion that there are those who make the decision to go into the National Gallery and engage with the artists showing there, difficult though their work might be; and those who make a decision not to. All things being equal, I suggested, an artist who makes a choice not to visit the National Gallery when in London will always be an inferior artist to one who does make that visit. That will not be because their technical skill will necessarily be any lesser, but because their base load of the experience of great art will be relatively diminished. There is an analogy in this with something as simple as learning to drive a car. After one passes the driving test, many of the technical functions of driving seem automatic. One does not have to think to change gear, or turn the steering wheel, or use the brakes, one just does it. No one is going to claim the technical functions of driving a car are natural, but eventually they come to seem natural. Even so, some people are more naturally good at driving than others,

and so some people are more naturally good at art than others. But whether one is learning to drive or learning to make art, what improves the ability of both the gifted and the not so gifted is an adequate base load of knowledge and experience. In other words, the more lessons you have from an expert, the better driver or artist you will be. What this means specifically for art is that it is the non-academic choices an artist or art student makes to engage with the history or tradition of art that determines the quality and quantity of their base load knowledge of art. That decision informs an artist's practice whether they like it or not, or whether they are aware of it or not. Having gone through an extended period when the received wisdom has been that collections like the National Gallery are not relevant to contemporary art practice, and few London-based art students even visit the National Gallery any more, it requires a contrary nature to go against the mainstream and engage with historic art. Head has that nature but, as he admits, it has not always been easy to stand against the crowd, particularly when he enrolled as a postgraduate student at the University of Lancaster in the 1980s:

> Lancaster was typical of most art courses. There were no true artists on the staff. I became more theoretical when I was there, hiding behind the cleverness of my knowledge of photorealism of the 1970s. When David Tinker visited Lancaster he commented that my work had become cold. He didn't tell me that the light was fading, but thinking back it was what he meant. So someone as passionate about art as me is not immune to the pressures put upon artists from non-creative environments. It was not that I was being bullied, I reached an agreement with my tutor that we had nothing in common and should not talk about art.[60]

Tinker was Head's principal tutor as an undergraduate student at the University of Wales, Aberystwyth, and as this encounter indicates, he clearly placed the mantle on his students to maintain their integrity, even if it was not the easy decision. As Head states, it was not just tutors like Tinker who believed this, but fellow students at Aberystwyth, such as Steve Whitehead, whom Head remembers would happily quote van Eyck in the university's studios.[61] This off-centre approach to both the making and morality of art was clearly unusual, and reinforced Head's position outside the mainstream, run-of-the-mill art world. But it is only by going against the mainstream that surprising discoveries emerge. It is while sitting in front of Titian's *Diana and Actaeon* in the National Gallery that Head announces it to be *like* a Cubist painting. It takes a lot of visits and a lot of looking at one painting to see this, but once the revelation is achieved then 'Cubist' paintings can be seen all over the place. In each, as in *Diana and Actaeon*, bodies are twisted and shaped not according to the rules of actuality, but in line with the necessity of the painting. Similarly Old Master images of tables, floors and landscapes are not painted to reproduce reality, as critics have often suggested,[62] but in accordance with the logic of the particular painting, which might require sight of the top of a table as well as its side, a floor that recedes logically into the distance using the laws of perspective, or which tips up to allow the viewer to see everything on it clearly. It is all just as Titian painted Diana, not to reproduce the actuality of a female figure, but to show her back, her buttocks, her breasts, the side of her face and the front of her face all simultaneously. In other words, it is just as Picasso and Braque sought to paint all the way around a still life, not just one viewpoint, during their Cubist phase. Without a rejection of the mainstream view through a direct and on-going engagement with great art, none of this is revealed, and no lessons learned. But that engagement has happened here with Head, and as a result he is an artist who sees Titian as

a kind of Cubist; and I am a writer who sees Head as a kind of Cubist.

———

It is a legacy of modernist criticism that the standard view of Analytical Cubism is that it represented a retreat from nature, with artists – principally Picasso and Braque – increasingly analysing the form of their subjects, whether a still life, or landscape, or portrait, not to gain more information about that subject, but to derive from it abstract forms, shapes and patterns that could result in 'abstract' paintings. This view presents Analytical Cubism as a withdrawal from nature towards some-

thing that might be thought of as pure art, by which is meant a formalist art that is wholly abstracted away from the actuality of the real world. In this reading of Cubism it is undoubtedly Clement Greenberg who holds most responsibility for downplaying the connection between the actuality of nature and the painted Cubist image, particularly in his 1958 essay 'Collage'. From this sprang the view that a painting can only be itself.[63] Even Greenberg's arch-rival, Herbert Read, seems to have accepted this understanding of Analytical Cubism, although he did come at it from a different angle. Rather than a rejection of the actuality of nature, Read suggested the early Cubists simply misunderstood the work

27. Clive Head, *Under Hungerford Bridge*, 2004

Oil on canvas
167.6 × 279.4 cm
(66 × 110 in)
Private collection

of Paul Cézanne, and consequently failed to realise that his landscapes of Provence were in fact rooted in a very deep engagement with the actuality of the landscape, and were not an escape from it.[64] It is not a bad thing to be sceptical about the received wisdom on Cubism, and to question it. The received wisdom might be right, of course, but we can play a little game with other possibilities, which might even change our assumptions about what Picasso and Braque were trying to do in the early twentieth century. For example, what if we refuse to believe that Analytical Cubism was a detachment from nature and think of it instead as a rigorous engagement with nature? What if we think of Cubism not as a move towards abstraction in art, but as a form of realism? That might seem counterintuitive, as for most people Cubist paintings do not look very real. The image is, after all, chopped up and angular. But that need not stop Cubism being realist if the artist is engaging with the real world outside of themselves, a world we are calling actuality, rather than creating images purely from their imaginations, emotions or narrative sources like literature or the Bible. With Analytical Cubism, Picasso and Braque were doing exactly that, engaging with actuality, and we can see this through the things they painted. These tended to be simple still lives made up of bottles, glasses and musical instruments. As a game, therefore, what if we treat Analytical Cubism as if it embodies Ginner's statement on Neo-Realism. 'All great painters', Ginner wrote, 'by direct intercourse with Nature have extracted from her facts which others have not observed before.'[65] The facts extracted through the analysis of simple still life objects in Analytical Cubism include a recognition that objects are not static in space, even when they are still, because the artist moves around them. As they do so they might close in on them, focusing more intently on some objects than others. Some objects might seem to line up as they move, so that it becomes possible to make the shapes of a violin and a

bottle align with each other, even though they do not have any real relationship in actuality. By moving your head and eyes around a group of objects set up to form a still life, you can make things seem to align. Read called this the creation of 'good form' or 'good Gestalt', and it was one of the characteristics that differentiated actuality from art. In the real world of actuality a violin and bottle have no real connection, they are separate objects. But in an artwork like a painting, the neck of the bottle might line up with the neck of the violin, and they become connected. Multiply this many hundreds of times and what you have is a set of objects in the actuality of the studio being analysed in order to establish connections between them. It is these connections which are then set down in the painted world created by the artist. But it is also very like the way we see in life, with all the disparate people, objects and events in our everyday actuality being connected in our minds in order to strip life of seeming chaotic. The mind turns actuality into something that seems to have logic and reason behind it. Indeed, Gestalt theory began not as a theory in which artists establish connections between objects, but as a theory of how the human mind establishes connections or patterns in life so as to order the apparent chaos of life. This suggests that the human eye itself is an Analytical Cubist, dissecting everything we see into a collection of constituent parts that comprise the relevant and irrelevant, the prominent and modest, the near and far, and then re-ordering those elements in order to make connections. These elements are reconstructed into what we perceive as reality. It also suggests that the Analytical Cubist might be closer to how the human mind understands the world, as in actuality we rarely see vistas or panoramas because the vista or panorama is an artificial construct that assumes the viewer is monocular and static. In reality we viewers are human beings and we move in on some things, focusing on them more closely, dismiss other things as irrelevant,

establish connections that are not necessarily there, and so on, much as the Analytical Cubists analysed the objects of their still lives. It is the vista and panorama that is anti-realist because it fails to acknowledge the viewer's complex and fluvial relationship with the real world, whereas the Analytical Cubists acknowledged this relationship. Therefore, Analytical Cubism was not a detachment from nature, it was really a rigorous engagement with nature, and so it was a form of realism.

Threads that link Head to artists like Richard Estes and Canaletto might be easier to discern than those that lead to Picasso and Braque, but the process I have described that led to the Analytical Cubist paintings of Picasso and Braque might be applied with equal conviction to Head. That is not to say Head's style is Cubist, but the analysis and ordering that underpins this aspect of Cubism is similar. We might say that Head's methodology is Cubist. Like the Analytical Cubists Head has come to reject the vista, and it would be wrong to see his work as simply a land or cityscape. Indeed, in conversation Head has used the term 'inscape', a phrase that has its origins in the writings of the poet Gerard Manley Hopkins, who used it to indicate the distinctive

identity of things. For Hopkins this was not an identity seen in terms of an object or person's static appearance, but an identity that is established through a process of dynamic engagement.[66] We might extend this in relation to Head by taking Hopkins' corollary to *inscape*, the instress, by which he meant the recognition by the human mind of the distinctive inscape of other beings or things. Yet the key phrases here are dynamism and distinctiveness, with both Head and the Cubists clearly engaging with aspects of actuality in what is literally a dynamic way (which is to say, in simplistic terms, they move around it). In doing so they reveal what Ginner suggested was the *raison d'être* for realism, the extraction of 'facts which others have not observed before.'[67] Head moves around the scene in *South Kensington*, in and out of the cafe, up and down the street, and around not only a lateral 300 degree arc, but up to the sky and down at his feet. Curiously, if you took all of his photographs and drawings of any one place – which would number over 100 individual images – and attempted to combine them into a scene, they would even resemble one of the shattered and dissected images of the Cubists.

There is no doubt that, in making his paintings, Head goes through a Cubist phase. In a work like *Victoria*, in both the early drawing (Plate 24) and the final painting (Plate 90), there is clear evidence that he is trying to reconcile the diverse points of view, to find the angle, plane and line that works, and establish a credibility to the artificial space. The jumps in space are in fact extraordinary, as anyone who has tried, as I have myself, to stand in this entrance to Victoria Station and 'see' the painting. That there is a real struggle in this process is perhaps not apparent from the final image, in which the apparent impossibilities of rendering such complex space onto a canvas have been somehow resolved, and as Head says, this Cubist-like struggle with space is a feature of all his work, even if people are not aware of it: 'The testimony to Cubist thinking is all deleted in the making process.'[68]

As this also suggests, there is an accumulative process here in which information and experience are gathered from an entire environment, and in this it emulates the way we negotiate the world as three-dimensional beings within a three-dimensional space. It does not mimic any static or monocular view. This means that in Head's paintings the reality of the image is closer to the experience of being human in the world. Objects are not seen in a static pose, but shift in time and space. The passage of time might even be indicated by the shadow of one object falling in a different direction to another object, as in *Spring Blossom, Geneva*, 2005 (Plate 80), with the shadows of the balcony railing on the left hand side, the cars in the middle distance, and the figure on the bridge each suggesting a different time of day. The shifts in space result in some elements being seen close up, while others are far away. Objects will be tilted and shifted in angle, while the artist himself is not stuck in a single spot, but walks through the scene, looking from left to right perhaps 200 degrees laterally, as well as up at the sky and down at the pavement. Head

will peer round corners, shift perspective and create numerous pockets of space each of which will have its own logic in terms of the lines of perspective and angle of view. It is in this methodology that Head most resembles an Analytical Cubist, who might similarly show a still life with bottles and musical instruments, not from the traditional single viewpoint, but from different angles, from the top, front, side and back, sometimes close to, and sometimes from far away. Even the shifts of time have parallels in the scion of Cubism, Futurism, whose adherents also attempted to show the passage of time through divergent shadows. The results of these methods in both Analytical Cubism and Futurism was a shattering of the image, as the artists struggled to unify the space to show objects from so many different angles. Indeed, the struggle with space was so great, that arguably the Cubists were forced to abandon the illusion of three-dimensional space in their work completely. Head has taken this basic principle and reworked it in a realist visual language using the urban landscape, with the result that the shifts in space, perspective, time and view that he achieves are far greater than anything attempted by Picasso or Braque, but they are rendered into what looks like a single flat and coherent image. Head is attempting nothing short of *refaire le cubisme sur nature*,[69] and in doing so has resolved the Cubist problem with space.

Again using our fictitious art student wanting to know how to do this, we can conceptualise this astonishing achievement by considering how one could render an image that in life would require you to turn left to right over 200 degrees of a circle. At the same time in that image one would have to move one's head up and down, as far up as it will go and as far down as it will go. And at the same time one would have to move around the scene, backwards and forwards, close up to some objects and away from others, two or three metres forwards, and then back again, each time looking

around corners and at objects from different angles. For the realist artist in the twenty-first century the attempt to replicate and explore the nature of photography is no longer at the cutting edge. That was a task set and achieved by artists in the twentieth century. Nor is it enough to simply resolve the Cubist problem of space. Instead a new task is set for the new century: to bring realist painting closer to the experience we have of any location in life. That experience will not be the static monocular view of the camera, it will always be binocular and dynamic, attaining in the realism of art something of the flux of actuality in a way never successfully done in painting before. The astonishing achievement of Head is that he is seeking to do this while maintaining the credibility of his images, none of which really look like the places they depict, but all of which achieve the illusion that they might be mirrors held up to the world around us. It is only when a viewer of his work visits the original sites that gave rise to the painting that they realise the space in the actual scene bears no resemblance to the space in the paintings. The painted space is an absolute construction, a fabrication made not to reflect actuality, but to allow all the objects in the paintings, seen at so many different angles and through periods of time, to co-exist in a single picture plane, without looking incongruous. And just as the Analytical Cubists were heavily influenced by the movement through time and space of early movie film, so we can say that Head's paintings are probably the closest painting has ever come to depicting the world with all the shifts in time and space we see in a moving image, while remaining a conceivable and coherent image. As this shows, there is no outright rejection here of the lessons of modernism, the experience of life as it is lived now, or even the diverse theories of art that have underpinned art in recent decades. Instead, there is a desire to re-engage painting with life, through the recognition of painting's essential characteristics. Head's work draws on the past to engage with now, the Urgency of Now.

————————

Despite a firm denial that his paintings are concerned with narrative meaning, Head seems to have had a long standing interest in railway stations and their surrounding areas. Among his earliest works are images like *We Always Remember Whose Money It Is*, 1988 (Plate 29), which takes its title from a building society poster depicted underneath a railway bridge in Manchester. As this painting shows, railway architecture is among the most successful ways in which to introduce austere and sometimes brutally functional engineering elements into city scenes, and the contrasts this sets up have long attracted artists, particularly realist artists. This can be seen in Head's *Geneva Junction*, 2005 (Plate 78), in which there is a strong contrast between the attractive bourgeois architecture of Geneva as it is set against the neat but functional lines of the tram rails in the road and cables above. A similar collocation exists in *South Kensington* between the attractive buildings in one of London's most expensive areas, and elements like the cafe, with its harsh neon light and advertisement for the unappetising sounding 'Cruz Smoothies'. It would be easy to read narrative meanings into these juxtapositions, but Head is insistent they are not intentional and so they are in a sense not there. They might be read into the paintings, but this is against his preference and wholly in the mind of a wayward viewer. If a road sweeper appears in the scene it is simply because road sweepers are surprisingly common on London streets, and they tend to hang around places for longer than most other people. This makes them more likely to become part of the painted scene. They also tend to wear bright colours which helps them to become focal elements for an artist seeking points of contrast in a city where most people tend to dress in a very limited range

of dark colours. Most notable for people searching for narrative meanings in Head's work is the *Evening Standard* newspaper sign in *South Kensington*, reading '500,000 Home Loan Losers'. This is not, Head insists, a social comment, but simply the sign that happened to be there on the day. If it reads as a comment on the high house prices of Kensington, and the collapse in 2008 of the English housing market, then that is unintentional and he has made no selection of the scene based on apparently narrative elements like this. In one instance Head became notably impatient with two fellow artists who suggested that his depiction of one of the figures in *Coffee with Armin* (Plates 30 and 92) looking out of the coffee shop at the church over the road meant there was some spiritual meaning to the work. 'Actually he's not looking at the church', Head said. 'He's looking at the barber's next door, wondering whether to get a hair cut'. The point about this is not that Head was trying to correct a specific narrative reading of the painting, rather he was attempting to undercut the whole idea of narratives of this kind. Head acknowledges the psychological intensity of the relationships between figures in paintings, but the idea of specific readings arising from this is something he refutes. What this makes clear is that if people engage fully with the visual dynamics of the paintings they would not make such literal claims. They are reading the paintings rather than looking at them. In the reality of *Coffee with Armin* the male figure in the coffee shop would be unable to see the church (or indeed the barbers), and it is only the viewer of the painting in our world who is in the privileged position of being able to see the complete configuration of the diverse spaces.

Despite this there is a need to recognise a tendency for Head to be attracted to the less glamorous side of urban life. The phrase that has come to the fore in discussing this with him is the need for contemporary painting to engage with the Urgency of Now. This is effectively a rejection of any notion of painting returning to the past,

29. Clive Head, *We Always Remember Whose Money It Is*, 1988

Acrylic on paper
51 × 38cm
(20 ⅛ × 15 in)
Private collection

facing page: 30. Clive Head, detail, *Coffee with Armin*, 2008

Oil on canvas
155.6 × 203.8 cm
(61 ¼ × 80 ¼ in)
Private collection

even if the importance of historic artists as mentors is acknowledged. Art now has to engage with life now. In Head's case this does not mean he is attracted to images of violence or decadence, but it could be to the back of a building rather than its well-maintained front. Or, a view of Piccadilly from a shabby arcade where real life happens, rather than the prettified scene of Piccadilly Circus which is maintained entirely for tourism, as can be seen in *Haymarket* (Plates 31 and 94). Rather than seeing a picture postcard scene, we are set well away from Piccadilly Circus so that the Shaftesbury Memorial Fountain is almost (though not quite) removed from view. This approach was particularly apparent in a trip made by Head to Prague in 2003, with the realist artists Anthony Brunelli, Bertrand Meniel and Raphaella

Spence, and myself. Head was one of the artists who came out most strongly against painting tourist scenes of Prague. With well-known sites, such as the Charles Bridge, so over-photographed, they were, in Head's words, 'almost impossible to see.'[70] The result of this trip was a deliberate decision by Head to avoid obvious clichés of Prague, such as the Charles Bridge, and move instead towards an almost anonymous section of Prague's riverside in the works *Yellow House, the Last Day in Prague*, 2003, and *Prague Early Morning*, 2006 (Plate 74).

A similar attitude is apparent in a number of other paintings, including *Tracks*, 1997 (Plates 32 and 57), showing the back end of Scarborough railway station in Yorkshire, and *Sloane Square*, 2000 (Plate 64), which is

31. Clive Head, *Drawing for Haymarket*, 2009

Pencil on paper
13.1 × 23.4 cm
(5 ⅛ × 9 ¼ in)
Collection of the artist

32. Clive Head, *Study for Tracks*, 1997

Acrylic on paper
48 × 61 cm
(18 7/8 × 24 in)
Private collection

set on the platforms of Sloane Square Underground station. There is also an earlier depiction of South Kensington Underground Station, again called *South Kensington*, 2000 (Plate 66), which shows the platform levels. There is nothing typically picturesque about any of these paintings, and this attitude to subject matter is something that Head seems to have derived partly from the first generation American Photorealists. When visiting New York in the mid-1980s to meet many of the early Photorealists, Head was astonished to find they had no sentimentality towards their subject matter, and that they chose scenes of New York streets for no better reason than they were right in front of them. While New York seemed romantic and exotic for Head, having grown up seeing the city depicted in numerous American movies and television shows in England, it was mundane and ordinary for figures like Estes, Blackwell and Goings. It was this embrace of the mundane and ordinary that was taken up by Head.

It can be seen in *Kingsferry Bridge*, 1990 (Plate 54), one of Head's earliest paintings after he completed his studies at the University of Wales, Aberystwyth, in which we see the monster of a concrete bridge that links the Isle of Sheppey, in southern England, with the mainland. Remarkably, perhaps, Head chooses to make the view even more unpicturesque by placing the viewer behind a large articulated lorry, so that, like on many long and tedious car journeys, we are faced with looking at the back end of a truck. There is a similar attitude towards the unpicturesque in contemporary life in the work of historic realists, such as Gustave Caillebotte, in works such as *La Place de l'Europe*, 1877, and *Le Pont de l'Europe*, 1876 (Plate 33), the latter seeming to have a particularly close affinity to Head's paintings *Observatory*, 1998 (Plate 58), and *Valley Bridge*, 1998 (Plate 60). Similarly it must be difficult for anyone to look at Head's *Inverness Terrace*, 2006 (Plate 81), without Caillebotte's *Rooftops in the*

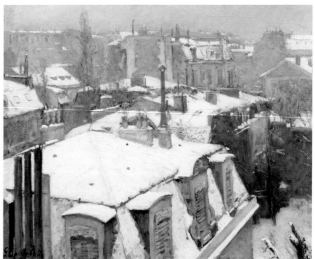

Snow, 1878 (Plate 34), coming to mind. As always, Head's influences are diverse, but as in the case of artists like Estes and Caillebotte, the selection of places that are mundane and ordinary – and perhaps, in the eyes of some people, ugly – does not indicate that Head revels in the unsightly. There is a genuine interest in seeing the mechanics of things, with the backs of railway stations and the ginnels of towns and cities providing a fascinating glimpse of the real workings of places, their functions stripped bare and their histories revealed. I accept that this too is a narrative imposition on Head's work that he might not appreciate, and he is increasingly of the opinion that it is no longer necessary for him to select subject matter. Instead he could stop anywhere on a London street and explore the same visual problems that would interest him if he was to be highly selective.[71] But it does imply a motivation as to why he chooses some scenes and not others, and why viewers respond to his off-track

images perhaps more readily than they do to endless depictions of obvious sites and sights by other realist painters. Indeed, I remember an apposite phrase Head would frequently use when teaching if a student used an easy solution to a pictorial problem: 'It's a bit obvious.'

A notable reaction to Head's painting *Haymarket* by Colin Wiggins, Director of Education at London's National Gallery, was that the painting would probably be the first time an image of discarded chewing gum would make it into the National Gallery. This was a reference to the detritus Head has depicted on the pavement area in the foreground of the painting. It is not the first time Head has done this. In *South Kensington* it is cigarette butts, and in *Cologne*, 1998 (Plate 59), it is spray can graffiti on the pavement. As Wiggins also noted, however, had chewing gum been invented in Canaletto's day he would probably have included it too. It was not just the

American Photorealists who discovered the streets are not as tidy as the picturesque tradition suggests, and this has always been a part of the realist canon, a key factor that differentiates realism from idealism.

In this we can see a fascinating line of descent that can be drawn here, from the Neo-Realism of Camden Town Group artists like Ginner, Gilman and Gore, through the Kitchen Sink School artists, like Edward Middleditch, Jack Smith, John Bratby and Peter Coker, and on into Head. The bright skies in Head's paintings might seem to have nothing to do with the smog-ridden London of Gilman in the 1910s, and Bratby in the 1950s, but that is just evidence of a broadening out of the English realist tradition to take in a knowledge of American Photorealism. Curiously this is not a static situation, however, and in his latest painting, *Leaving the Underground*, 2010 (Plates 35 and 97), derived from

35. Clive Head,
Drawing for Leaving the Underground, 2009

Pencil on paper
13.2 × 17.2 cm
(5 ¼ × 6 ¼ in),
Collection of the artist

the view up the stairs out of Victoria Underground Station, he has not only again selected subject matter that 'has very little glamour',[72] but even jettisoned the American Photorealists' sunny skies. On its own that might seem a small modification, but the fact is it does not exist on its own – it is part of a continuing journey into unknown territory – and this gives it significance. In essence Head stands in a complex relation to the English realist traditions of Neo-Realism and the Kitchen Sink artists, and the American tradition of Photorealism. He is the natural heir of both sides, but he is also the agent for an adjustment of the traditions to the here and now, the urgency of our now. The smog of old London town that seems to hang around in the work of a Neo-Realist or Kitchen Sink artist has gone from London, and so the smog is absent from Head's paintings. But other aspects of the reality of city life are very much apparent. Writing on the preliminary studies of the new Victoria painting Head stated:

> When I first visited this site the sun was shining, when I returned it was gloomy and then on a third visit it started to rain. So what I end up photographing changes according to circumstances outside of my control. In the end I have to work with what I find. The world is always in a state of flux and chaos. At some point the artwork brings order to this chaos, but this doesn't happen for me when I take photographs. Standing on the steps for half an hour, being jostled by people, and trying to record all the space around me (the slice of the shop on the lower left is actually behind me and beneath my feet [down the stairs]) seems to exacerbate this sense of chaos and disarray. It is only in the calm of the studio that something coherent begins to emerge, something which surprises me.[73]

If Head moves various forms of realist painting forward, he also accepts that the traditions of the Old Masters are part of his history as an artist, in a way that was unthinkable to both the modernists and even the American Photorealists. Indeed, in adjusting the realist tradition to the here and now Head has done a remarkable thing almost unparalleled in the history of realism, at least since Manet. He has filtered the urgency of now through a gauze woven from threads that stretch back to the examples of historic artists like Canaletto. Ultimately it is through this hybridising method that Head has created a new and revitalised form of realist painting for the twenty-first century, tying together diverse threads that weak artists fail to realise can have a connection. Any run-of-the-mill photo-rendering realist of the last decade can see some kind of connection between their work and the paintings of Canaletto, which will probably remind them of photographs. But it takes a more powerful realist painter to recognise the equal relevance of Titian, Rembrandt or Matisse – each of whom finds space in Head's lexicon – when facing the modern world. And an even stronger one to admire Canaletto for the way his paintings are *not* like photographs.

Evidence for Head's hybridisation of his art can be seen again in the railway paintings. *Blackfriars Bridge*, 2003 (Plate 36), shows the view looking out across the River Thames, with the railway bridge guiding our line of sight over the river. References to the mechanics of the railway are indirect, but a particular focus is placed on the engineering structure of the bridge. Compositionally the painting is relatively straightforward, with a view across the river, but little in the way of a sidewards expansion of the scene. In this it resembles other 'full-frontal' works by Head, such as *Cologne* (Plate 59) and *Governor's Island*, 1999 (Plate 63), in which the well-established realist trope of showing simultaneously a view across the bridge and down the river was disrupted by simply turning to look sideways from the bridge. Yet *Blackfriars Bridge* also bears a passing resemblance to one of Poussin's paintings, especially in the golden light and the two trees. Head says

that he does not invent information, although he does acknowledge being partial in selecting whether to use a piece of visual information he has gathered, so the trees were presumably present. And we have to assume that the light itself is also not wholly fabricated, although with some provisos that will become clear. But a Poussinesque sensibility has somehow been mapped onto these elements, not to create a pastiche of Poussin – the Poussin quality is in passing and could as equally well be ascribed to Claude, Cuyp or Turner – but to establish the recognition that this painting exists as an artwork within the history of art. Today we tend to call this use of art history appropriation, but in Head's case that is the wrong word. Homage – or the phrase we have used previously, aesthetic induction – would be more appropriate. What we are really seeing is the acknowledgement of a relationship to the past, and a revisiting of the history of art, with a definite self-awareness, but *without* irony.[74] It is a recognition that realist painting does not have to draw solely on photographic conventions to be realist, and that until the invention of photography in the 1830s, realism could not draw on anything but non-photographic sources. In

36. Clive Head,
Blackfriars Bridge, 2003

Oil on canvas
33 × 50.8 cm
(13 × 20 in)
Private collection

Head's work nothing illustrates this more than the series of paintings known as the cafe series.

Identifying the starting point for a painting series is rarely straightforward. In most cases an artist will explore the themes that ultimately lead to a series in various forms long before the series itself becomes recognisable. Claude Monet's Haystacks series, for example, did not begin when he started painting stacks of hay in the fields around Giverny in the late 1880s, it began when he painted *Impression Sunrise*, a view of the harbour at Le Havre, without a haystack in sight, in the early 1870s. As for his equally well-known Poplars series, perhaps we should even look to the earliest known work by Monet, *View from Rouelles*, painted in 1858, to find an origin for the images he started in the 1890s. And so it is with most artists, including Head. With Head's cafe series the quintessential examples might be *Piccadilly* (Plate 87) and *Rebekah* (Plate 89), each showing a female figure sitting in a London coffee shop, with views into the coffee shop, and out of the windows into the street. An earlier example using this format was *Trafalgar* (Plate 86), in which Head's wife Gaynor was the model. But in a later version, *Coffee with Armin*, 2009 (Plate 92), the format changed, with the nominal station point shifting to the outside of the coffee shop. Although the girl in the window is still present, the title and the painting itself places greater emphasis on the male figure (Head's friend and art dealer Armin Bienger) sitting more deeply within the interior space. As the series has evolved, the most recent examples, *South Kensington*, 2009 (Plate 93), and *Coffee at the Cottage Delight*, 2010 (Plate 95), show ever increasing complexity, particularly in the number and placement of figures, but also in the amount of space – or number of pockets of different space – that are shown.

Although the sequence of works just described suggests an evolution, from the relatively simple (*relative* being the operative word here) image of *Trafalgar*, which Head describes as 'experimental', to the highly resolved complexity of *Coffee at the Cottage Delight*, this is far from the truth. The place from where these images emerged is extremely complex, and just as we might see the progenitor of Monet's haystacks in a painting of Le Havre made 20 years earlier, so with Head's coffee shops the origin lies in much earlier work, not all of which has anything to do with coffee houses. Of course there is a thread that links these paintings to the work of American Photorealists too, particularly in the work of Estes and Blackwell, in the acute angles from which the cafe windows tend to be seen. This might bring to mind work like Estes' *Chipps*, 1976, or Blackwell's *Broadway*, 1982. Estes's *Café Express*, 1975, showing a view from within a cafe out of the window on to the street is also a link that comes to mind, but this is a misleading thread as Edward Hopper's cafe scene *Chop Suey*, 1929, and *Tables for Ladies*, 1930, provide equally relevant influence on Head, both in terms of subject matter and its treatment – at which point we might just as easily cite August Macke, with his *Hat Shop*, 1913. Indeed, the Impressionists and Post-Impressionists dealt with cafe scenes regularly, such as van Gogh's *Café Terrace*, 1888, and the subject had even older origins, particularly within the realist canon, stretching back to the paintings of David Teniers in seventeenth-century Holland. Some of these historic influences can be seen as part of the environment of art, informing the whole art scene rather than providing specific or direct influence. Others are direct, however, so that while it might be obvious that Head would have an interest in the work of Estes, and possibly Hopper, it is worth noting that as a student he also made an in-depth study of seventeenth-century Dutch art, travelling around Holland extensively to visit both the metropolitan and provincial museums there. Perhaps on this trip he saw van Gogh's *Café Terrace*,[75] a painting that arguably informed one of his early works,

called *The Night Café*, 1991 (Plate 37), which seems to take on some of van Gogh's colouring and surface texture. But with this painting we can also bring possible influence from closer to home for Head, by recognising a connection to the Neo-Realism of Camden Town Group painters like Ginner and Gilman. When looking at Head's *The Night Café*, Ginner's *The Café Royal*, 1911, and Gilman's *An Eating House*, 1913 (Plate 38), spring to mind, not only in the way that colour is used and paint applied, but in the way space is defined, an important feature given the significance of redefining space in Head's later coffee shop paintings.

Yet the threads that lead to Head's coffee shop paintings are not entirely from other painters of cafe scenes, or even earlier work by Head showing coffee shops. The importance of figures in these paintings is something that has been apparent in Head's work for a number of years, and even links these works to other series, such as those of railway stations. The ordinariness of a figure seated in a coffee shop has a parallel in the ordinariness of the seated female figure on the platform in *Sloane Square*, 2000 (Plate 64). So does her apparent isolation, a feature that has only recently been broken in the coffee shop series with the painting of *Coffee at the Cottage Delight*. In any future survey, concentrating solely on the coffee shop series, it would probably also be sensible to include Head's *Cliff Lift*, 2006 (Plates 40 and 84), which shows the interior of one of the funicular railway carriages which carry people up the steep cliffs in Scarborough, and in which two female figures, a seated older lady and a young girl, look out over a wide angle view of the sea. Head has described the picture as a 'painting of the figures', but it is one which, 'defies classification as a genre painting or a portrait'.[76] The same could be said of many of the coffee shop paintings, most of which preserve the anonymity of the figures, unless one knows who Head's sitters are, such as his wife (in *Trafalgar*), his regular model Bryony (in *Piccadilly*) and myself (in *Coffee at the Cottage Delight*). This is aside from the rare exceptions

37. Clive Head, *The Night Cafe*, 1991

Oil on canvas
71 × 35.5 cm
(28 × 14 in)
Private collection

38. Harold Gilman, *An Eating House*,
c.1913–1914

Oil on canvas
57.2 × 74.9 cm
(22 ½ × 29 ½ in)
Image © Sheffield Galleries and Museums
Trust/Bridgeman Art Library

facing page: 39. Clive
Head, detail, *Sloane
Square*, 2000

Oil on canvas
112 × 183 cm
(44 ⅛ × 72 in)
Private collection

of named sitters, such as *Rebekah* and *Coffee with Armin*. Most other figures are genuinely anonymous in all of Head's paintings, and yet the intensity of the portrait as a genre in painting is clearly something that interests him, and he has made a small number of direct portraits of his family and friends that explore this idea, such as *Cliff Lift*. In this we see two highly intimate portraits, derived from painting directly from the models, and the intensity of these images seems to prefigure paintings like *Piccadilly* and *Rebekah*. Head shuns, to the point of exasperation, the narrative readings of his work that this type of image seems to elicit, and similarly rejects the idea of supposedly non-conscious narratives influencing his work. But he acknowledges that he is working within an art historical and cultural tradition. If the two portraits of his children indicate that Head is revisiting Gwen John's work – as has been suggested[77] – or they demonstrate that he is drawing water from a deep Anglo-American well of images in art and literature,[78] then it is indicative of a specific cultural identity, not a specific narration, and this is something that Head

certainly recognises. Writing to a German art collector in 2008 he stated:

> Painting is a means to understand and establish the aesthetic identity of the individual, and it is also a quest to find some kind of universal expression of a personal experience. [My] roots are in the English landscape, but I have an interest in the directness of American realism, rather than the more discreet English traditions of the twentieth century. I am far more comfortable with the older traditions of Western painting because they are closer to my origins.[79]

It is in this statement that we see what is probably one of the least known about aspects of Head's history as a painter. Although his work as a landscape artist (in which I include cityscapes) is most familiar to people now, it was not an unbroken line between the realist landscape paintings he made in the 1980s and early 1990s and those he has been producing since the late 1990s. In the middle of this Head made a series of very large scale figure paintings, such as *Lay Martyr*, 1995 (Plate 41), based loosely on the

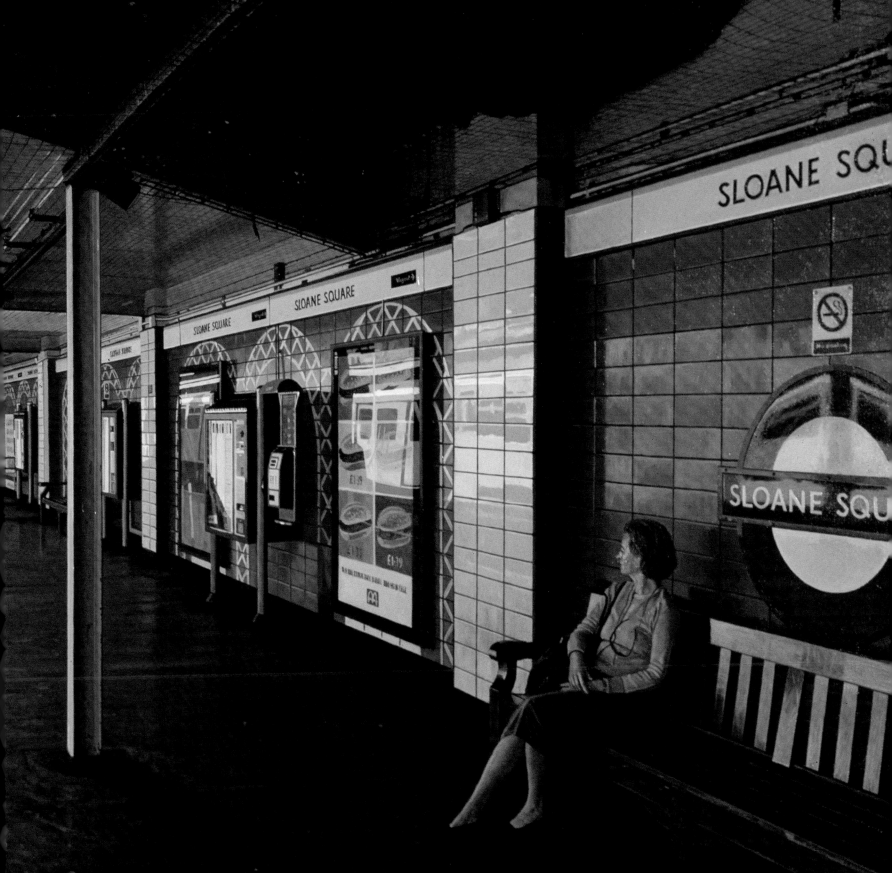

classical paintings of the seventeenth and eighteenth centuries, but notably without any explicit narrative. At the time, I remember, we tended to view these highly wrought works as 'post-modern' in the sense that the narrative meaning of a religious painting by Caravaggio, or a mythological one by Poussin, is probably unknown by the average viewer today, and so Head was simply creating modern classical paintings in which the unknown narrative was built into the image.[80] But what seems more likely, in the light of how he abandoned this type of painting in favour of realism in the late 1990s, is that Head was exploring the boundaries of non-narrative painting *per se*, not as a clever post-modern statement, but as a fundamental aesthetic position. Non-narrative classical paintings gave way to non-narrative realist paintings, but what emerged from this classical period was surely a recognition by Head that lacking a narrative is not the same as lacking psychological intensity. Perhaps we should call this 'aesthetic intensity', although it is clearly not the same as the aesthetic intensity of Roger Fry's concept of significant form, or Clement Greenberg's formalism, each of which led to dehumanised abstraction in art. Rather it is located in the humanity of Head's paintings, and part of that humanity is the human presence in the work. The figures, female or male, in Head's coffee shop series are not portraits in the strictest sense, as that would imply a narrative of identity. Nor are they symbolic signifiers. They are best thought of as intense human presences offering the viewer a route through which to empathise themselves into the paintings.

In this we see an important aspect of Head's work that is particularly evident in the coffee shop pictures. In their humanity the paintings want viewers to engage with them, to empathise themselves into them, and engage with the physicality of the paint and canvas, and the materiality of the organisation of colour, tone and form, and the illusion of the image itself. It is that humanity that leads Head, as an essential Cubist, to reject

the alienating shattered image of the Analytical Cubists and reintegrate the scene, in spite of its extraordinary shifts of view. It is to create what Herbert Read called the 'reconciling image', an image that defines the function of art as a reconciling force for humanity.[81] The aesthetic or psychological intensity of the female figures in *Piccadilly* and *Rebekah* is like a portrait in its concentration, but it is set against a wide opening out of space in every direction, not in the manner of a jarring Cubist dissection, but as an integrated whole, more like a refreshing Claudian vista. In Head's work the city is an optimistic space inhabited by people. As such people viewing that space can enter into it by empathising with it.

above: 41. Clive Head,
Lay Martyr, 1995

Oil on canvas
216 × 118 cm
(85 × 74 in)
Collection of the artist

facing page: 40. Clive
Head, detail, *Cliff Lift*,
2006

Oil on canvas
109.2 × 132 cm
(43 × 52 in)
Private collection

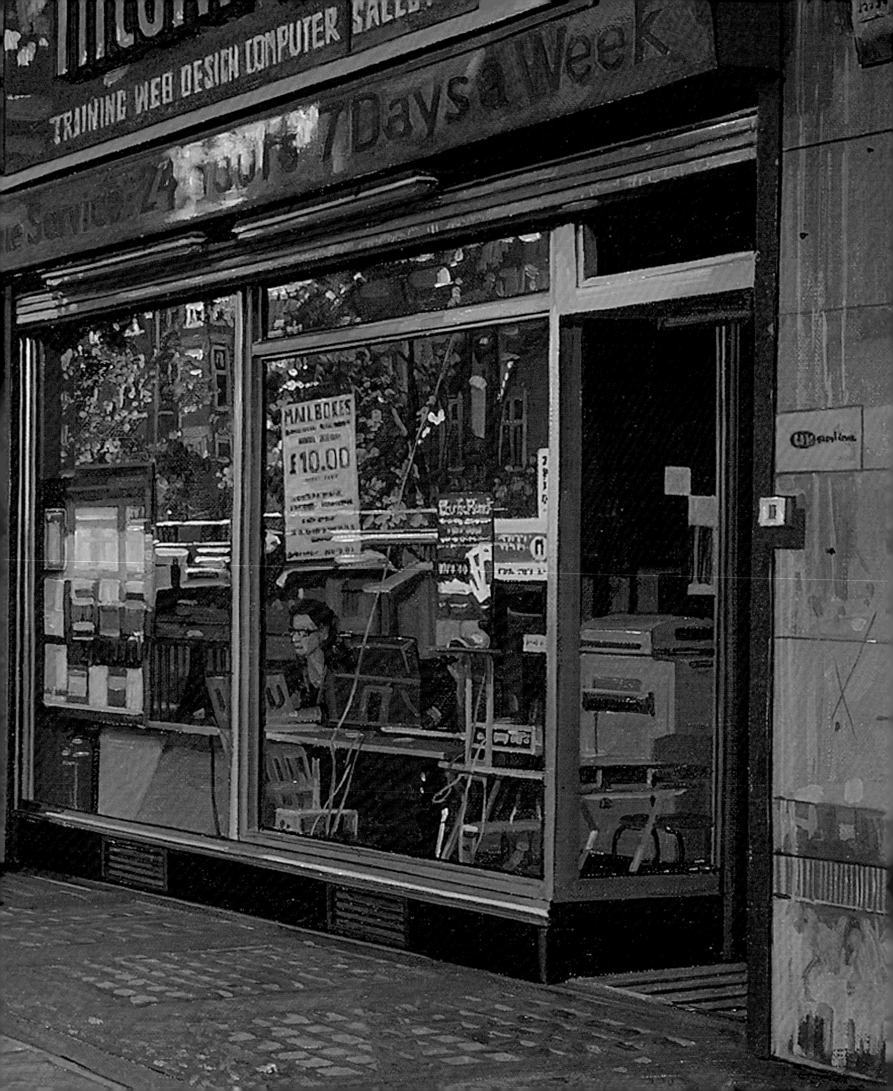

Chapter Three

Hidden Harmonies

Standing in front of Nicholas Poussin's *The Adoration of the Golden Calf* (Plate 43) in London's National Gallery, Clive Head is perplexed.[82] This is not due to Poussin's painting, but the inexplicable fact, as Head sees it, that so many people seem to find Poussin a difficult artist. Before the major show in 1995, at the Royal Academy, there was a very common feeling that Poussin was too 'difficult and cerebral' an artist for modern audiences,[83] and, given the relatively deserted room full of Poussins we found ourselves in during Christmas week, the idea that Poussin is not an artist with mass appeal has not completely gone away. But Head is still perplexed. 'Surely these are very generous images', he suggests. 'They are very clear paintings, full of beautiful rhythms and warm colours.' I confess that I too once found Poussin a difficult artist, and as a teenager would prefer the painter with whom Poussin is often paired in art historical studies, Claude Lorrain. I suggest initially that it takes a little maturity to appreciate Poussin, whereas the fresh colours and blue skies of Claude are always going to be attractive to a broader audience. I am not sure Head believes me, and I have to admit that I feel something of a rebuke for my teenage self, now long past being around to defend himself, at what could be perceived as shallowness. My justification for once preferring Claude over Poussin must have sounded like little more than saying it is because I like the colour blue.

But that was not what I meant, and as we discuss the Poussin problem further a startling revelation occurs. I suggest that Claude's landscapes seem to offer a much fuller escape from this world into the alternative reality of the painting, whereas Poussin's figures always seem trapped in some way, almost as though they are in a box. For a teenager dreaming of escape, the distant mountains in a Claude are always going to be more appealing than a shallow box. I suggest that in a Claude escape is always to the distant mountain over there. In a Poussin it is into the box over here. 'But Poussin is probably one of the most uncompromising artists there is when it comes to creating an alternative reality,' Head states. 'Whereas most good painters acknowledge the picture plane as a barrier between this world and the alternative reality they are creating, Poussin goes much further. He uses colour and tone to push his reality away from our reality by *painting* a picture plane in the shadow of the physical picture plane, the actual surface of the canvas. I'd call this a shadow plane space. This is less apparent in Claude, but studying Poussin I'm convinced that he consciously sets up a *second* barrier between our reality and his alternative reality.' I must look confused at this, and ask Head if he means the tendency Poussin has to leave an area of empty space between the picture plane and the figures, almost like the front of a theatre stage. 'No, it's not

42. Clive Head, detail, *Marylebone Road*, 2007

Oil on canvas
114.3 × 132 cm
(45 × 52 in)
Private collection

43. Nicholas Poussin, *The Adoration of the Golden Calf*, before 1634

Oil on canvas
154.3 × 214 cm
(60 ¾ × 84 ¼ in)
Image © The National Gallery, London

the greater difference between their actual colour and their apparent colour.'

This seems clear, but I have to ask what it has to do with Poussin having two picture planes. 'If we translate this into the painted space', Head explains, 'then we first need to acknowledge that the painted space is a different reality to our own and so the pervading light of our reality need not apply to it. The painted space will have its own pervading light, which might resemble the pervading light of our reality, but is inevitably separate from it. So, if we think of the eye being a sort of point zero in our world, at which colour is absolute, then the equivalent point zero in a painting will be the picture plane, the surface of the canvas. That is where vision of the alternative reality begins, so it is like the point at which the eye is set. In the same way a colour moving away from the eye in our world is affected more and more by the pervading light of our world, so a colour moving away from the picture plane in a painting, and appearing to recede into the illusion of depth in that painting, will be affected by the pervading light of the alternative reality of the painted world. You could imagine a colour like cadmium red existing in an absolute state on the surface plane of a painting. At that point the status of that colour would be problematic because its truth is as much to do with its physical existence in our world as it is in the painted reality. It is the point at which it potentially denies the act of transformation into a colour of the painted world. But if it was possible to move that red physically into the fabricated world of the painting, it would take on the pervading light of that fabricated world and its truth would be dependent on its existence within this new world, and not in its appearance in actuality.'

There is a startling logic to this which does take me by surprise. I had never really thought about colour in this way, but it does explain the ability of colour to define space in paintings. If the pervading light of a paint-

about geometry, it's about colour and tonal values', Head insists. 'If we stand on a hill and look out over a landscape we see a scene with a colour range which is conditioned by the pervading light. It doesn't matter whether we are looking at objects that are red or blue or green, they all exist under a pervading light that is unique to that scene. We know this to be true because when we look at distant objects the colour of the pervading light becomes more obvious, often taking on a blue or grey tone. That's aerial perspective, but aerial perspective is really a shorthand way of describing an effect of the pervading light condition. In that pervading light, objects that are near to us appear brighter and might look an intense shade of red or blue or green, but they are still influenced by the same atmosphere as the distant objects. You can think of the eye almost as a point zero where absolute colour exists, at least for the sake of this argument, but as an object moves away from the eye into the landscape it is influenced by the pervading light of the place we are in. For more distant objects, the cumulative colour of the atmosphere accounts for

ing is set, then the affect it has on a colour will determine that colour's position in space. A warm light might enrich a neutral colour in the foreground or create a purple or pink ambience in the distance. A colour that is less affected by the pervading light would appear very close to the surface of the painting, which is to say close to the 'point zero' of the picture plane. There is a genuine logic I have never really grasped before in describing the relationship between the pervading light and the spatial depth of a painting as aerial perspective, because it really is a perspective system, and like the geometry of linear perspective, it defines space in a painting.

'The thing with Poussin', Head continues, 'is that he doesn't accept the zero point as being the physical picture surface. Most artists would recognise the surface as the point at which absolute colour exists, but as I said, absolute colour, and also a full tonal range from the darkest black to the whitest white, encroaches on our material world. The picture plane is a dangerous cusp at which art can falter into reality. Poussin understands this, and he doesn't want his paintings to encroach on our world, so he pushes all the colour and tonal values back, to ensure everything in his paintings exists well inside the alternative reality. There is no ambiguity there, just a conscious decision to create more conventional space on a plane that is behind the surface of the canvas. The zero point will be the colour and tone that you might see in the near distance in another artist's painting, as it will already have been conditioned by the pervading light at that position in the painting, even though it is placed very near the front of the painting. That's why we can say a painting by Poussin starts in the shadow of the physical picture plane.

'And that is why Poussin is one of the most uncompromising artists there is when it comes to creating an alternative reality. The whole thing is to do with painting.

At no point do we have a colour in Poussin that is to do with colour in our world. He doesn't even want to admit to the existence of our world, so he pushes his alternative reality a step away from our world by denying the validity of the physical picture plane as the starting point for the painting.'

Head recognises that most painters have some understanding of this, but he sees a tendency for too many of them to mix their colours with our reality in mind. This makes them try to match colours to our world, so that if they want to paint a post box they will mix post box red paint instead of trying to conceive of how that red post box should look in the pervading light of the painted world they are trying to fabricate. An understanding of that pervading light should lead to a decision to add a set amount of another colour to the post box red depending on the position in depth of that post box in the painting. In the background of the image it would be differently affected by the pervading light from the way it would be affected in the foreground. The lesson Head derives from Poussin is that rather than trying to make paintings in which you are mixing localised colour – which is to say mixing colour as if you work for Royal Mail Engineering and are going to paint actual post boxes – artists need to think of colour in paintings as if they are planes of reflected light. The colour of the post box in a painting will be determined by the temperature and colour of the pervading light of the painted world. In Poussin all colours are set to the pervading light of the alternative reality that he is creating, not the pervading light of our reality.

I must admit I am astounded by this. For some months Head has been talking about the need to address the issue of colour in his paintings. He seems happy that we have come to discuss geometry and line in the creation of space, but colour seems to have become more of a concern, possibly due to its neglect in our previous discussions. 'Everyone picks up on local

colours being repeated in my paintings', Head says. 'But the real colour rhythms are in the more neutral masses that reflect the pervading light. They run through everything, a bit like the colour we see in atmospheric perspective running through every colour we see in the world. All of my colours are conceived as planes of reflected light and not spots of absolute colour. I want pigment to become coloured light in space and to set a temperature and atmosphere that is unique. You should look at Sassoferrato for a completely different light aesthetic to Poussin. Wonderfully cool.'

As we walk away from the Poussins I ask if I can use an analogy to try to understand this. 'You usually do', Head replies. 'Is it', I ask, 'like the difference between a modern colour movie and an old black and white one? At the cinema the usual assumption is that the colour of a film should be as lifelike as possible. We know this is impossible to achieve, but there is usually a presumed desire to make film colour life-like. That colour is always referring back to our reality, our world. But, of course, a movie is not our world. There is a picture plane in the form of the projection screen that stops us physically entering into the reality of the film. Before colour film, however, when movies were black and white, there was a second barrier based on colour values. A film was not just separated from our world by the picture plane of the cinema screen, but by the fact that there was no attempt to make the colour like colour in our reality because in the film's reality there was no colour. Is that what you are saying about Poussin? There is no compromise with the pervading light of our reality, so his paintings are wholly separated from us both by the barrier of the picture plane and a barrier of colour values?' Head is happy with this analogy, but adds: 'The only thing is that a black and white film avoids the issue of colour altogether. The pervading light of that reality is so extreme in its difference to our reality that colour ceases to exist. So I suppose it is the absolute rejection of the colour problem, whereas a painter must work with colour to create an alternative reality that is coloured by light. That is far more difficult, especially when you think we also have to consider tone. Everything we have said about colour applies to the tonal range between black and white. At the picture plane you would have absolute black and absolute white, but if you moved them into the painted world they would be modified by the pervading light of that world. Only at the picture surface can their actuality exist, which is why Poussin tends to narrow the extremities of the range. He neutralises and finds a coloured light for everything, even that which locally might be colourless. Once you move away from the picture plane the whitest white cannot exist in any painting. It must take on an invented colour and tonal value. That invention must be true to the artist's aesthetic identity as much as the unique demands of each painting. Add to that things like the question of geometry, linear space, the articulation of form through the painted mark, and you have both the simplicity and the complexity of painting. Unless you just go and copy a photograph, of course, in which case it's all given to you by a machine.'

All of this is an example of Head pushing the understanding of his work away from being a reflection of our world, our reality, and insisting that it exists wholly independently as an alternative to our world, in the same way that Poussin's paintings are wholly independent of our world. I am struck by the fact that it is Poussin that elicits this discussion given Poussin's pivotal role in Cézanne's understanding of his own work, and by extension Cézanne's position as the father of Cubism. The links between Head's work and this history of art are complex, but they have a discernible pattern, a 'pattern in the carpet' as Herbert Read would have called it, that moves his paintings away from photography and ever further into the history of aesthetic art.

But the question is whether Head also paints his images 'in the shadow of the picture plane'. I am not sure this thought would have even occurred to me had it not been for our conversation in front of the Poussins, but looking at a painting such as *Inverness Terrace*, 2006, (Plate 81) there is something that fits. *Inverness Terrace* is an interesting painting in the way it offers up so many different spaces, and in many ways it is a direct antecedent to Head's current highly complex images, such as *Haymarket*, 2009 (Plate 94), and *Coffee at the Cottage Delight*, 2010 (Plate 95). But that is a connection based on space created through linear perspective or geometry. What we are seeking here is a connection to Poussin through the application of colour and the conception of light. That need not be a direct connection – by which I mean a connection based on Head using the same colour and pervading light as we see in a Poussin – but

it is a connection based on his attitude towards colour and light as a means of defining space in a painting.

In its construction *Inverness Terrace* comprises multiple spaces. Putting it simply, the interior scene, with Head's children, Alexander, Edward, Rachel and Annabel, and his wife Gaynor, on the left, is treated differently in terms of its geometry from the view of the central balcony, and that in turn has a different mathematical structuring to the view in the far distance. All of this has a different perspectival organisation to the vertiginous drop to the street below on the right, a technique Head has developed in other works too, such as *View of London from Buckingham Palace*, 2005 (Plate 75). In *Inverness Terrace*, it is possible to discern many more subtle shifts in the geometrical organisation, but the basic point is made through these few examples. The painting is a convolution of spaces that do not uniformly

44. Clive Head, *Study for View of London from Buckingham Palace*, 2004

Oil on canvas
25.4 × 50.8 cm
(10 × 20 in)
Private collection

adhere to a common perspectival system – if they adhere to one at all. Indeed, in the curvature of some of the lines, Head abandons the horizon altogether, creating objects that have no cogent vanishing point. It is speculation for me to suggest this, but perhaps it is because the mathematical systems that Head uses are so complex that the colour, tone and pervading light systems he employs become so important. This would mean they are not simply important as a means of knitting the painting together, but also tools used to reinforce the sense of space when, at times, the logic of some of the geometry might not do this alone. That is not a suggestion that colour, tone and light are correcting errors, but rather that there is a mutual reinforcing system at play which allows the artist to take even greater liberties with one side of the system – for example, the geometry – provided that this is compensated for by the other side of the system – for example, the pervading light.

Curiously, the painting appears to have two systems of pervading light: the interior apparently lit by yellow artificial light, and the outside by the rose-coloured natural daylight of a bright winter afternoon. It would be tempting to say this is similar to the multiple perspectival systems Head employs, with multiple viewpoints finding a correlation in multiple pervading lights. But this is not the case, and Head is insistent that there can only be one pervading light in a painting if it is to maintain its coherency. In *Inverness Terrace* this is borne out by the fact that the pervading light, linked to that pink tinge, is as apparent in the yellow and cream of the interior space as it is in the balcony and street scene outside. It is there in the sky too, and it is a unifying light that knits together the whole of the painting – the whole universe of the image, so to speak. During the making of *Inverness Terrace* Head acknowledged that there was a deliberate separation of the interior and exterior space, writing: 'The separation of the interior-exterior space will be further emphasised by the

difference in ambient light – warm against the cold wintry light of the urban landscape.' But he also noted that it would be the colour and tone of the pervading light that would get these differences to harmonise: 'The main issue in introducing colour and tone is to try to get the different areas to work together.'[84] In *Inverness Terrace* the figures, the table and the chairs might be seen under the localised conditions of the yellow spotlights, but they are all subjugated to the overall light of the painting, its pervading light. This does not mean they are subsumed into the pervading pink light of the outside scene, as this too will have localised light that is similarly subjugated to the overall pervading light of the painting. In life, for example, the street would have a different light to the balcony or sky, and we can see this in the way that some areas of the painting are in shadow and others in the full light of the sun. Yet each of these localised lights is subjugated to the pervading light of the painting. In effect, we do not simply have the localised colour of objects, such as the purple velvet covering the chairs, or the white Portland stone of the balcony, being modified by the pervading light of the painting. Rather we have the localised light, such as the yellow light of the interior and the highlights and shadows of the exterior, coming under the influence of the overall pervading light of the painting. The diversity of these elements is unified into a single coherent image with the help of a common pervading light that underpins each of them, much as a single law of gravity underpins our understanding of the real world, unifying it into a single coherent experience.

All of this can be seen in Poussin as well as Head, but it is in fact part of the common currency of painting. Walking around the National Gallery, or even galleries of modern art such as Tates Modern and Britain, one is struck by this common element in almost all the painters' work. They all set a pervading light and subjugate all other elements in their painting to that light,

or if they do not they fail to create a fully functioning alternative reality. As Head insists, however, with Poussin we see a shadow picture plane, with the point at which the influence of the pervading light of the painting impacts upon objects depicted being brought forward, so that even at the picture's front edge, its picture plain, the pervading light of the painting has a strong impact. This is not unique to Poussin, but it is an unusually strong trait in his work, and the same appears to be true of Head. The pervading light is already well-established at the point at which Head stations the viewer, so there is no sense that colour or tone is any more absolute at the supposed front of the view than at the back. *Inverness Terrace* is an image that operates in the shadow of the picture plane as the image is already well inside the pervading light conditions of the alternative reality even at the point at which it is closest to our reality. Other paintings by Head seem to show this equally strongly, such as *View of London, Twilight*, 2000 (Plate 65), *Spring Blossom, Geneva*, 2005 (Plate 80), and *Marylebone Road*, 2007 (Plate 85). It is probably a character trait of all his work, but it is made more visible in these images in which the pervading light is pushed most vehemently away from the normality of light in our world. As in Poussin, this seems to be the result of an insistence that those paintings possess an essential otherness to our world.

———————

The problem, according to Head, is that although the essential elements of art are not in themselves difficult to understand, too many people underestimate the profundity of what art can do well, and overestimate the importance of what it cannot do well, or cannot do at all. In Head's own words: 'The act of making a painting is a humble thing really. You learn the techniques, you practice them so as to do them well, and then you hope you possess something special that raises your painting from being just a picture into being a work of art.' Of course, that something special is one of the most difficult elements to pin down. A great art museum like London's National Gallery might be full of images of the Virgin Mary, but we know none of these are great because they show an image of the Virgin. If they were great because of their subject matter they would all be works of genius, as would any representation of the Virgin sold in a church shop, or even the badly printed images of the Virgin often handed out at her shrines. But the fact is, even within the great art galleries of the world, some images of the Virgin are greater than others, and some are not great at all. That is to make a value judgement, as opposed to expressing an opinion. Some of the artists who created these images possessed that something special of which Head speaks, not every time they painted, perhaps, but certainly sometimes. And in every case the quality of the paintings as works of art lies outside of their subject matter. As Head states:

> Subject-matter is, to a degree, to be encountered by chance, factors in the world that we have no control over (a car blocks our view so we move on, etc.). We find ourselves in this place, that place, this city, this country, with these people, etc. We make the subject profound, but I have always been doubtful of emphasising too much the politics of the subject matter itself. The essence of any painting lies in the vision, the artistry of the individual. In the past subject matter was largely pre-given. Though I would not dismiss the importance of subject matter, we have to look through it in recognition of the power of the creative self. The one thing that remains constant in our haphazard relationship with the world is our aesthetic constancy.[85]

As this suggests, what that something else is that turns a painting into a work of art is not straightforward to pin down as a formula, but it is not preternatural or

necessarily even mysterious. 'If you look at Auerbach', Head says, 'you see him faced with a visual problem. It might be the relationship of a tree to a building or the way a person is sitting in a chair. There is nothing remarkable about the subject matter in an Auerbach, it is all simply a visual problem. López is the same. Both artists are faced with having to solve that problem, and their tools are their technical knowledge, their experience and their materials.'[86] Set out this way the problem, and the need to find a solution, seems almost to resemble a mathematical problem, with the only possible difference being the emphasis placed on the materials in finding that solution. Even in this, however, some mathematicians will side with Head and see a need to engage with physical and material elements – things which we might call aesthetic elements – in order to arrive at what can seem to an outsider a highly abstract and immaterial solution. Certainly the great mathematician and physicist Paul Dirac placed significant emphasis on the importance of considering the aesthetics of mathematical formulae,[87] whilst Phil Beadle has written on the superiority of the chalk and blackboard over digital screens in classrooms because of the physical engagement they allow with the material world, even as abstract ideas are being explored:

> [When I am] scribing arrows outlining connections between ideas, I want to be able to do it quickly: as quick as I think; as quick as I talk. I want to be able to teach with my whole body, use gesture, employ pause to illustrate nuance, become as one with the board; become, in those rare moments of flow, both dancer and dance. Now the board dictates that, rather than pirouette, twist and enthuse, I click a frigid button.[88]

As an artist who used to make great use of a blackboard in his own studio teaching, even smuggling one back into a university after their use had been officially banned on health and safety grounds, I am sure Head would agree. But whatever the case, the problems of art faced by painters like Auerbach, López and Head, and their solutions, do not rely on artists beings visited by divine spirits, or being mentally unbalanced, or even possessing strange habits like having to paint only during the hours of darkness. It is far more materialistic, and in a sense mundane, than that. Art is essentially a material activity, and the solution to the visual problems faced by the artist are material in nature. 'For a painter', Head says, 'the solution to the problem does not start with thinking I need to create an alternative reality. It starts with drawing a line or mixing a colour, and that leads to an alternative reality. If it happens any other way it is just another form of conceptualism, illustrating the idea of an alternative reality rather than creating one.'[89]

In Auerbach's case the painting process is convoluted, often involving painting an image, scraping it back and then repainting it, all repeated over a long period of time. At some point the artist stops and the work is in some sense finished, or the solution to the problem found. Head cites Estes in this context, noting that Estes once told him that he will be painting an image until he hears it click. Possibly Estes meant this in a metaphorical way, but when Head retells the story you get a real sense that it is almost an audible click in the studio, and that he has heard it too. However, one has to be careful of taking the analogies of artists too literally. I think it was Picasso who once said that he knew that a painting was finished when adding one more mark to it, or taking a mark away, would ruin it. It was the same point being made by Estes with his click, but Picasso's description has been turned into a clichéd assumption that a work of art can be perfect. It cannot. If it could be perfect then the artist would stop painting because he or she would have found the solution to the visual problem. As Head says, 'In some ways I am painting the same picture over and over again. The paintings get

more complex because I realise the solution to the problem is more complex, not because I want to show off some kind of technical skill.'[90] Painting the same picture over and over again is a recognition that no painting is ever perfect. It is only ever a provisional result, a provisional solution. There is no static point in the way suggested by the idea that adding or taking away a mark would ruin perfection. The painting simply clicks when it is functioning as a viable alternative reality at the best level at which that painting can function. As Head would probably say, when it is functioning as credible space.

So what does click when Head is painting in his studio? Pushed on this Head suggests it is a question of the world created within the space of the painting working, or functioning. It is a point at which the humility of the artist starts to break down. Artists are certainly not seen by Head as ordinary, as they are capable of bringing new realities into existence. That makes the artist extraordinary. Related to this is some advice Head gave me on what I should say to a group of art students that I am to give a talk to on the New Aesthetics. He suggests offering them two options. 'Ask them', he says, 'do they want to be mere illustrators, taking bits of this world and representing them back at people? Or do they want to be gods who each get to create their own universes?'[91] The analogy is appropriate. A painter can illustrate a political point, or a photograph, or a philosophy. They can illustrate their own life, or indeed an emotion. But none of this will be art. It will be concept-illustration. Alternatively, a painter can create a unique universe. As astronomers will tell you, even our universe is not infinite, and like our universe the painter's universe does not go on forever. It has a boundary beyond which there is nothing. In painting the boundary is the edge of the canvas, or the frame; but it is also the picture plane at the front. Beyond these edges there is nothing. Everything that exists within the painted universe must

do so within that frame. Discussing this with Head, he agrees that this is a fact lost on those artists and students who drill holes in their canvasses, or tear them, or make the painting spill out beyond the picture frame. At that point there is a failure of art. Visiting Nick Hornby's intervention in a display of School of London paintings at Tate Britain recently Head was vehement in his opposition to a line from a painting by Matthew Smith being extended up the wall of the gallery. On the opposite wall a painting by Francis Bacon, called *Study for a Portrait of Van Gogh IV*, had also been extended onto the wall surrounding the image. Commenting on this Head noted: 'Just as a poem is not complete until it is read, a painting cannot function until it is seen. It asks for very little, but to deny it a simple wall to hang upon, and a space for the viewer to enter it (without the distraction of surrounding detritus), it will remain just an object, like all the other objects that clutter up our lives.'[92] And, in private, he has told me: 'It's like your analogy between painting and plumbing. What if we leave the water to leak from the pipes? What if we fail to connect them properly? All of that could happen if we ask the wrong questions of the plumber, and we wouldn't end up with a bathroom that works, or a Versailles that amazes us. We would end up with leaks and floods and the whole thing failing to work. It would be dysfunctional.'[93]

Assuming that the answer from my students to Head's question is that they want to create (like gods) and not illustrate (like Hornbys) then we have the answer to the question of the click. The universe that is created by the artist has its own internal logic and its own components that have to co-exist. That co-existence is what we mean in art when we talk of harmony. In a similar way, our universe works through the harmonious co-existence of its internal logic. At one time scientists would even have referred to this co-existence as harmony, although now they tend to talk of the laws of physics.

Whatever the laws of a painted universe, even if they are fantastical and wholly different from the laws that govern our universe, they must possess an internal logic or harmony to function. Without that the painting will fail to persuade the viewer that it is a valid universe. It will be stillborn, a dead thing. With that logic, however, the painted universe will function. It will possess its own life, and the moment that the painted universe achieves functionality is the moment of the click. For the viewer, the click is the moment at which we can believe in the validity of what the artist has created, not as an illustration of an idea, or concept, or emotion in our world, but as something that is independent in its reality. The click is a shared moment between the artist and the viewer, or, as Head puts it, it is the moment when we have to distinguish between art and life. 'The artist and the viewer are equally of this world but they must share a faith that the truth of art exists independently of our mundane reality.'[94] In more forthright tones, Head warns of the consequences of failing to establish this independence, writing on the work of another painter that:

> Of course he introduces a bit of school boy fantasy in the form of pornographic imagery (all British artists do this) but the seediness of his vision is less to do with his adolescent fantasies than his abandonment of space and light. His work is just part of this world. Without space, it has no necessity to create order and no means of escape for the viewer to enter into an alternative realm.[95]

It is often said that the problem with Dante's *Divine Comedy* is that Hell is full of excitement and passion, but Heaven is just a bit – well – boring. Art might not be about subject matter, but subject matter is a motivating force for artists, and while some artists are motivated by vases and teapots, others need something a little more dramatic to prick their interest. As a result, artists have tended to eschew Dante's Heaven and look instead to his Hell for inspiration.

At first sight this idea seems to fly in the face of art being concerned with harmony. There was nothing harmonious in Hornby's extensions to existing artworks at Tate Britain; nor is there harmony in the school boy porn fantasies of weak artists trying to pep up their dull work; and there are likely to be precious few comfortable armchairs waiting for us when we get to Hell. It all starts to suggest that art is not concerned with harmony at all, but with its diabolical equivalent, discord. Yet, for Dante, who was a great artist after all, Heaven was meant to be preferable to Hell because it was harmonious. In this there is the artist's dilemma – too much harmony is undeniably dull. In seeking to create a universe that functions, which is to say, a universe that clicks, an artist needs to establish a coherent harmony between the diverse elements of that universe, but, as Dante shows, a viewer's interest cannot be sustained by harmony alone. As Dante knew and practiced, there is also a need for the potential of chaos.

'I think chaos is the wrong word', Head tells me. 'You are right, there is a force pulling against the excess of harmony, but art cannot be chaotic. If it is then it stops being art.'[96] His preferred term is 'difference', so that if harmony is the ironing out of the differences between the objects depicted, allowing universal laws to be applied to each in turn, difference is the establishment of the individuality of each object, giving it an existence that is unique to it and which does not apply to anything else.

These two elements appear to be at work in *Coffee at the Cottage Delight* (Plates 45 and 95) in which various forces combine to create a harmonious universe, but there are elements which push the credibility of the scene to its limits. As we have seen, the pervading light of a painting is a harmonising factor in Head's work,

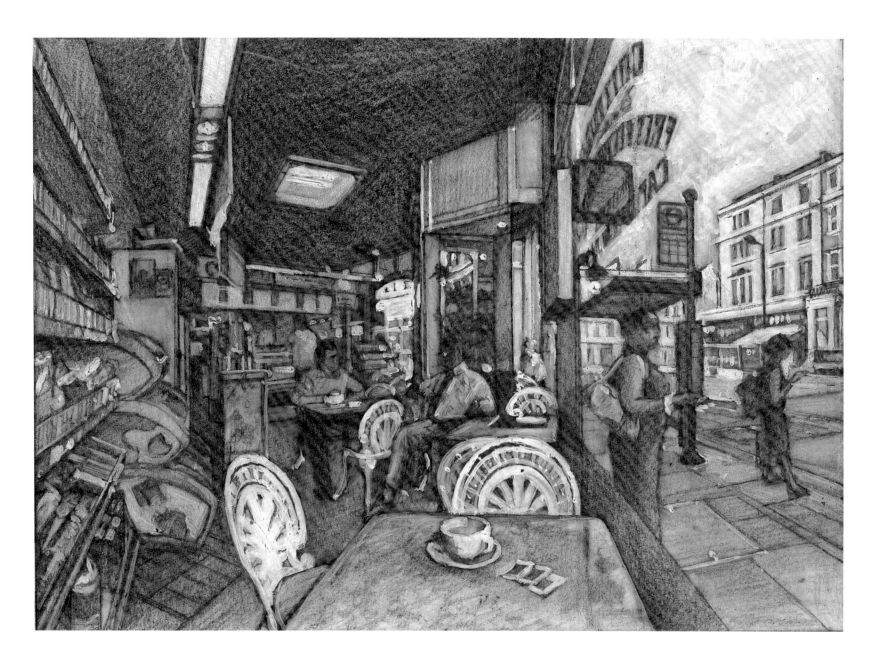

possibly one of the strongest. But alongside this we can identify more overt colour rhythms that run through the images. In this painting the blue of the shirts of the two men clearly harmonise, and this is then picked up by the blue of the dress of the woman outside. The subtlety of this type of colour rhythm should not be underestimated, as careful observation will see touches of the same blue, albeit with different tonal values, used elsewhere, sometimes in places where one would not expect blue in real life. Look closely and you will see it is there in the first two windows of the National Westminster Bank, in the background of the scene. For the most part, however, this type of colour rhythm is open and explicit, creating overt relationships between different parts of the painting. But, alongside these elements there is the establishment of difference. In *Coffee at the Cottage Delight* there are elements, like human figures, their clothes, the asphalt of the road, the plastic

45. Clive Head, *Drawing for Coffee at the Cottage Delight*, 2009

Pencil on paper
12.1 × 17.2 cm
(4 ¾ × 6 ¾ in)
Collection of the artist

fixtures and fittings of the cafe, and so on, that possess their own individual identity. The aim is not to replicate in paint the actual look of each of these, but there is a desire to make clear the individual identity of each of them. In the same way that a metal chair in our universe has a different physical characteristic – or a different presence – to human flesh, so a painted metal chair in a painted universe has to have the same level of difference to painted human flesh. In part that difference is achieved through colour and tone, but it is also achieved through the modulation of the paint (Plate 46). There are subtle changes in the way paint is handled as a material thing and the way it is applied to the physical surface of the canvas. Head calls these differences in the application of paint the 'hierarchy of paint'. 'We don't experience life as if everything we see in the world is made of the same substance and has the same physical properties. It is all different.' This is a major problem with painters who simply copy photographs. 'The photograph is inadequate for telling you about these physical differences. A photograph cannot tell you how a hand is different from a cup, or a table, because in a photograph they are not different. It is the same flat dye on flat paper, all the same thickness and all without any physical presence.'[97] In Head's work paint is recognised as a physical medium, and it is through that physicality of paint that Head defines the individuality of different things. As soon as you recognise that this difference exists – that a hand is not a chair – then you are forced as a viewer to accept that the hand and chair must occupy different spaces. In Head's words:

> Whereas a lot of realists tend to downplay the significance of the material surface, and see painting as a form of imaging, over the years I have selected certain tools to create very particular *painted* outcomes. I consciously reject any tools that negate the painted surface, such as an airbrush, but also conventional

brushes that do not allow a definite, directional mark. It is these marks that are the building blocks of the painted world, tiny planes of reflected light. Taking [sic] care of the painting at this level and the construction of credible form in space will be reinforced.[98]

This was not always the case with Head's working method and, as he admits himself, he did at one time blend the surface, destroying the individuality of the painted marks. The move towards a recognition that painting is the painted mark is evident in the change in materials Head uses, with the titanium white he once preferred for its uniform consistency (which allowed easy blending), giving way to flake white now, a pigment that, 'reinforces the density of the mark'. That said, he still rejects a common idea, seen in the work of artists like Peter Doig, that there is any value in 'marks for marks' sake', but the point to which he has come now with his work is a recognition that across a canvas every object is defined individually, which is to say, its difference is established, and so the whole painting must comprise different spaces to allow each of these objects to exist. By differentiating objects in a physical and material way through the mark-making the artist has, in effect, another way of creating a sense of space in the painting. In a photograph two objects can occupy the same space because physically those objects have no individual form; but in a painting the physicality of the paint forces objects into a spatial relationship with each other, and they cannot occupy the same space in the same way that two individually separate objects in our world cannot occupy the same space. This means that we can see space opening out in the canvas as we respond visually to physical differences. In *Coffee at the Cottage Delight* the leg of the central figure must be in front of the chair back not simply because that leg covers part of the chair, or it is a different colour, but because the trouser-covered leg and the chair have

46. Clive Head, actual size detail, *Coffee at the Cottage Delight*, 2010

Oil on canvas
167 × 238.2 cm
(65 ¼ × 93 ¾ in)
Private collection

different physical properties. These are manifest in the painting by different qualities in the painted brush mark, and that difference forces each to have an individual identity that prevents us from seeing them as occupying the same space. This means there must be space between that leg and that chair, and suddenly the canvas is not simply a flat surface, but a universe expanding at an event horizon, which is to say the point at which one reality gives way to another, and that new reality is defined by the physical relationships between the objects depicted. Head would take this point even further, out of the macro level of a leg in front of a chair, or a hand on top of a cup, into a micro level whereby each brush mark is defined in space as being in front of, behind, or in line with every other brush mark.

The establishment of difference pulls partly away from the harmonising elements in the painting, not toward chaos, as Head rightly says, but toward an individual identity. To use another analogy, if you want to harmonise with a group of football supporters then you wear the same team colours. If you want to establish an individual identity you wear something else. Except we are not really talking about colour here, but physical presence. This can be a dangerous strategy, of course, as harmony establishes cohesion, difference undermines it. Nonetheless, a level of differentiation pushed to the limits of its acceptability adds excitement to an image – adds what used to be called in old art schools 'tension', and as such it moves us a little closer to the thrill of Dante's Hell, and away from the potentially stultifying effect of the excessive harmony of Heaven.

———————

For Head, the painting process begins with a physical experience in the material world, that is a physical experience in actuality. It is necessary to understand this initial experience as from it emerges the motivating force to make the painting. Yet the resulting painting will be outside of actuality – it will be a separate universe of its own. That universe will be a reality, and be derived from an experience in our actuality, but it is not the same as our actuality. In art, realism is always divided from actuality, which is to say our reality, by the barrier of the picture plane. From that experience of actuality the painting grows, so that the answer to the question often asked of Head – how do you begin your paintings? – is simply that the painting begins with an experience in actuality.

If we expand that, what we mean is that a painting begins as an experience of place. According to Head his selection of a place is never predetermined and almost always instinctive. Although in the past he has undertaken commissions, and collaborated in projects with other artists in which they have worked on common themes these are increasingly rare. 'I do need to feel my own connection to a place and not have it imposed on me', he says. 'I even had problems when a friend heard I was going to Zurich for a commission and started suggesting some places I could paint. I knew I didn't want to paint any of his suggestions. It wasn't that they were not good suggestions, it was simply that I don't want to paint someone else's images.'[99]

Despite this vehemence, the decision to select one place and not another can seem an almost sedate process. 'When I was at the start of the painting *Piccadilly*', Head says, 'I went to London with an artist friend of mine. We had a coffee together and then went our separate ways trying to find something to paint. My friend ended up wandering around London all day looking for the perfect picture, and eventually came back to the cafe a bit dejected saying he couldn't find anything to paint. I had just stayed in the same cafe all day and that is what I painted.' The point of this story is not that Head is undiscerning in what he chooses to paint, or that he is lucky in having found his subject so

quickly. Head's experience of the cafe became his subject matter through his physical engagement with it. As this suggests, subject matter is not something out there that the artist has to find; rather the artist engages with a bit of the world and that engagement becomes the subject matter that motivates the creation of a work of art. That said, there are some conscious, or at least semi-conscious, decisions in the selection of subject matter. Head's work has always orientated towards a limited number of themes, including coffee shop scenes like *Trafalgar*, 2007 (Plate 86). But often it is the ordinariness of these places that makes them suitable for painting. 'I am not a kitchen sink painter', Head says. 'So I am not interested in dull and down at heel subject matter just because it is dull and down at heel.'[100] What he likes is the way everyday places like cafes have a kind of anonymity about them. A Nero coffee shop could almost be anywhere, and even when Head paints in popular tourist areas he does not show what the tourists want to see. In the painting *Haymarket* there is a representation of the little statue of Eros, but the painting is not the over-reproduced image of Piccadilly Circus that everyone else photographs. Even Piccadilly Circus is made almost anonymous. 'This allows me the space to explore what I am really interested in', Head says, 'without over familiar things getting in the way.'[101]

From the initial experience, during which Head might draw, photograph and even map out, in what are almost abstract sketches, the overall composition of a painting, a drawing will be created. In some ways a much older name for drawing – a cartoon – is appropriate here as Head's drawing is not an independent artwork and it is not a finished product in its own right. It is more like a stage post in the process of making the painting, and as such is part of an evolving and organic process that leads towards the click that indicates the fact that the painting functions. It is important to stress

this as it is a significant difference between Head's method and that of many contemporary realists. Some realists will argue that they use the photograph as if it is a drawing medium, as though a camera is an easy sketch book. But using photography in this way runs the risk of denying the role of evolution in the progress of the painting. As we have seen, Head does not end up with a photograph that he copies, but he does go through a series of drawing processes that allow the painting to evolve into its final form. Some of those drawing processes do include the use of photographs, but the transfer is never direct. The same applies to the drawing. Even when Head works up a drawing into something that might seem similar to the finished painting, and begins plotting its main elements on to the final canvas, the drawing changes partly to take account of the organic relationship between the artist and the physical materials he is using, and partly in recognition of the fact that in trying to establish credible space modifications might be necessary. Art is never about coming up with an idea and then making it, just as it is never about having a finished image, like a photograph or even a drawing, and then copying it. Even when an idea or a pre-existing image exists, the art itself evolves from the experience of making the artwork.

The remarkable feature of Head's drawings and photographs is not that there are so many of them – sometimes over 100 – but that they offer almost no clue as to how to solve the problem of organising the image (Plate 47). Head's drawings are the first stage of a process that aims to try to solve this problem. A good example of this is the coffee cup in the front of *Coffee at the Cottage Delight*. There are a series of photographs that Head took that show this cup sitting on the table, but there is no overall view that shows the coffee cup in relation to the two figures seated in the middle distance, or the woman standing outside the window.

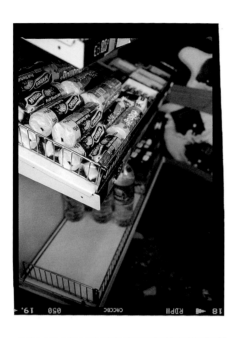

47. Small selection of transparancies for
Coffee at the Cottage Delight, 2010

There could not be as the spaces between these three elements – coffee cup, seated figures and woman outside – would be too great for any camera to cope with. What Head has instead is a series of images of the coffee cup that he has to place in space. What we should say is that he has to establish the existence of the coffee cup in the painting to ensure its space is credible. Even at the time of my visit to his studio, during the production of *Coffee at the Cottage Delight*, the problem of establishing the coffee cup in space was proving difficult to resolve. It was, at that time, without a solution. As Head pointed out, the coffee cup is so close to the front of the picture, compared with the figures, that if you painted it using standard perspective it would look ridiculously large, like something from *Alice in Wonderland*. So a standard solution, like classical linear perspective, is not available. Like a mathematician, Head

has instead to find a new and unique solution, a new and unique formula, to solve this particular problem.

It is worth noting how markedly Head's methods have changed over the years, as his is a developing process of art, not a formula or dogma. Previously he would almost invariably produce a small scale colour sketch of the image in acrylic paint on paper, between the drawing stage and the canvas stage, and on some occasions there would even be a colour oil study, as with *Tudor City*, 2002 (Plate 49). This stopped, however, when he realised that the colour sketch was anticipating solutions to the problem of the image that needed to be resolved on the canvas. Effectively, the colour sketch was in danger of becoming a pre-existing image that was, at least in part, being copied onto the canvas, rather than allowing Head and the canvas to work out their own solutions thrown up by the need to render conceivable

48. Clive Head, *Study for 42nd Street Sunday Morning*, 2001

Acrylic on paper
56 × 76 cm
(22 × 29 ⅞ in)
Private collection

49. Clive Head, *Study for Tudor City*, 2002

Oil on canvas
31.1 × 45.7 cm
(12 ¼ × 18 in)
Private collection

space. With the pencil drawing, however, this is not seen as a problem. Even when a small scale drawn version of something that looks like it will be the final painting is created, that is not the end of the evolution. In fact, the process of working all the elements out seems to begin again, this time taking account of the increased scale of the canvas compared to the small scale of the drawing, and those points at which Head recognises his solutions in the drawing will not work on the canvas. For this reason only the basic elements of the small scale drawing are plotted onto the canvas with the aim of simply establishing the co-ordinates of the main features. Once this is done Head will start to create a detailed drawing, or cartoon, on the canvas. He will do this freehand. This is a fact that many people find astonishing as it is the most direct rejection of the methods of almost all other realists working today. While most current realists will either grid up with squares a final photograph, or photomontage, and copy the detail from this, square-by-square, to the canvas, or project a final photograph, or

photomontage, onto the canvas, using a projector or epidiascope, tracing the projected image, Head eschews this type of short cut. 'You cannot do what I do using that method', he says. 'You just look at what other people do when they take short cuts. The paintings don't function.'[102]

Head appears to be genuinely bemused by the fact that other artists are astonished that he can draw his images freehand. 'Artists have always done this', he says. 'The problem is the skill level of most artists is now so low that someone being able to draw looks like magic to them. And then you get people like David Hockney trying to persuade everyone that artists could never draw and always used *camerae obscuras* and the like.' Head also points out that there are other realist artists who can, and do, draw freehand, such as López and Lewis Chamberlain. 'The drawing process is important as it is not about putting down lines that you then fill in. This isn't painting by numbers. Drawing is the first step in establishing space in a painting. With a drawn line

you have the definite edge of a plane which you have to decide is in front of another plane or behind it.'[103]

The drawing process in Head's work is astonishing to see, and extremely complex and it is clear that a great deal of the organisation of the painting is worked out at this stage. It involves a mixture of mathematical calculation and intuition. Head will get through many dozens of scraps of paper, on which he will literally work out the mathematics of angles and identify vanishing points. But it also involves a huge number of erasers as the mathematical answer is not always the correct one to allow him to establish credible space. A mathematically correct angle leading to a vanishing point is not necessarily a visually correct one, and so it might be altered or discarded to make a line finish, not at a vanishing point, but instead in what Head calls a 'vanishing zone'. In his words this is closer to the way we experience the actuality of the world:

> Classical perspective is based on people standing on a fixed point with one eye closed. That is why it works so well with a camera which takes a picture from a fixed point and only has one 'eye'. But most people have two eyes and they do not stand still. This means when we see the lines of a building or road receding into the distance they cannot meet at a single fixed point, because we are not in a single fixed point. The camera lies about this. They disappear into a general area, a vanishing zone.[104]

Curiously mathematicians acknowledge this, with the vanishing point now generally referred to in mathematics as the 'zone of infinity'. This might sound like a prison camp in a science fiction film, but it is simply a realisation that despite the idea of receding lines meeting at a vanishing point, the lines never really do meet – or at least they do not meet until they reach infinity. Head's vanishing zone is slightly different, however, in that it is not based on a mathematical rule that says receding lines never meet, but on how we experience the world as human beings. Head would probably say that what is even more important is that the systems he uses establish the most credible space possible in a painting. If that means deviating from classical formal structures underpinned by mathematics, it does not mean ditching mathematics altogether. It simply means that for a particular painting a new formulation of the mathematical equation has to be worked out in order to allow the painting to function. In this sense Head's painting approximates high-level mathematics, which is governed not by the fixed arithmetic formulae of the school classroom, but by creating mathematical solutions relevant to the particular problem at hand. A simple example of this can be shown using *Piccadilly*, 2007, (Plate 87). There is a red post box in the painting, the top of which is more or less on the eye-line of the painting, so if you hung the painting properly on a wall the top of the post box would be at the same height as the viewers' eyes. That is the horizon line, and because the top of the post box lines up with the horizon line it should be a straight line. That is because we should see objects below the horizon line as if from above, looking down on them, and see objects above the horizon line as if from below looking up at them. Things that are on the horizon line are level with our eyes, and we look straight on to them. If Head painted the post box in this way, however, it would look flat, and so he deviates from the mathematically correct formulation of lines of sight, and paints in a little bit of the top of the post box that we would not see if we were looking at it either in real life or in a photograph. By doing that simple thing he suggests that the post box is not a flat object like a silhouette, but a three dimensional one. More simply put, it looks more convincing by abandoning the conventions of perspective. This does not mean he abandons rules, but he does reinvent them to make them more appropriate to the particular painting.

In the creation of a painting like *Coffee at the Cottage Delight* (Plate 95), at some stage the drawing process

50. Michael Paraskos
with *Coffee at the Cottage
Delight*, image © John
Gibbons

comes to an end. Two things happen to the drawing on the canvas at this point. The first is that Head will rub out much of the detail. The drawing is once again a guideline and not a finished work of art, and not something that will trap the artist into making certain choices. Certainly it is not a map with spaces to fill in like a painting by numbers kit. The second thing that happens is that the drawing is sealed in with a wash, or intermediate varnish, made from 95 per cent turpentine, a splash of an alkyd painting medium (Liquin), and a small amount of oil colour that will give the painting an underlying tone. This is effectively the ground, sealing the graphite of the pencil drawing onto the canvas to prevent it smudging and polluting the paint placed on top of it. In his earlier paintings, foregoing the intermediate varnish, Head would at this point create an underpainting, usually in acrylic paint, which would approximate the finished colours and

tones of the final image, but over which a final top layer of acrylic paint or oil paint would be used. My recollection of seeing Head's work as under painting is that the images tended to be much flatter and the colours less vibrant than the final layer, even when that final layer was also in acrylic. According to Head, this was a last stage at which to balance out the colour and tonal harmonies across the whole canvas, and with that in mind it is notable how Head used to paint across all areas of a canvas in his older work, building up the entire image as a whole, whereas now he tends to bring a small area of the canvas up to a high level of finish before moving on to the next. This leads to the slightly disconcerting sight of an almost completely finished section of a painting cheek-by-jowl with a wholly unpainted area. It is not a technique Head recommends to the novice painter, as he recognises that there is a need to maintain an overall colour and tonal

rhythm across an entire canvas, and that the easiest way to achieve this is to work all areas of a painting up at the same time. But, as he says himself, he has been painting for long enough to have a good idea of the rhythms of an image without having to see the different elements of that rhythm in front of him. In the case of *Coffee at the Cottage Delight* this meant he began painting the border area of where the window divides the interior and exterior space, working vertically. Asked why he began here, Head is unsure for a moment, but says that his general aim when starting is to set down the lightest and darkest tones, and the border between interior and exterior space is usually a good place to do that. The reason for setting down the lightest and darkest tones is to create space in which the painting can continue to evolve. By setting down the lightest tone that is not white Head has the flexibility and freedom to make use of a lighter tone if he needs to later on. Similarly, by setting down his darkest tone that is not black he has the flexibility and freedom to make use of a darker tone later on if he needs to. The most important thing, however, is that this sets the perimeters of the painting, its lightest light and darkest dark, and in doing so establishes the pervading light of the painting from the outset. Head has questioned my phrasing of the process here, suggesting that the setting down of the tonal range evidences the pervading light, rather than establishing it, as the pervading light is more elusive than this suggests, although it does, he says, exist as an ideal even before the first mark has been laid on the canvas. Nonetheless, once the initial tones are set, everything else must operate in a relationship to them. As Head notes, however, this sounds far simpler than it really is. There are, he says, severe limitations in relying on a tonal range:

> The distance between the brightest light and a darkness, so dark that you can't see your hand in front of your face, is so much greater than the distance

between black and white paint. Couple this to a painting problem that is dealing with areas that are bathed in daylight, and those that are poorly lit such as the interior and you get some idea of the huge problem that needs to be addressed.[105]

In the past he might have tried to extend the tonal range through the use of glazes, but this is no longer the case. Instead he notes that, 'The fact remains that it is not possible to imitate the tonal range of light in paint, and to do so would imply a mimetic concern.'[106]

In the application of paint, *Coffee at the Cottage Delight* then proceeded through the central male figure, on to the woman outside the coffee shop by the window, then the reflected self-portrait of the artist, left to the second male figure, and generally in a left-right growth from that point on. It almost grows, in this instance, from the centre outwards, but that is not always the case. A measure of this still being an organic process, in which Head responds to the needs of the painting, is given by the fact that even at these late stages he will often return to the original site that motivated the painting to re-experience it. Models might also be brought into the studio to allow a figure or even a limb to be redrawn (Plate 50). What is apparent is that there is no set formula to the creation of the paintings, except to recognise that the demands of the painting need to be met, even if that means abandoning previous drawn and photographic sources in favour of new ones at a late stage.

The aim is to reach that moment when Head hears the work click, and the painting starts to function. What happens at that moment is that a new world, a new universe, is brought into being not in terms of metaphor or hyperbole, but literally. It exists literally, and though we can no more enter into that world physically than we can enter into the infinite other universes that scientists and fiction writers tell us exist on the other side of worm holes, black holes, or even rabbit holes, we can em-

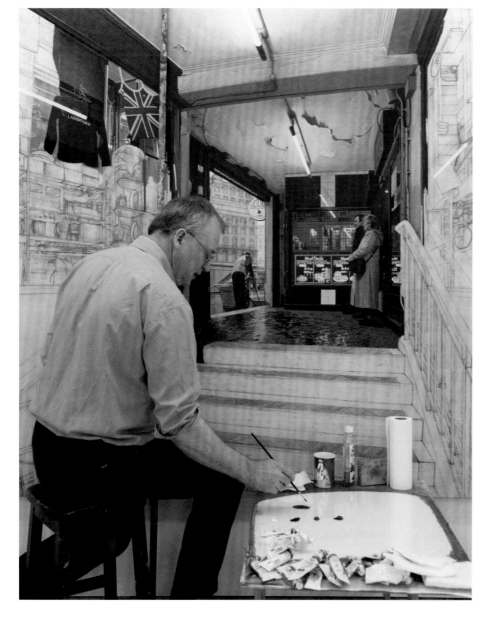

51. Clive Head painting *Leaving the Underground*, image © John Gibbons

pathise ourselves into the fabricated reality. In the words of Kandinsky, 'For many years I have searched for a way of letting the viewer go for a walk in a painting and of making him lose himself in it. Sometimes I succeeded, too: I could tell from watching him.'[107] Whether we are viewers of the paintings of Kandinsky or those of Head this principle remains the same. The quest is for that click of which Estes spoke, a point at which the universe of the painting starts to function as an independent entity, as a new creation. Whether we look at the abstract paintings of Kandinsky or the realist ones of Head; at a still life, a landscape, a city scene or a geometrical composition; they all require sufficient credibility as alternative worlds to allow us to suspend our disbelief, and muster sufficient faith to go for a walk in what are the only real worlds of art.

Epilogue

All avant-garde artists are dissatisfied with the art world. This is not a selfish position based on their relative acclaim within that world, it is because they are to some extent dissatisfied with the world as a whole. The act of making art is an attempt to establish an alternative reality, a superior order, to the flux and chaos that an artist sees in the world around them. Art is always rooted in this world, but it is never a straightforward celebration of it, even if the artist shows an undoubted love for his or her subject matter. Nor is it a straightforward condemnation of this world, even if the artist shows an inexorable hatred for their subject matter. In both cases, the important thing is the establishment of an alternative reality that is not the same as our reality – that is a reality that transcends our reality. The great nineteenth-century German philosopher Conrad Fiedler understood the importance of this. It was not to do with personal taste, or ideological preference. It was far more important than that. 'Artistic activity', he wrote, 'begins when man finds himself face to face with the visible world as with something immensely enigmatical.' Out of that encounter, Fiedler suggested, in the creation of a work of art, 'man engages in a struggle with nature not for his physical but for his mental existence.'[108] The dissatisfaction is with the enigma, so that all those artists who seem to revel in the vagueness of what they call the 'ambiguity of the image' are simply selling the viewing public short. Ambiguity is anathema to art, and as an ideological position it has terrible practical consequences, in badly drawn forms, vague lines, poor spatial construction and the incompetent use of light, tone and colour. Art is the establishment of reality, and so to make bad art, either deliberately or through sluggishness, is immoral. That is not to say art cannot be funny, witty or playful, but in making an artwork the artist always means it as a definitive statement (which is to say a statement that defines). That is why bad art is immoral, because bad art demeans our definition of nature.

Head is an artist whose work is founded on a fundamental morality. Do not mistake this for an antithetical reaction to late twentieth-century art, which was the product of the simple inability of many artists to make good art; or a wilful decision by a few to make bad art. Head's morality is deeply felt, and not chosen for effect. In rejecting the mores of the last century, he establishes new values in art for our time. That is the revolution. A measure of the importance Head places on artists making the right choice, in moral terms, rather than the right choice for personal gain, can be seen by looking at the situation that faced him at the start of the twenty-first century. It was a time when the act of painting, let alone realist painting, was so unfashionable that the declaration 'painting is dead' was almost a truism.

52. Clive Head, detail, *Citta del Vaticano*, 2005

Oil on canvas
109.3 × 193 cm
(43 × 76 in)
Private collection

Painting still existed, not least in the work of Head, but it was almost impossible to get critical attention, or major gallery shows. Painting existed as a discreet activity, funded by small scale sales and commissions. This was true for almost all painters.

As Head describes it, this was a moment of crisis for him, when he seemed to face two unpalatable options. The first was that he could abandon the art scene in Britain completely, leaving it to be dominated by concept-illustrators, and show instead entirely with a major New York Photorealist gallery. This would inevitably have associated his work with Photorealism, and probably have pulled him inexorably in a photorealistic direction. The second was to become a discreet painter of landscapes and portraits, working in Britain on a commission basis, and shows in galleries outside of the contemporary art scene.

In 2000 Head visited Rome and out of this came a series of paintings, *The Pincio Terrace* (Plate 67), *Santa Maria in Via* (Plate 77), *Scalinata di Spagna* and *Citta del Vaticano* (Plates 52 and 76). They are beautiful, even pretty, pictures that few people would object to hanging on their walls. They are heavily influenced by art history, and Head can list the specific influences on each image, with names such as Claude and Canaletto, Ruisdael, Rosa and Constable. Head has said of Rome: 'I was a bit in awe of its splendour and art history, and seemed willing to paint it in a more conventional, picturesque manner. It is the problem in painting Venice too, which is why I have never tried, apart from one small painting which I made when I was 17. The weight of the past in Italy can be a bit overbearing.'[109] Effectively, the apparent choice for Head was either to be swallowed up by an historic Photorealist agenda, that could be made to look contemporary at least through the selection of current subject matter; or by the European landscape traditions, whether that is the English landscapes of Constable, or the *campagna romana*. The little acrylic paintings he

made of Rome in 2000 offer a sense of what this might have meant, attractive, decorative and ultimately derivative images that would have ensured a steady income at a difficult time.

Yet neither of these options was the moral choice, as they were both a shirking of the responsibility of the artist to define our reality. Reasserting a Photorealist reality from 50 years ago is not defining our reality of now, it is the sluggard's choice not to engage with our world and establish its reality. Similarly, reasserting an historic landscape tradition, no matter how beautiful, is a flight from reality, a refusal to be relevant. Both positions would be as immoral as the makers of bad art, and none of this could establish the reality of now, imbued with the urgency of now.

Commenting on *Citta del Vaticano*, Head states: 'I stand by this painting, but it probably represents a bit of a loss in confidence in the now. It was made when the art world seemed to be closing down my platform and squeezing out painting altogether. At moments like this artists can return to the past, but this rather attractive painting signifies a moment of crisis.'[110] For that reason, both the easy options that seemed to be offered to Head in 2000 were ultimately rejected, and he did not become either a copier of photographs or a painter of attractive landscapes that offer an escape into the past. The direction he chose was far more uncertain, and not guaranteed to offer any success, but it was the right choice. It was the moral choice that was so out of kilter with the mainstream art world of that time, it was an ultimate avant-garde statement of intent. The result of that intent is the increasingly sophisticated practice we see today, which is uncompromising in its engagement with the world in which we live now. While Head's paintings offer astonishing passages of beauty in the definition of light, tone and colour, and the handling of paint, and they show extraordinary daring in the linear construction of space, it should never

be forgotten that the very existence of these works is an engagement with our world now, in all its different forms. In the simple existence of these paintings all previous versions of reality, all previous forms of art, are rendered historic. As Head states, 'Realist painting must be avant garde. It must be in parallel with our current interaction with the world, and ahead of the conventions like photography or video which have passed into our popular culture.'[111]

The avant-garde of which Head writes, is not the historic avant-garde of late modernism that for too long mistook contemporary life for challenging subject matter. It is an avant-garde that is far more fundamental, that seeks to redefine reality. It is born of a dissatisfaction with the fundamentals of existence, not the froth of life. Consequently, space itself becomes the meaning of this art, and although we cannot predict how Head will develop this agenda, there are fascinating hints in his preparatory studies for forthcoming works. Similarly, *Leaving the Underground* holds the possibility of being another step forward, which will extend even further the concept of a realist painting showing a dynamic, multifaceted, and ultimately Cubistic space. But there is also a challenge in this work for other artists, not to imitate Head as followers, or reject him as an adversary, but to join him in the future of art, the future of reality. Head is under no illusion that his project is complete or entirely successful. As he says himself, he only hopes that his future will bring more substance to a practice that he believes is fundamental to the human condition. Painting is an incredibly difficult pursuit, and no one should be under any doubt that it is not. But when it is successful, and defines its own reality in a way that allows the viewer to engage with the world it establishes, then it lifts the human spirit to astonishing heights.

Plates

54. *Kingsferry Bridge*,
1988–1990

Acrylic on canvas
76 × 182.8 cm
(30 × 72 in)
Private collection

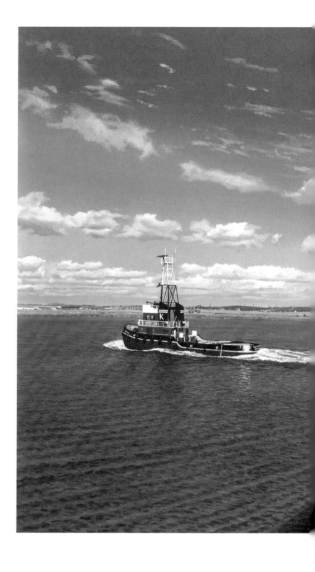

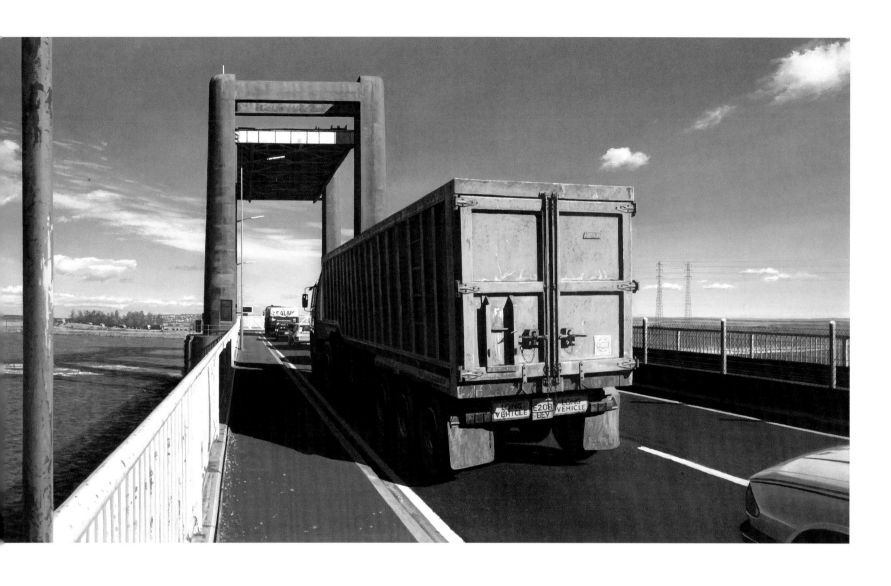

55. *Gatwick*, 1996

Oil on canvas
91 × 183 cm
(35 ⅞ × 72 in)
Private collection

56. *Summer Serenade*,
1996

Oil on canvas
76.2 × 114.3 cm
(30 × 45 in)
Private collection

57. *Tracks*, 1997

Oil on canvas
127 × 163 cm
(50 × 64 ⅛ in)
Private collection

58. *Observatory*, 1998

Oil on canvas
117 × 198 cm
(46 ⅛ × 78 in)
Private collection

59. *Cologne*, 1998

Oil on canvas
137 × 180 cm
(53 ⅞ × 70 ⅞ in)
Private collection

60. *Valley Bridge*, 1998

Oil on canvas
140 × 200 cm
(55 ⅛ × 78 ⅜ in)
Private collection

61. *Waterloo*, 1999

Oil on canvas
140 × 295 cm
(55 ⅛ × 116 ⅛ in)
Private collection

62. *East River*, 1999

Oil on canvas
140 × 193 cm
(55 ⅛ × 76 in)
Private collection

63. *Governor's Island*,
1999

Oil on canvas
137 × 193 cm
(53 ⅞ × 76 in)
Private collection

64. *Sloane Square*, 2000

Oil on canvas
112 × 183 cm
(44 ⅛ × 72 in)
Private collection

65. *View of London, Twilight*, 2000

Oil on canvas
124 × 218 cm
(48 ⅞ × 85 ⅞ in)
Private collection, image
© Steve Gorton

66. *South Kensington*,
2000

Oil on canvas
150 × 287 cm
(59 × 113 in)
Private collection

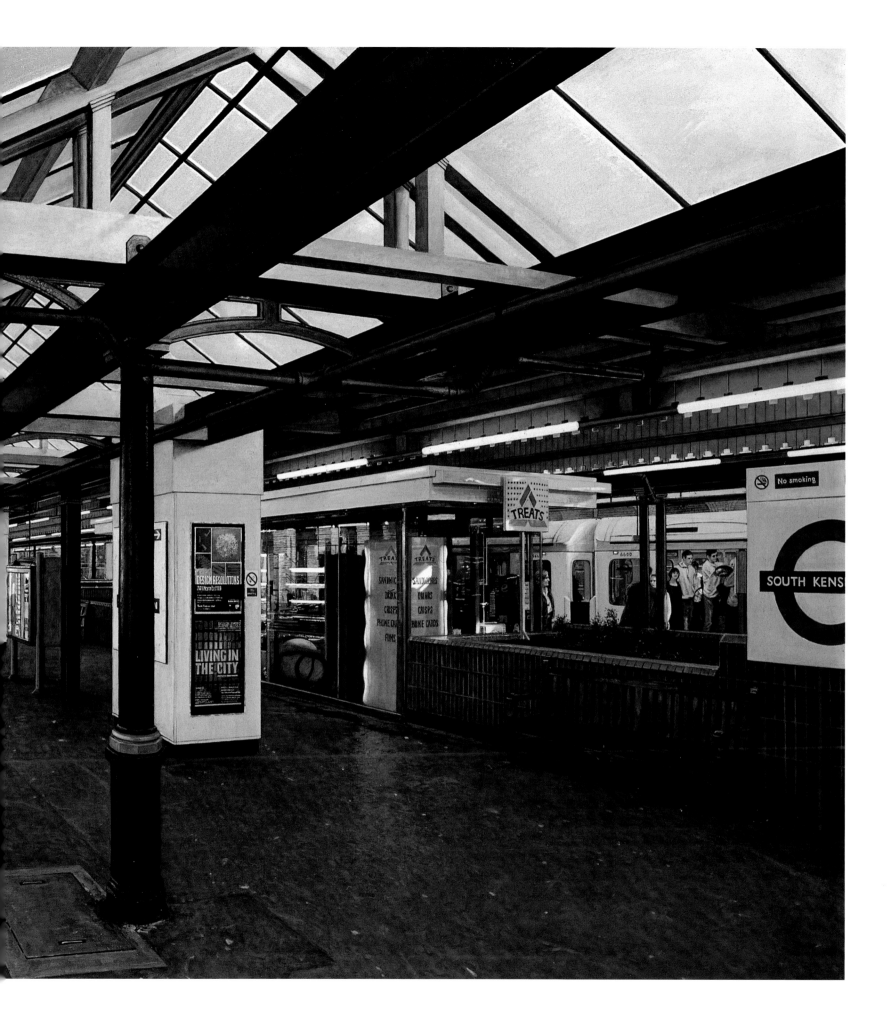

67. *View of Rome from the Pincio Terrace, Morning Light*, 2001

Oil on canvas
191 × 260 cm
(75 ⅛ × 102 ⅜ in)
Private collection

68. *Fresno*, 2001

Oil on canvas
132 × 190.5 cm
(52 × 75 in)
Private collection

133

69. *42nd Street Sunday Morning*, 2001

Oil on canvas
170.2 × 292.1 cm
(67 × 115 in)
Private collection

70. *Brooklyn Heights,*
2002

Oil on canvas
107 × 216 cm
(42 ⅛ × 85 in)
Private collection

71. *Paris, Morning Light*,
2002

Oil on canvas
134.6 × 256.5 cm
(53 × 101 in)
Private collection

72. *New York, October 2001*, 2002

Oil on canvas
190.5 × 267 cm
(75 × 105 ⅛ in)
Private collection

73. *Honey in the Sunshine*, 2003

Oil on canvas
191.7 × 236.2 cm
(75 ½ × 93 in)
Private collection

74. *Prague Early Morning*,
2004–2006

Oil on canvas
132 × 249 cm
(52 × 98 in)
Marlborough Fine Art

75. *View of London from Buckingham Palace*, 2005

Oil on canvas
109.1 × 218.5 cm
(43 × 86 in)
Museum of London/
image © Museum of
London

76. *Citta del Vaticano*, 2005

Oil on canvas
109.3 × 193 cm
(43 × 76 in)
Private collection

77. *Santa Maria in Via*,
2005

Oil on canvas
118 × 124 cm
(46 ½ × 48 ⅞ in)
Private collection

78. *Geneva Junction*,
2005

Oil on canvas
109.3 × 150 cm
(43 × 59 in)
Private collection

79. *Clouds over the Moskva River*, 2005–2007

Oil on canvas
109.3 × 167 cm
(43 × 65 ¼ in)
Private collection

80. *Spring Bloss[...]*
Geneva, 2005

Oil on canvas
98.5 × 158.5 cn [...]
(38 ½ × 62 ⅛ ii[...]
Private collectio[...]

81. *Inverness Terrace*,
2006

Oil on canvas
111.8 × 185.5 cm
(44 × 73 in)
Museum Frieder Burda,
Baden-Baden

82. *Rachel in the Studio*,
2006

Oil on canvas
68 × 65.4 cm
(26 ½ × 25 ½ in)
Museum Frieder Burda,
Baden-Baden

83. *St. Paul's from Blackfriars Bridge*, 2006

Oil on canvas
95 × 168 cm
(37 ⅜ × 66 ⅛ in)
Private collection

84. *Cliff Lift*, 2006

Oil on canvas
109.2 × 132 cm
(43 × 52 in)
Private collection

85. *Marylebone Road,*
2007

Oil on canvas
114.3 × 132 cm
(45 × 52 in)
Private collection

86. *Trafalgar*, 2007

Oil on canvas
157.5 × 188 cm
(62 × 74 in)
Private collection

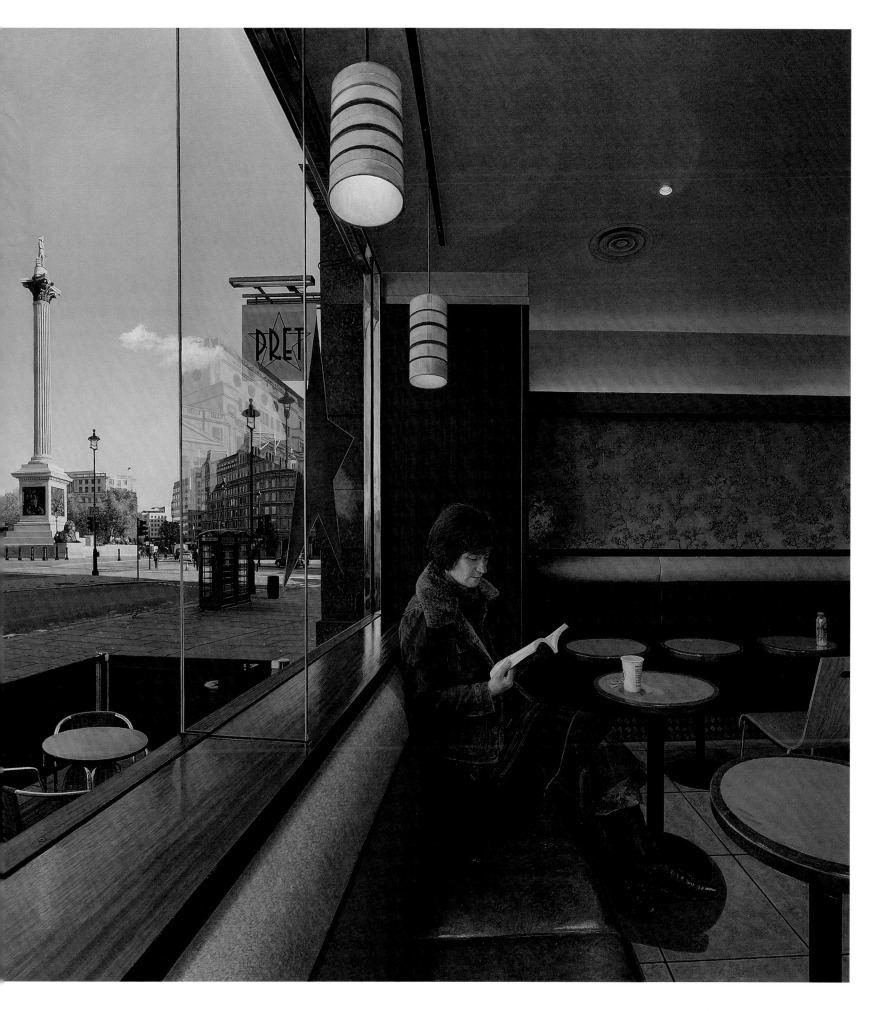

87. *Piccadilly*, 2007

Oil on canvas
153.6 × 231.7 cm
(60 ½ × 91 ¼ in)
Private collection

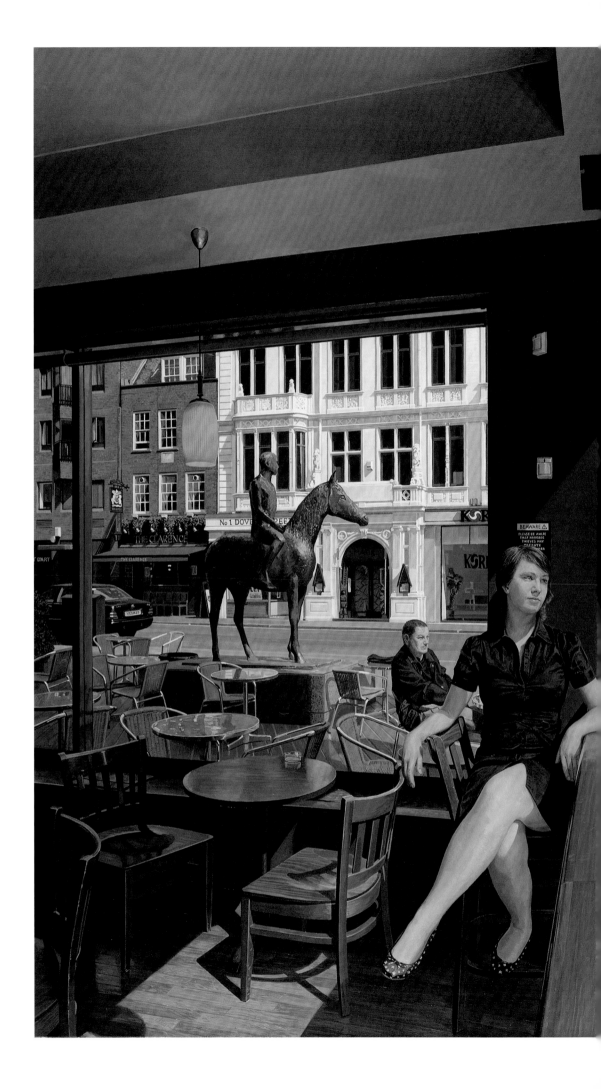

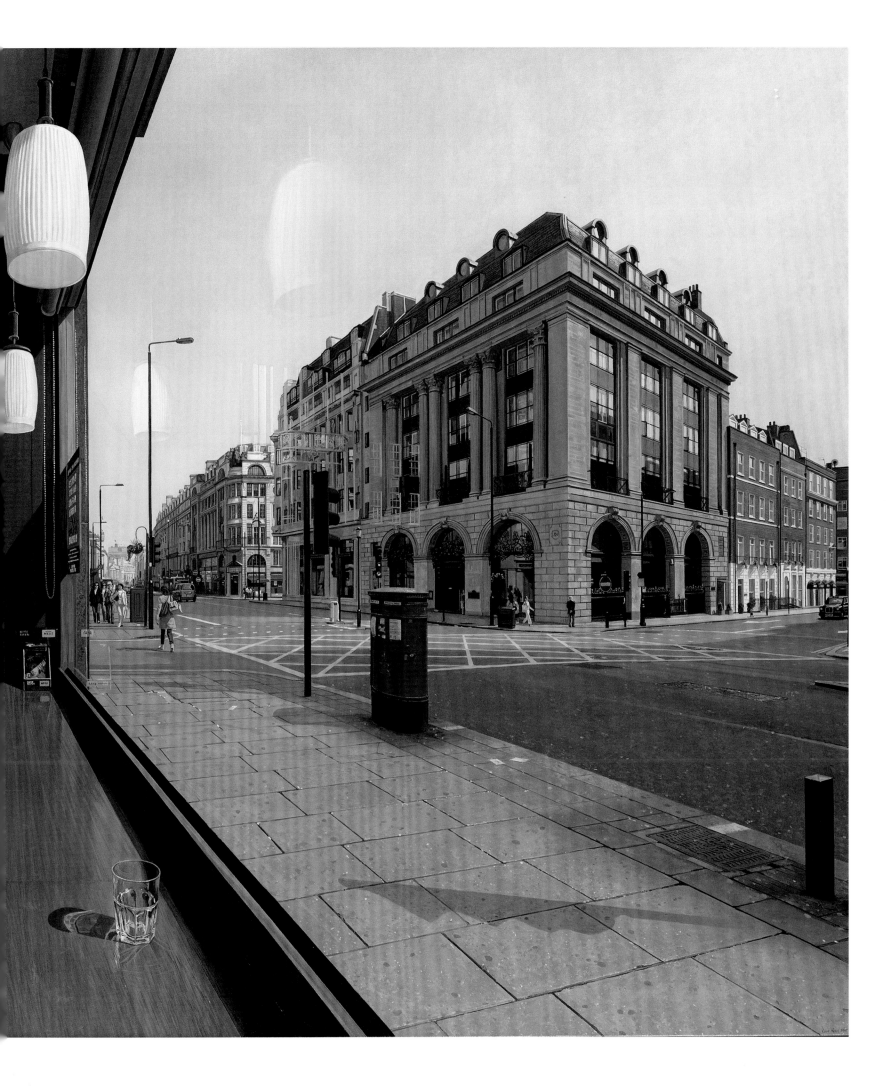

88. *Canary Wharf*, 2008

Oil on canvas
152.4 × 307.3 cm
(60 × 121 in)
Barclays Bank, London

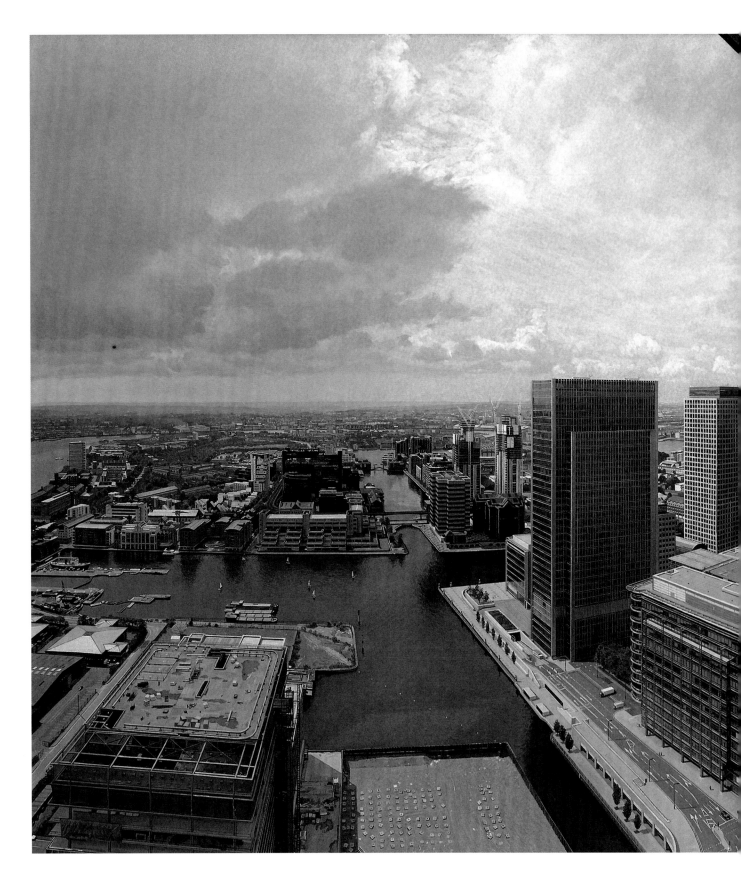

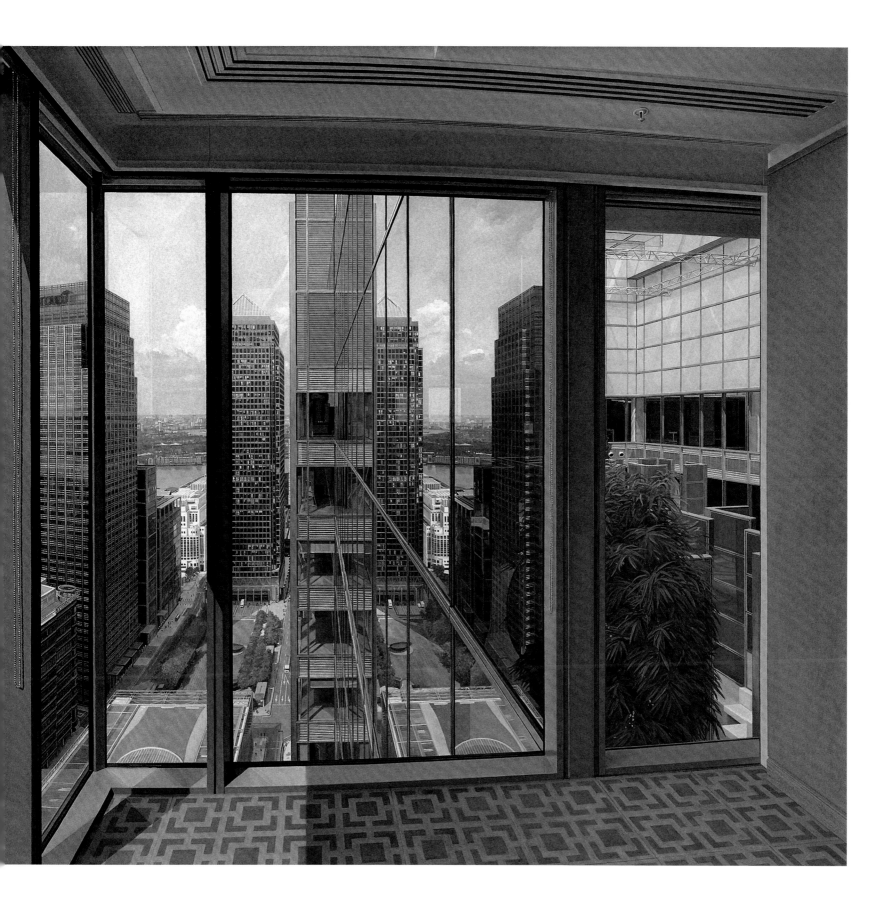

89. *Rebekah*, 2008

Oil on canvas
166 × 216 cm
(65 ⅛ × 85 in)
Private collection

90. *Victoria*, 2008

Oil on canvas
160 × 302.3 cm
(63 × 119 in)
Private collection

overleaf: 91. Detail of
Plate 90

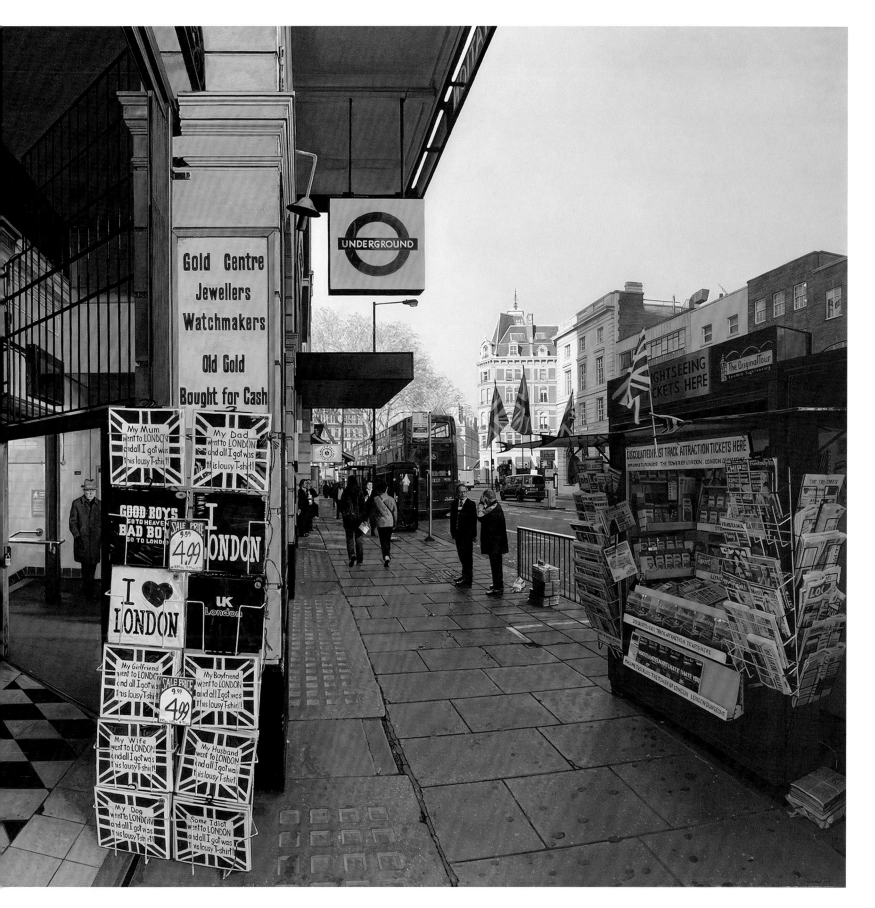

177

92. *Coffee with Armin*,
2009

Oil on canvas
155.6 × 203.8 cm
(61 ¼ × 80 ¼ in)
Private collection

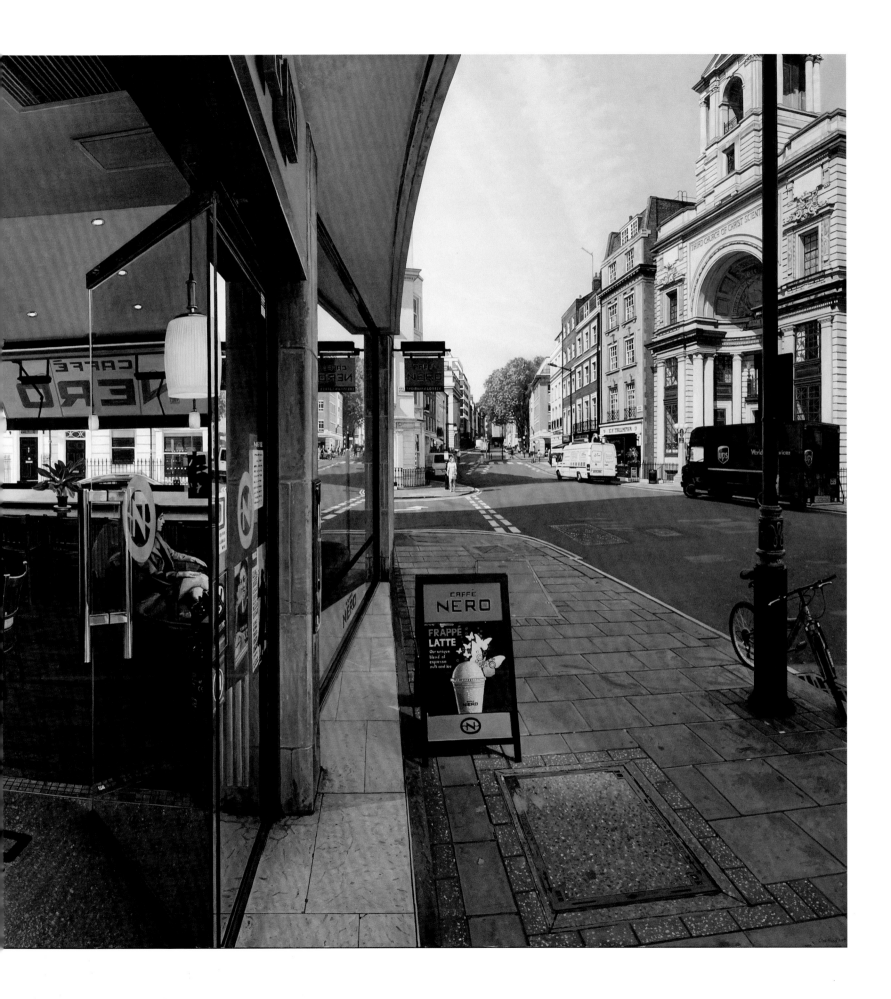

93. *South Kensington*,
2009

Oil on canvas
161.3cm × 279.4cm
(63 ½ × 110 in)
Private collection

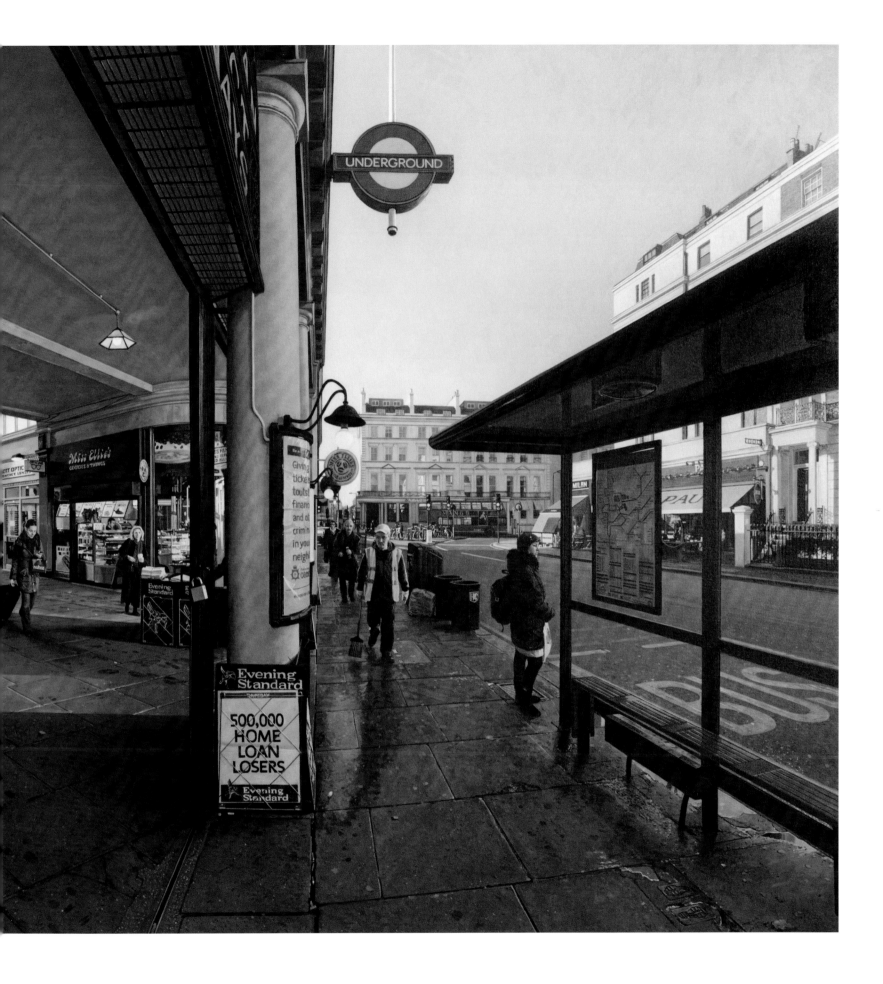

94. *Haymarket*, 2009

Oil on canvas
158 × 282 cm
(62 ¼ × 111 in)
Private collection

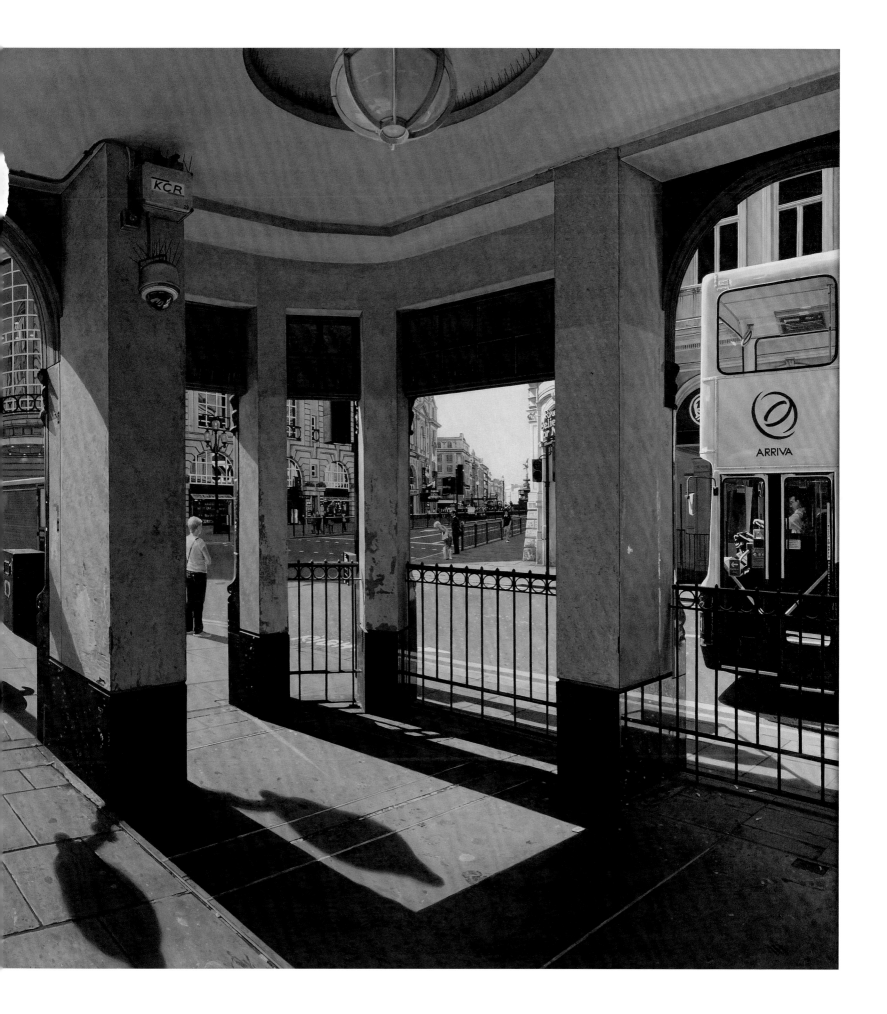

95. *Coffee at the Cottage Delight*, 2010

Oil on canvas
152.5 × 228.7 cm
(60 × 90 in)
Landau Fine Art, Montreal

overleaf: 96. Detail of
Plate 95

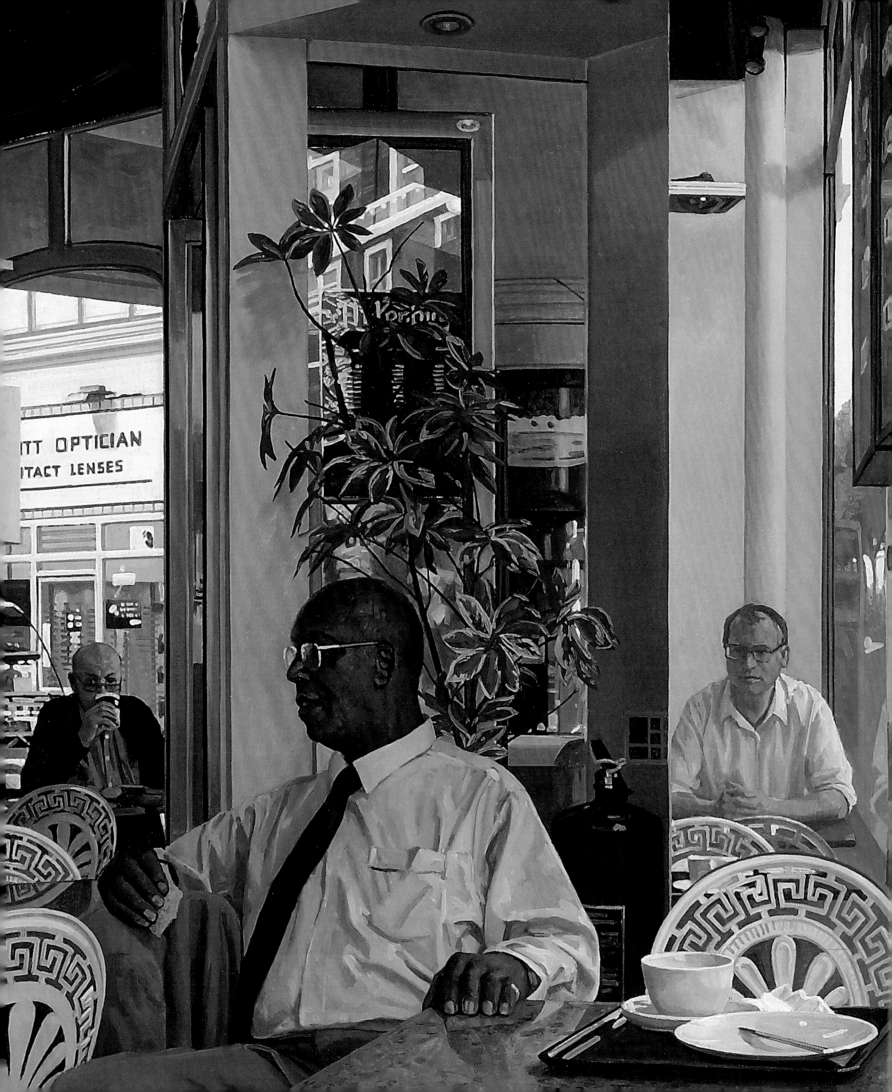

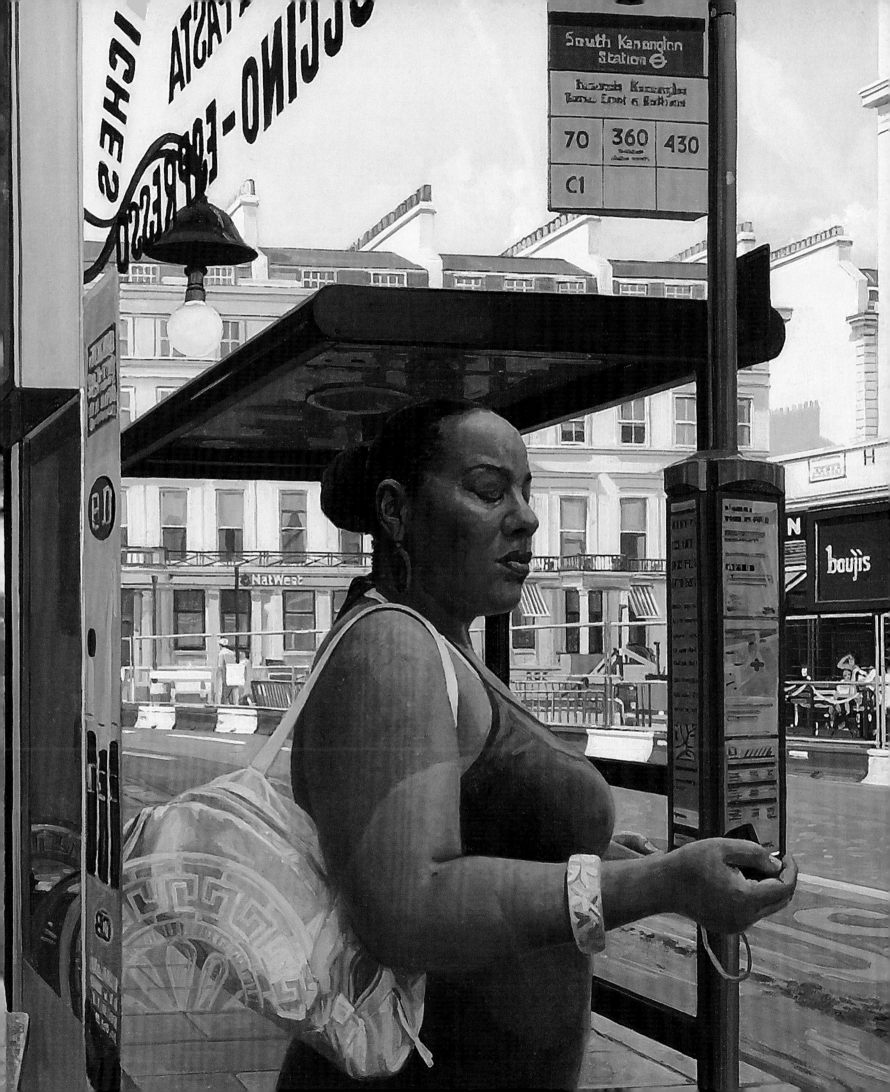

97. *Leaving the Underground*, 2010

Oil on canvas
174.4 × 227.1 cm
(68⅛ × 89⅜ in)
Marlborough Fine Art

Notes

1. Patrick Heron, 'Space in Painting and Architecture', reproduced in Mel Gooding (ed.), *Painter as Critic, Patrick Heron: Selected Writings*, Tate Publishing, London, 1998, p.73.

2. Letter from Clive Head to Michael Paraskos, 25 June 2009.

3. Roland Barthes, *Camera Lucida*, Hill and Wang, New York, 1981, passim.

4. David Sylvester, 'English Abstract Art', reproduced in David Sylvester, *About Modern Art. Critical Essays 1948–96*, Chatto and Windus, London, 2002, p.151.

5. The term 'photo-rendering realist' is used in the same sense by Louis Meisel. Meisel writes that rendering is, 'The craft of copying with exacting care'. See Louis K. Meisel, Photorealism, Harry N. Abrams, Inc., New York, 1981, p.274.

6. David Hockney, *Secret Knowledge: Rediscovering the Lost Techniques of the Old Masters*, Thames and Hudson, London, 2001, passim.

7. Frank Van Riper, 'Hockney's "Lucid" Bomb At the Art Establishment', *The Washington Post*, 20 February 2003.

8. Van Riper, for example, writes: 'Any contemporary artist who has worked from photographs [as so many do without compunction or any reason not to] knows how the "optical characteristics" of a photograph can help strengthen a drawing or painting by giving it at least a true-perspective underpinning.' See Frank Van Riper, 'Hockney's "Lucid" Bomb At the Art Establishment', *The Washington Post*, 20 February 2003.

9. Roland Barthes, *Camera Lucida*, Hill and Wang, New York, 1981, passim.

10. A useful overview of this is given by Jan Schapper and Julie Wolfram Cox in *Messages from the Margins? Cubism, Collage and Controversy*, Monash University Faculty of Business and Economics, Clayton, Australia, 2003, p.4 and passim.

11. Conversation between Clive Head and Michael Paraskos, Clive Head's studio, Scarborough, 30 January 2010.

12. Irma Ahearn Gallery, *The Prague Project*, Roberson Museum and Science Centre, Binghamton, 2005, pp 22–23.

13. See Jerome Ashmore, 'Sound in Kandinsky's Painting', *The Journal of Aesthetics and Art Criticism*, vol 35, no 3 (Spring 1977), pp 329–336.

14. Conversation between Ekkehard Altenberger and Michael Paraskos, APT Studios, London, 4 December 2009.

15. Conversation between Clive Head and Michael Paraskos, Scarborough, 19 December 2009.

16. Letter from Clive Head to Robert Neffson, 16 December 2009.

17. Frank Auerbach, *Frank Auerbach*, Marlborough Fine Art, London, 1990.

18. Letter from Clive Head to Michael Paraskos, 26 October 2009.

19. Robert Crotty (ed.), *The Charles Strong Lectures 1972–1984*, E. J. Brill, Leiden, 1987, p.x.

20. Letter from Clive Head to Robert Neffson, 21 November 2009.

21. ibid.

22. Linda Chase, 'Introduction to Naples Museum of Art', *Photorealism: The Liff Collection, Naples Museum of Art*, Naples, USA, 2001, p.8.

23. Conversation between Clive Head and Michael Paraskos, National Gallery, London, 1 October 2009.

24. Michael Paraskos, discussion with Clive Head, National Gallery, London, 21 October 2009.

25. Susie Nash talking on Jan van Eyck's Annunciation (c.1436), *The Private Life of a Christmas Masterpiece*, BBC4 Television, broadcast 21 December 2009.

26. Quoted in John Arthur, *Realism Photorealism*, Philbrook Art Centre, Tulsa, 1980, p.67.

27. I am not the first to note this: see John Arthur, *Realism Photorealism*, Philbrook Art Centre, Tulsa, 1980, p.68.

28. John Arthur, *Realism Photorealism*, Philbrook Art Centre, Tulsa, 1980, p.68.

29. Damien Hirst's exhibition 'The Elusive Truth', at the Gagosian Gallery, New York, was in effect a standard contemporary Photorealist show.

30. Interview with Clive Head, Scarborough, 3 June 2009.

31. This is in fact a paraphrase of the definition of photorealism given in the press release for Damien Hirst's 2005 exhibition 'The Elusive Truth', at the Gagosian Gallery, New York: 'Take a photograph, and copy it meticulously, until your painting and the photograph are indistinguishable.' (Science Photo Library, 'Damien Hirst Turns his Hand to Sciencephotorealism' [sic], Science Photo Library, 15 March 2005.) However, see also note 5.

32. This is not universally accepted, even in fiction. Writing in *Tait's Edinburgh Magazine* in 1848 George Troup thought the idea of hearing Rochester's thoughts over a distance of 50 miles 'objectionable'. See Richard Menaker, *Telegraphic Realism: Victorian Fiction and Other Information Systems*, Stanford University Press, Stanford, 2007, p.79–80.

33. Anthony Blunt in *The Spectator*, 8 October 1937, 584, quoted in Lynda Morris and Robert Radford, *AIA: The Story of the Artists' International Association 1933–1953*, Museum of Modern Art, Oxford, 1983, p.43.

34. Letter from Clive Head to Robert Neffson, 11 August 2009.

35. The word 'filters' in computer graphics programmes refers to

different effects that can be applied to an image, such as turning a colour image into a black and white or sepia one, and not to the physical filters that are placed over the lens of a camera.

36. Linda Chase, 'Introduction to Naples Museum of Art', *Photorealism: The Liff Collection, Naples Museum of Art*, Naples, USA, 2001, p.8.

37. Letter from Clive Head to Robert Neffson, 2 October 2008.

38. Letter from Clive Head to Michael Paraskos, 17 October 2008.

39. See Herbert Read's comments on the creation of Coleridge's poem *Dejection*, in Herbert Read, *The True Voice of Feeling*, Faber and Faber, London, 1953, pp 33–36.

40. Letter from Clive Head to Ken Wood, 21 December 2009.

41. ibid.

42. E. Marie Letterman, 'Thought Provoking Ideas and Other Redundancies', available at http://emarieletterman.blogspot.com/2009_11_01_archive.html, accessed 7 November 2009.

43. Conversation between Clive Head and Michael Paraskos, Clive Head's studio, Scarborough, 4 June 2009.

44. Both cited in James Hyman, *The Battle for Realism*, Yale University Press, New Haven, 2001, p.134

45. ibid.

46. Charles Ginner, 'Neo-Realism', in *The New Age*, 1 January 1914, pp 271–272.

47. This became one of the Aphorisms of Irsee. Clive Head and Michael Paraskos, *The Aphorisms of Irsee*, Orage Press, London, 2008, Verse 2.

48. Conversation between Clive Head and Michael Paraskos, Clive Head's studio, Scarborough, 4 June 2009.

49. Herbert Read, *English Prose Style*, Bell, London, 1928, p.42.

50. Interview with Clive Head, National Gallery, London, 1 October 2009.

51. The word aesthetics is derived from the Greek *aisthesis* which means to feel or experience through the senses.

52. Jean-Paul Sartre, *Being and Nothingness* (trans. Hazel Barnes), The Philosophical Library, New York, 1956, p.186.

53. Reproduced in Maurice Merleau-Ponty, *The World of Perception*, Routledge, London, 2004, p.66.

54. F. David Martin, 'The Autonomy of Sculpture', in *The Journal of Aesthetics and Art Criticism*, vol.34, no.3, Spring 1976, p.276.

55. ibid p.281 and passim.

56. Nancy Kleinholz, 'Pimp my gallery: red-light district comes to the National Gallery', in *The Metro* newspaper (London edition), 18 November 2009, p.38.

57. Letter from Clive Head to Armin Bienger, 8 December 2009.

58. Letter from Clive Head to Robert Neffson, 16 December 2009.

59. Letter from Clive Head to Michael Paraskos, 15 October 2009.

60. Letter from Clive Head to Michael Paraskos, 21 June 2009.

61. Telephone conversation between Clive Head and Michael Paraskos, 7 February 2010.

62. See the opening comments of David R. Smith, 'Irony or Civility: Notes on the Convergence of Genre and Portraiture in Seventeenth-Century Dutch Painting', in *Art Bulletin*, vol.69, no.3, pp 407–408.

63. Clement Greenberg, 'Collage', reproduced in Clement Greenberg, *Art and Culture: Critical Essays*, Beacon Press, Boston, 1961. pp 70–83.

64. Herbert Read, *The Philosophy of Modern Art*, Faber and Faber, London, 1952, p32–33.

65. Charles Ginner, 'Neo-Realism', in *The New Age*, 1 January 1914, pp 271–2.

66. Stephen Greenblatt et al. (eds), 'Gerard Manley Hopkins' in *The Norton Anthology of English Literature*, Norton, New York, 2006, pp 1513–16.

67. Charles Ginner, 'Neo-Realism', in *The New Age*, 1 January 1914, pp 271–272.

68. Conversation between Clive Head and Michael Paraskos, Clive Head's studio, Scarborough, 30 January 2010.

69. Although Head is dismissive of the Duchampian tradition of anti-art that emerged in the 1920s, it is notable that he is not averse to modernism as a whole. He has an admiration for Matisse, even paying what he admits is a visual homage to Matisse in the reflected ironwork above the door on the extreme left of *South Kensington*, and he has stated: 'Cubism and Futurism presented a truly radical art, upsetting accepted formats, but not destroying art itself.' Letter from Clive Head to Michael Paraskos, 20 June 2009.

70. This event is recorded, albeit incompletely, in a catalogue called *The Prague Project*, Roberson Museum and Science Centre, Binghamton, 2004.

71. Interview with Clive Head, London, 31 December 2009.

72. Letter from Clive Head to Armin Bienger, 8 December 2009.

73. ibid.

74. It is worth noting the aphorism in Clive Head and Michael Paraskos, *The Aphorisms of Irsee*, Orage Press, London, 2008, Verse 21: 'Art is never ironic. It can be funny, witty or playful, but the artist always means it.'

75. On show at the Kröller-Müller Museum in Otterlo, The Netherlands.

76. Clive Head and Robert Neffson, *Clive Head: New Paintings*, Marlborough Fine Art Ltd, London, 2007, p.28.

77. ibid, p.24.

78. See Elaine Shefer, 'The Woman at

the Window in Victorian Art and Christina Rossetti as the Subject of Millais's Mariana', in *The Journal of Pre-Raphaelite Studies*, vol.IV, 1983, pp 14–25.

79. Letter from Clive Head to Torsten Prochnow, 29 September 2008.

80. An account of Head's paintings using this argument was written at the time by Robert Withers, *Talking of Post-modernism, a way ahead*, Elizabethan Gallery, Wakefield, 1995.

81. See Herbert Read, *Art and Society*, William Heinemann, London, 1937, p.33.

82. Conversation between Clive Head and Michael Paraskos, National Gallery, London, 30 December 2009. The subsequent Head quotations in the following pages date from this conversation unless otherwise stated.

83. See Editorial, 'The British Poussin', in *The Burlington Magazine*, vol.137, no.1106 (May 1995), p.291.

84. Clive Head and Robert Neffson, *Clive Head: New Paintings*, Marlborough Fine Art Ltd, London, 2007, p.18.

85. Clive Head and Robert Neffson, *Clive Head: New Paintings*, Marlborough Fine Art Ltd, London, 2007, p.26.

86. Conversation between Clive Head and Michael Paraskos, Marlborough Fine Art, London, 19 October 2009.

87. See Michael A. Guillen and Dietrick E. Thomsen, 'P. A. M. Dirac an Eye for Beauty', in *Science News*, vol. 119, no. 25, 20 June 1981, pp 394–399.

88. Phil Beadle, 'You can't dance in front of an interactive button', in the *Guardian*, London, 28 October 2008.

89. Telephone conversation between Clive Head and Michael Paraskos, 7 January 2010.

90. Conversation between Clive Head and Michael Paraskos, Marlborough Fine Art, London, 19 October 2009.

91. Conversation between Clive Head

and Michael Paraskos, Clive Head's studio, Scarborough, 13 November 2009.

92. Letter from Clive Head to Benedict Read, 25 March 2009.

93. Conversation between Clive Head and Michael Paraskos, Clive Head's studio, Scarborough, 13 November 2009.

94. Letter from Clive Head to Michael Paraskos, 22 June 2009.

95. Letter from Clive Head to Michael Paraskos, 3 January 2009.

96. Conversation between Clive Head and Michael Paraskos, National Gallery, London, 19 October 2009.

97. Conversation between Clive Head and Michael Paraskos, Tate Britain (Van Dyck Exhibition), London, 24 April 2009.

98. Letter from Clive Head to Michael Paraskos, 12 January 2020.

99. Conversation between Clive Head and Michael Paraskos, National Gallery, London, 19 October 2009.

100. ibid.

101. ibid.

102. Conversation between Clive Head and Michael Paraskos, Clive Head's studio, Scarborough, 13 November 2009.

103. ibid.

104. Conversation between Clive Head and Michael Paraskos, Masala Zone Restaurant, London, 6 February 2009.

105. Letter from Clive Head to Michael Paraskos, 12 January 2010.

106. ibid.

107. Quoted in Hans Konrad Röthel, *The Blue Rider*, Praeger Publishers, New York, 1971, p.3.

108. Conrad Fiedler, *On Judging Works of Art*, trans. Henry Schaefer-Simmern and Fulmer Mood, University of California Press, Berkeley, 1940, p.48.

109. Letter from Clive Head to Michael Paraskos, 30 January 2010.

110. ibid.

111. ibid.

1965
Born Aylesford, Maidstone, Kent.

1976
Joined Reeds Art Club at Reeds Paper Mill, Aylesford. Head's father is a machine operator at the mill. Head begins to paint and exhibit regionally. As a teenager, he regularly visits the London museums, developing an in-depth visual knowledge of Western painting.

1982
Tours Greece and Italy, studying Classical antiquities and Renaissance Art.

1983–1986
Studies at the University of Aberystwyth under David Tinker.

1983
Meets Gaynor Hanily, whom he marries in 1986. They now have four children: Alexander, Edward, Rachel and Annabel.

1984
Tours The Netherlands, studying seventeenth century Dutch painting.

1986
Awarded the Sir Francis Williams Prize for painting at the University of Aberystwyth.

1987–1989
Studies Visual Arts (M.Phil) at Lancaster University.

1988
Awarded British Academy Scholarship to study in New York. Interviews Richard Estes.

1991
Awarded the Elizabeth Greenshields Memorial Prize for realist painting.

1991
First solo London exhibition at the Woodlands Art Gallery, Blackheath. Also

curates his first group exhibition of realist painting. Since then Head has curated further exhibitions, supporting many artists and introducing important American painters to the UK. He has written widely on contemporary realist art.

1992–1995
Produces a large body of Neoclassical figurative paintings which are exhibited by the Nicholas Treadwell Gallery in Europe and Paton Gallery, London.

1994–1999
Founded and chaired the Department of Fine Art at the University of York (Scarborough).

1995
Meets Jason Brooks whilst teaching. He encourages Brooks to start realist painting and they exhibit together in London.

1996
Moved to Scarborough where he currently lives and works.

1996
Joined Blains Fine Art, London, later to become Haunch of Venison Gallery.

2000
Began exhibiting with the Louis Meisel Gallery New York. Meisel regards Head as the only British painter to be included in the Photorealist movement and Head's work is included in museum shows worldwide. Head regularly visits New York for the next five years.

2000
Tours California with the art dealer Harry Blain.

2000
Study visit to Rome.

2003
Joins the International Photorealist Project in Prague. The work produced is later exhibited in the US.

2005
Commissioned by the Museum of London to commemorate the Golden Jubilee of HM The Queen.

2005
Onset of a neurological illness which renders Head partially disabled. Continues to paint but he has to change his working practice. Foreign travel becomes difficult. London becomes his principle subject. He is finally diagnosed and treated for Dopa-Responsive Dystonia five years later.

2005
Joined Marlborough Fine Art London. His friend and long-time supporter Armin Bienger becomes his agent. Marlborough continue to represent his work worldwide.

2007
Guido Persterer begins to promote Head's work in Zurich.

2007
Malermeister at the Schwäbische Kunstsommer, University of Augsburg, Irsee, Germany. Joined by his friend Michael Paraskos and they begin to collaborate in writing on contemporary aesthetics.

2007
Head's correspondence with the artist Robert Neffson published.

2009
Gives a lecture at the London Knowledge Lab, entitled 'Can Science Save Art? Moves Towards a Wider Mathematics of Art'.

2010
Invited to exhibit at the National Gallery, London.

1999
Clive Head, Blains Fine Art, London

2001
Clive Head, Paintings 1996–2001, Linda Chase and Tom Flynn, Blains Fine Art, London

2002
Studies Deserving Study, John A. Parks, American Artist
Photorealism at the Millennium, Louis K. Meisel and Linda Chase, Abrams, New York

2003
Exactitude, John Russell Taylor and Clive Head, Plus One Plus Two Gallery, London
Realism, Edward Lucie-Smith, Flowers, London
Iperrealisti, Gianni Mercurio, Viviani Art, Rome

2004
Blow Up, New Painting and Photoreality, St Paul's Gallery, Birmingham
The Prague Project, Gregory Saraceno and Clive Head, Roberson Museum and Science Center, Binghamton, New York

2005
'Panoramic Painting from Buckingham Palace on Display', Maev Kennedy, the *Guardian*, London, 12 March 2005

2007
'The New Certainty: Contemporary Realist Painting', Michael Paraskos, *Art of England*, London, November 2007
Clive Head New Paintings, Marlborough Fine Art, London

2009
Exactitude: Hyperrealist Art Today, John Russell Taylor with an introduction by Clive Head, Thames and Hudson, London

2010
'A Revolution is Announced', Michael Paraskos, *The Epoch Times*, 13 January 2010

Solo Exhibitions

1991
Monuments to the Moment. Super Realist Paintings of the Urban Landscape, Woodlands Art Gallery, London

1995
Silent Happenings, Elizabethan Gallery, Wakefield

1999
Clive Head, Blains Fine Art, London

2001
Clive Head, Recent Paintings, Blains Fine Art, London

2002
International Cityscapes, Bernarducci Meisel Gallery, New York

2005
Clive Head, New Paintings, Louis K. Meisel Gallery, New York
View of London from Buckingham Palace. Commission to commemorate the Golden Jubilee of HM the Queen, Museum of London

2007
Clive Head: New Paintings, Marlborough Fine Art, London

2010
National Gallery, London

Select Group Exhibitions

1991
Contemporary Realism, Maidstone Museum and Art Gallery (touring)

1991–1992
Treadwell Gallery at Marcus and Marcus Gallery, Amsterdam

1991–1994
Treadwell Gallery at Galerie Goetz, Basel

1996
Making a Mark, The Discerning Eye, Mall Galleries, London
Trojan, Paton Gallery, London

1997
Talent, Allan Stone Gallery, New York

2000
Urban Realism, Blains Fine Art, London

2001
Near and Far, Louis K. Meisel Gallery, New York
Great Britain! UK in NY, Bernarducci Meisel Gallery, New York

2002
Art Chicago, Louis K. Meisel Gallery, New York
Photorealism at the Millennium, Louis K. Meisel Gallery, New York

2003
Exactitude, Plus One Plus Two Gallery, London (curated by Clive Head)
Iperrealisti, Chiostro del Bramante, Rome
Realism, Flowers East Gallery, London

2004
The New Photorealists, Louis K. Meisel Gallery, New York
Nine Real Painters, Flowers Central, London
Blow Up, New Painting and Photoreality, St Paul's Gallery, Birmingham, United Kingdom
Some Photorealism, Louis K. Meisel Gallery, New York

The Prague Project, Roberson Museum and Science Centre, Binghamton, New York
The Big Picture, Bernarducci Meisel Gallery, New York

2005
Art Basel
Moscow Fine Art Fair

2006
TEFAF Maastricht
Large Urban Landscapes, Louis K. Meisel Gallery, New York
Summer Exhibition, Marlborough Fine Art, London
Vienna Fair, Vienna, Marlborough Fine Art, London
The Reality Show, Peninsular Fine Arts Centre, Virginia, USA

2007
TEFAF Maastricht
Art Basel

2008
TEFAF Maastricht
Art Basel
Scarborough Realists Now, Scarborough Art Gallery

2009
TEFAF Maastricht
Art Basel
Summer Exhibition, Marlborough Fine Art, London
Art International Zurich, Persterer Contemporary Fine Art

2010
Winter Exhibition, Marlborough Fine Art, London
TEFAF Maastricht
Art Brussels
Art Basel
Realism: from Courbet to Duane Hanson, Kunsthal, Rotterdam

Index

Page numbers in *italics* refer to illustrations

Abbott, Berenice 17
Altenburger, Ekkehard 20
American Photorealism 25, 63, 65, 66, 68
Analytical Cubism 41, 55–7, 58, 59, 73
Arthur, John 26
Auerbach, Frank 20, 32, 45, 47, 82
 Tower Blocks, Hampstead Road 46
avant-garde 99, 100, 102

Bacon, Francis 47, 53
 Study for a Portrait of Van Gogh IV 83
Baeder, John 25
Barthes, Roland 11, 17, 18, 32
Beadle, Phil 82
Bienger, Armin 61, 68, *180–1*
Blackwell, Tom 25, 26, 30, 63, 68
 Café Express 68
Blains Fine Art, London, exhibition *50*
Blunt, Anthony 32
Braque, Georges 41, 54, 55, 56, 58
Bratby, John 65
Breughel, Pieter, the Elder 48
Brunelli, Anthony 62
Bryony (model) 69

Caillebotte, Gustave 63, 64
 La Place de l'Europe 63
 Le Pont de l'Europe 63, 64
 Rooftops in the Snow 63–4, 64
Camden Town Group 47, 65, 69
Camera Obscura 15, 93
Canaletto, Antonio 44, 45, 53, 57, 65, 66, 100
 Venice: The Upper Reaches of the Grand
 Canal with S. Simeone Piccolo 23, 24
Canary Wharf, 1 Churchill Place 19
Caravaggio, Michelangelo Merisi da 44, 73
Cézanne, Paul 48, 56, 78
Chamberlain, Lewis 93
 Things That Go 27, 29
Chardin, Jean Baptiste Siméon 48
Chase, Linda 23, 39
 Photorealism at the Millennium (with Louis
 K. Meisel) 14–15
Claude Lorrain 53, 67, 75, 100
 Landscape with Apollo and Mercury 52, 52
Coker, Peter 65

Coleridge, Samuel Taylor 42, 50
conceptualism 20, 22
Constable, John 100
Courbet, Gustave 48
Craig-Martin, Michael, *An Oak Tree 20, 22*
Crick, Francis 42, 43
Crotty, Robert 22
Cubism 18, 24, 41, 42, 54–5, 56, 57, 58, 73, 78
Cuyp, Aelbert 52, 53, 67

Dante Alighieri, *Divine Comedy 84*
Delacroix, Eugène, *The Massacre at Chios* 9–10, *10*
Delaunay, Robert 18
 The Eiffel Tower 18
Dirac, Paul 82
Doig, Peter 87

Ecole d'Avignon 47, 48
Estes, Richard 30, 50, 53, 57, 63, 64, 68, 82
 Chipps 68
 Supreme Hardware 25, 25, 26
 Telephone Booths 26
Eyck, Jan van 47, 48, 54
 Annunciation 24–5

Fiedler, Conrad 99
Freud, Lucian 47
Frink, Elisabeth 30
Fry, Roger 73
Futurism 18, 58

Gertsch, Franz 26, 30
Ghirlandaio, Domenico 48
Gilman, Harold 47, 65
 An Eating House 69, 70
Ginner, Charles 26, 47, 48, 57, 65
 The Café Royal 69
 The Sunlit Square 48
Goings, Ralph 63
Gore, Spencer Frederick 65
El Greco 48
Greenberg, Clement 55, 73

Head, Clive
 bibliography 196
 chronology 195

exhibitions
 group 197
 solo 197
photographed 6, 15, 40, 57, 97
works
 42nd Street Sunday Morning 92, 134–5
 Blackfriars Bridge 66, 67
 Brooklyn Heights 136–7
 Canary Wharf 19–20, 21, 25, 31, 172–3
 Citta del Vaticano 98, 100, 148–9
 Cliff Lift 69, 70, 72, 165
 Clouds over the Moskva River 154–5
 Coffee with Armin 34, 35, 61, 68, 70, 180–1
 Coffee at the Cottage Delight 68, 69, 79, 84–92, 85, 87, 90–1, 94–6, 95, 186–7, 188–9
 Cologne 8, 11–12, 65, 66, 114–15
 East River 120–1
 Fresno 132–3
 Gatwick 106–7
 Geneva Junction 59, 152–3
 Governor's Island 66, 122–3
 Haymarket 15, 35, 62, 65, 79, 89, 184–5
 Honey in the Sunshine 142–3
 Inverness Terrace 63, 79–80, 158–9
 Kingsferry Bridge 7, 63, 104–5
 Lay Martyr 70, 73
 Leaving the Underground 6, 65–6, 65, 97, 102, 190–1
 Marylebone Road 74, 81, 167
 New York, October 2001 140–1
 The Night Café 68–9, 69
 Observatory 63, 112–13
 Paris, Morning Light 138–9
 Paris Sunrise 32–3
 Paris Window 26, 28
 Piccadilly 30–1, 35, 68, 69, 70, 74, 88, 94, 170–1
 The Pincio Terrace 100
 Prague Early Morning 62, 144–5
 Rachel in the Studio 161
 Rebekah 30, 68, 70, 73, 101, 174–5
 The Riviera 26, 28
 St. Paul's from Blackfriars Bridge 12–14, 13, 17, 18, 162–3
 Santa Maria in Via 100, 150–1
 Scalinata di Spagna 100

Separation 26, 27
Sloane Square 62–3, 69, 71, 124–5
South Kensington
 2000 63, 128–9
 2009 35–8, 36–7, 40, 45–8, 50–1,
 59–60, 65, 68, 182–3
Spring Blossom, Geneva 58, 81, 156–7
Study for Lights on 2nd Avenue 31
Summer Serenade 109
Tracks 62, 63, 110–11
Trafalgar 30, 68, 89, 168–9
Tudor City 92, 93
Under Hungerford Bridge 55
Valley Bridge 63, 116–17
Victoria 35, 48, 58, 176–7, 178–9
View of London from Buckingham Palace
 79, 79, 146–7
View of London, Twilight 81, 126–7
View of Rome from the Pincio Terrace,
 Morning Light 130–1
Waterloo 118–19
We Always Remember Whose Money It Is
 59, 60
Yellow House, the Last Day in Prague
 62
Head, Gaynor and children 68, 79
Hepworth, Barbara 51
Heron, Patrick 10
Hirst, Damien 26
Hockney, David 15, 93
Hopkins, Gerard Manley 57
Hopper, Edward
 Chop Suey 68
 Tables for Ladies 68
Hornby, Nick 83
Hyman, James 47

Impressionism 48
Irsee, Germany 49

John, Gwen 70

Kandinsky, Wassily 12, 20, 97
Kitchen Sink School 65, 66

Le Nain, Antoine; Louis; Mathieu 47, 48
Lebrun, Charles 47
López Garcia, Antonio, *Madrid Desde Torres*
 Blancas 27, 29, 82, 93

Macke, August, *Hat Shop* 68
Magritte, René 11
Manet, Edouard 66
Marlborough Fine Art, London 14
Martin, F. David 51
mathematics, and art 17, 38, 79-80, 82,
 92, 94
Matisse, Henri 52, 66
Meisel Gallery, New York 14–15
Meisel, Louis K., *Photorealism at the*
 Millennium (with Linda Chase) 14–15
Meniel, Bertrand 62
Merleau-Ponty, Maurice 51
metastoicheiosis 12, 20, 22, 23, 32
Middleditch, Edward 65
Millet, Jean François 48
Monet, Claude 68
 Impression Sunrise 68
 View from Rouelles 68

Nash, Susie 24
National Gallery, London 52, 53, 54, 65, 80
Neffson, Robert 20, 22, 34
Neo-Realism 47, 56, 65, 66, 69
New York 17, 100

Old Masters 15–16, 54, 66

Paraskos, Michael 69, 95
photography 17, 22–3
Photorealism 14–15, 23, 25–6, 47, 63, 100
Photoshop 38
Picasso, Pablo 24, 41, 54, 55, 56, 58, 82
'post-modernism' 73
Poussin, Nicholas 47, 66–7, 73, 75–8, 80–1
 The Adoration of the Golden Calf 75, 76

Ray, Man 17
Read, Herbert 50, 55, 73, 78
realism 17, 23, 24, 47, 67
Rembrandt 48, 66
Richter, Gerhard 26
Rosa, Salvator 100
Ruisdael, Jacob van 100

Salt, John 25
Saraceno, Gregory 18
Sartre, Jean-Paul 51
Sassoferrato 78

Scheibitz, Thomas 48
Schoenzeit, Ben 26, 30
School of London 47, 83
Smith, Jack 65
Smith, Matthew 83
Spence, Raphaella 62
Sylvester, David 12, 47
symbolism 22

Tate Britain 80, 83
Tate Modern 80
Teniers, David 68
Tinker, David 10, 54
Titian 44, 53, 66
 Diana and Actaeon 23–4, 26, 42, 42, 54
Turner, J.M.W. 67

University of Lancaster 54
University of Wales, Aberystwyth 54

Van Gogh, Vincent 48
 Café Terrace 68
Van Riper, Frank 16
Venus of Willendorf 9

Wallace Collection, London 52
Watson, James 42, 43
Whitehead, Steve 54
Wiggins, Colin 65

Acknowledgements

We would like to thank all those who have
helped in the production of this book.
Particular thanks go to Clive Head and his
family for their co-operation, and especially
Gaynor Head for help with proof reading
and advice. Thanks are also due to Armin
Bienger and his colleagues at Marlborough
Fine Art; Adrian Sutton, Harry Blain and
the Haunch of Venison Gallery; Colin
Wiggins and the National Gallery, London;
the Museum of London; Louis Meisel, Robert
Neffson, Benedict Read, Emma Hardy, James
Hyman, Lewis Chamberlain, Mark Bills,
Peter Smith, Colin Jellicoe, David Pears,
Alexander Head and Ken Wood. Also to
Prudence Cuming Associates Ltd., John
Gibbons, Malcolm Tweedie MacDonald and
Steve Gorton for photography and all the
museum and private collectors of art works
reproduced in this book.

In particular we would like to thank Jools
Holland for his support for this project, and
his excellent foreword.